Chapel Hill in Plain Sight

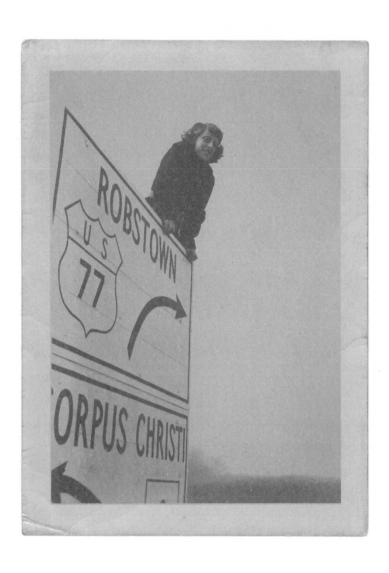

Chapel Hill

in Plain Sight

NOTES FROM THE OTHER SIDE OF THE TRACKS

Daphne Athas

Foreword by
Will Blythe

Chapel Hill in Plain Sight:
Notes From the Other Side of the Tracks
© Daphne Athas, 2010

Eno Publishers
P.O. Box 158
Hillsborough, North Carolina 27278
www.enopublishers.org

ISBN-13: 978-0-9820771-3-9
ISBN-10: 0-9820771-3-0

Library of Congress Control Number: 2010921750
Printed in the United States
10 9 8 7 6 5 4 3 2 1

Cover and frontispiece photos of Daphne Athas
by Arthur Lavine

Cover by Horse & Buggy Press,
Durham, North Carolina

Interior design & production by
Copperline Book Services,
Hillsborough, North Carolina

Eno Publishers wishes to acknowledge the generous
support of the Mary Duke Biddle Foundation.

For my nephew, Dana Spencer Francis,

with thanks for that day at Voidogelia, Pylos,

where Nestor feted Telemachos, and where we

realized our odyssey of connecting with each

other in family on that shore where your

grandfather swam.

Contents

Foreword

by Will Blythe

WHEN I THINK about Daphne Athas, I think about Daphne on her bicycle. I remember her wheeling up to Hill Hall on the University of North Carolina's campus where in the late Seventies the cinematographer Haskell Wexler's documentary on the Weather Underground (some of whose members were then still at large) was being screened. In my eyes, the subversion of that film and its outlaws instantly accrued to Daphne, not inappropriately I now think. I don't recall any other teachers there that night, and certainly none that rolled up on an old bike with big tires, but there was Daphne: Her love for learning has always been fresher than most freshmen.

This is a book about place as spirit by a perpetual student for whom the definition of things and the uncanny rhythmical glory of words have never lost their erotic allure. Amazing that words can do what they do! This is the first astonishment, in advance of the deconstructionist truth that words can also slip their moorings. Chapel Hill, with its abiding tendency to mythologize itself in rather sloppy fashion, has always needed a chronicler with dancing precision. And now, with Daphne Athas, it has that.

She is that rarest of writers who can simultaneously mythologize and demythologize a place in one fell swoop. That is to say, she manages to puncture self-satisfied swoonery more appropriate to booster clubs and tourist brochures and replace it with a legend at once more precise and miraculous. This is quite a trick. But she does it again and again. Consider her account here of the novelist Richard Wright's aborted visit to Chapel Hill. See, for instance, her stories about Junius Scales, the Communist organizer, and Milton Abernethy, the original proprietor of the Intimate Bookshop, both of whose travails complicate

the popular, even smug notion of Chapel Hill and its university as magnolia-scented bastions of free speech. It was all more complicated than that: Genteel Southern scholars and administrators sometimes barred the gates to the Southern Part of Heaven to those who deserved to be admitted for their bravery in challenging injustice through word and deed alike.

Daphne was my teacher, and a great teacher she was, able to insinuate Warhol's films, Seferis's poetry, and Welty's short stories into my and my classmates' Carolinian world with the easefulness of someone pouring a cup of coffee. As the years passed, and we aged from being Daphne's students to colleagues of a sort (which is how she treated us from the start), she continued to teach in the classic way: by example. To sit in her cinder-block house off of North Greensboro Street in Carrboro, discussing writers, politics, and history, not to mention good local gossip, was to realize that perpetual, deeply discriminating curiosity could be a voluptuous way of life.

Daphne, unlike a few of the more self-dramatizing subjects of this history (the beautifully named Ouida Campbell, for instance), has never had to strain after spurious bohemian visibility. She comes by it naturally. What a family history! She arrived in Chapel Hill with her parents and siblings from New England when she was in high school, and soon settled into a house known as "the Shack" at the corner of Merritt Mill Road and Cameron Avenue, nestled as tends to be the case in this town, beneath "green, lascivious trees." When the porch collapsed, it was burned for heat. Daphne sometimes awoke to see a rat eyeballing her from the ceiling. Her father, a Greek immigrant, liked to take a processional around the dinner table, pretending to be a Greek Orthodox priest holding a censor full of frankincense, proffering holy smoke. He ridiculed superstition, venerated knowledge, and yet in his exalting of Prometheus's theft of fire from Zeus, managed to keep a place in his heart for gods who were mutineers, those gods who loved humans in their impossibly mortal condition. His daughter appears to have a similar heart. And there is Daphne's wonderful piano-playing mother, all 193 pounds of her, hauling herself nightly up a stepladder

outside the Shack to the upstairs window of her bedroom, the only entrance, with the family watching to be sure she made it safely inside. "The tune we first hear is the tune we hear forever," Daphne writes.

Fortunately, the Athases sang a pretty fine tune. That tune is forever preserved in Athas's extraordinary novel, doubtless the greatest Chapel Hill novel ever (though that is not a category large enough), *Entering Ephesus*, a book that deserves to stand with such classic American family novels as Christina Stead's *The Man Who Loved Children*.

In the book at hand, Daphne writes in the tradition of the great Polish writers, perhaps my favorite essayists of the past and present century — the poets Adam Zagajewski, Zbigniew Herbert, and Czeslaw Milosz, for instance, all especially sensitive to the numinousness of place and the slipperiness of time, all of whom moved easily from the local to the metaphysical as if bicycling, like Daphne, from Carrboro to Greenlaw Hall.

In *Look Homeward, Angel*, Thomas Wolfe famously wrote rhapsodies to the Chapel Hill seasons. Daphne analyzes the (Old) wellsprings of such rhapsody as a form (it can be a little overwrought and self-pleased) while herself rhapsodizing with keen second sight over the very impulse to rhapsodize. Again, quite a trick! Perhaps it is her education in Hellenic myth, an immersion enhanced by frequent visits to Greece, that allows her to see Chapel Hill not solely from a home-grown perspective but from a yawingly vertical and infinitely horizontal stance in time and place. "Deep time," I think it is called. The discrimination does not drive out the affection.

"Because our town is so well-documented," she writes, "our forays into memory don't constitute nostalgia or legend or history per se, but the same old mystery demanding its vocabulary, a frontier with promises, discoveries, surprises, shocks of recognition. But really its syntax hasn't been invented. Not even yet." Readers, it has now.

When I grow up, which I hope to do someday, I want to be like Daphne. It may sound odd, perhaps poignant, and certainly a little late, for a fifty-three-year-old to confess this, but for as long as I've known her, Daphne has exuded the mutinous vitality of someone growing

younger over the course of a lifetime, if by youth we mean a condition of openness, a joyous awareness of the extraordinary oddness of simply being alive in — and *to* — a particular place and time. Judging from Daphne's example, genuine sophistication apparently requires wonderment. Long may she marvel.

Will Blythe is a magazine writer, author, and book critic, best known in North Carolina for his critically acclaimed memoir, To Hate Like This Is to Be Happy Forever. *The former literary editor of* Esquire, *he has written for numerous publications, including* Rolling Stone *and* Sports Illustrated, *and is a regular contributor to the* New York Times Book Review.

Origins and Acknowledgments

IN THE 19TH CENTURY Thoreau wrote in a letter to a friend: "It would be no small advantage if every small college were . . . located at the base of a mountain. . . . Some will remember, no doubt, not only that they went to college, but that they went to the mountain." Thoreau was referring to Williams College, but the University of North Carolina at Chapel Hill, the first public college in America to open its doors, fits the bill. Located at the edge of the eastern Fall Line above the Triassic Sea, riven with ravines and brooks, it mirrors endemically, geographically, and metaphorically the process of education. Up, down and around.

This book has been an evolutionary process. I had already written a novel called *Entering Ephesus,* based on elements of the Chapel Hill I lived in as a teenager. I had no intention of dealing with the town in realistic terms. But when I returned and started teaching creative writing at the university in the late Sixties after half a lifetime in Europe, New England, and New York, I hardly recognized the place.

I'd come to it from New England originally at age fifteen, grown up, and gone to high school and the university in those impressionable years when sights and sounds were so strange I'd written them down in description and dialogue with Southern accents. The fact that the town was dedicated to higher learning made living in it indivisible from learning itself, and it became my crucible.

During the later teaching years it dawned on me that Civil Rights and the Women's movements were born of the forces that had molded me, yet were initiated long before I was born. They are still the same forces in different guise that have ushered us into the cyber zeitgeist. They are mightier than I or anyone else could ever dream.

It was in the late Eighties that I thought of my early experiences as journalism. The short form was difficult for me, but the research fun. Most of the stories were about people I'd known as a teenager, all of them important in some way to Chapel Hill, as well as to me. The time frame of each essay covered the life span of one person, and these life spans were approximately the same in every essay. Sometimes, though, I had to do research to find out about the time before I knew the person, before he or she was born. Then later I had to research the time afterward when he or she had faded to obscurity.

The essays were published in local newspapers like the *Leader,* the *Independent,* and the *Spectator,* and I got more feedback than I'd ever had from a novel. Readers, some of whom I knew, but most not, wrote correcting or dialoguing in letters resembling blogs, except that they were politer, and blogs didn't exist then. Colleagues started telling me I should make a book of the essays. But how do you make a book of a loose assemblage of articles with the same timeline? No chance for development. Full of traps for repetition.

A vague sense of the forces affecting or affected by Chapel Hill in time formed in my imagination.

Everybody has his or her own Chapel Hill, and Chapel Hill itself has a collective vision spawned out of the collective memory, useful for publicity and commercial purposes. Memory affects myth and myth affects history, and myths have their fashions and history has its fashions. How do you separate these strands?

The significance of a place of higher learning is indisputable. Why would Jesse Helms have tried to fence the animals in the zoo if he hadn't feared some truth in the roars? In my experience, college-town residents, professors, students, retirees, hangers-on, or developers, are equally foolish and brilliant, noble and dumb, unsavory and ridiculous. They gossip as much, maybe slightly better than people in other towns, but are no different from characters you'd meet in fiction or sitcoms — Tom Sawyer, Jay Gatsby, desperate housewives, or Seinfeld. In small, well-lit places like offices, detective agencies, small towns, apartment buildings, or morgues, everybody gets to be famous.

So I collected the articles for a book. New York publishers couldn't figure out what to do with it. Neither could local or regional publishers. I gave it my best try and then let it languish. But many people who'd read it kept remembering and asking, and to these people of different generations, I owe gratitude.

I'm indebted to Mark Meares, friend and ex-student of mine, publisher of the newspapers the *Village Advocate* and the *Leader,* for he was the first to publish some of these pieces. During the course of years, when he became director of corporate and foundation relations at the university, his belief in them and encouragement grew exponentially as the funding imbalances between arts/humanities and science/technology became apparent.

I am beholden to poet Margaret Rabb, who suggested the order for the arrangement of the chapters and chose the sectional subtitles from phrases in the text. Her organization was brilliantly conceived, and a few days before her death in early 2010, we talked about how those choices affected the book.

Michael Parker, my friend, ex-student, and author of many novels, tried for years to get the book noticed. He wrote an essay which he read at conferences and which the *Pembroke Review* published in 1997. Switching the roles of teacher and student, I played the elements of memory, myth, and history while he played back the meaning of the *song* I'd written. It was like jazz, where your rendition of a motif induces a riff from me, a competition in ecstasy where nobody knows the end.

To Will Blythe, friend, ex-student, ex-fiction editor of *Esquire,* and author, I owe my thanks for his interest in the book. Having grown up in Chapel Hill in a later era than mine, an aficionado of the subtle balances between Southern gentility, basketball, literature, and family, he recognized something that struck a chord. I am beholden to him for his encouragement, dauntless humor, and efforts to get the book published in the Nineties.

Without Randall Kenan, ex-student, polymath, historian sci-fi lover, and author, this book would not have seen the light of day. I am deeply grateful to him as a Hermes of connection, for I had forgotten I'd left

him a copy. In 2009 he showed it to Elizabeth Woodman, director/ editor of Eno Publishers, and that August in Crete I received an email from her.

I owe deep thanks to my lifelong friend, the poet, Miranda Cambanis who, as first reader of the revision, confirmed my sense of its entity.

There were many others who sustained belief in this work through the years: I thank Reynolds Price for his suggestions and efforts, Marie Price, ex-student and former editor at Algonquin, Corlies M. Smith, my editor at Viking, Bob Summer, former UNC Press editor, Lee Smith, colleague and fellow writer, and Alane Mason, ex-student, W.W. Norton editor, and the founder-director of *Words Without Borders.* Colleagues in the teaching community were supportive, among them Howard Harper who wrote me an inimitable letter, Laurence Avery who introduced me to Clifford Odets's memoir, *The Time Is Ripe,* and Bland Simpson, who unearthed Gertrude Stein's riff on Chapel Hill. I also thank Marianne Gingher, Elizabeth Moose, James Peacock, Eric Darton, Michael Wilson, and many others.

For help in final production I thank Arthur Lavine, my friend from college freshman days, who became a noted American photographer and who gave his permission for his photographs to appear in these pages. I thank those who gave their devotion and permissions, my lifelong friends Wayne Williams, Nancy Smith Pfeiffer, Harriet Sanders Shealy, Dan MacMillan, and Richard Nickson, and their sons and daughters, Martha Williams Shaefer, Guy, Greg, and Joel Nickson, Barbara Scales, Amy Abernethy, and Julia MacMillan. Without Courtney Jones Mitchell, Dan Sears, David Brown, and Kate Anthony whose efforts enabled me to find photographs, the book would not exist in present form. I am grateful to Valery Yow, Jim Vickers, and Jacques Menache for information.

To Elizabeth Woodman, my editor at Eno Publishers, I express my gratitude for her enthusiasm and astonishing consideration. Because she came from an entirely different territory from readers who had known the material before, her queries and counter queries about

timelines and dates were of inestimable importance. A new character seemed to appear in the pages, a Boo Radley of Time itself.

In the beginning of the twentieth century a writer could spend his life searching for lost time as Proust did. In the beginning of the twenty-first it is apparent that time is not lost: place is. The cyber age has altered the dynamics of fast and slow and raised in a population trying to process this a faith in technology and computer hardware.

These systems constantly betray it because of human miscalculation — the BP oil spill, the Toyota malfunctions, and the delusive corporate business models of Wall Street that sent the economy into recession. A new concept of reality has arisen resembling the Fates in Greek drama who render human beings powerless. Yet it is we humans who control speed. With a click of the finger we bring up lost time and create virtual lives. Unlimited choices, and yet we feel ourselves shrink in importance.

It is easy to mythologize and museumize, but think tanks and institutions of higher learning still use Herodotus and Thucydides as models to deal with contemporary wars and peace. It was Thucydides in Bush's day, and since then journalists like Ryszard Kapuściński and Justin Marozzi have brought Herodotus back. The pendulum swings and high jinks in the halls of higher learning go on with new codes, faster speeds, and rules whose implications are not yet known.

Each story in this collection can be read on its own. If there is any meaning beyond, it may exist in unbidden phrases or dependent clauses, for truth does not submit well to factoid or techno language alone. I have enjoyed writing this book version even as I imagined new readers and in the process sometimes fancied I caught a glimmer of the Everlasting Now.

Daphne Athas
Chapel Hill
July 7, 2010

When There Is No Answer

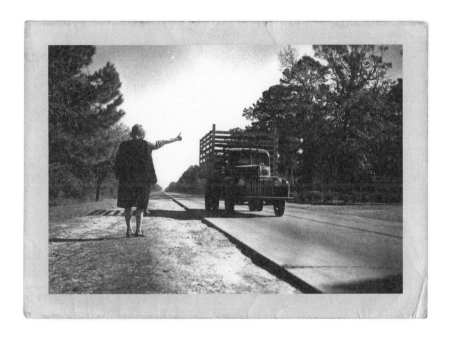

The Way to Find Hestia

THERE IS A PATTERN and a reason to a house that you forget when you live in it. If you live in a dump, you know.

Imagine sitting in a straight chair like Van Gogh's. You are leaning back against a rotten board wall reading by a dim light bulb; you are warm enough. Suddenly, overhead you hear a rustle and see a monstrous face coming toward you out of an aperture in the ceiling, descending straight down the wall which leads to your neck. It is propelled by four legs shaped like legs on ancient bathtubs. Out of its body a long, prehistoric tail coils like cable wire, shining dully in the light.

A rat is menacing because it leads with its nose. It is surreptitious because it can creep slowly, yet move in fits and starts. It is filled with fear. It darts to attack or to flee quicker than lightning. Its heart beats against its cold fur. Its eyes seem beadily blind. Its face contains a vile knowledge, an illusion behind a mask of suspense. It harbors lice, fleas, and disease. Its paws tread garbage and filth as a delight. Field rat, wharf rat, or garbage rat, the rat is one of those border tribes, the scavenger. Rats, like rain, have been controlled as an operating menace. But there is something splendid in the appreciation of a rat, for he is the enemy of Hestia, the Greek goddess of home and hearth.

Our first house was an elegant white, clapboard mansion named Thalassia, a word concocted from the Greek *thalassa* (sea) by our father, a Greek immigrant, to mean *house by the sea*. Its green blinds opened on to Gloucester Harbor in Massachusetts. I was six years old when I became conscious of it as home. Neat, sturdy, and handsome among the estates secreted along the wooded headland to the

lighthouse, ours was not fake Tudor, Norman, Italian, or labyrinthine and had no pergolas, piazzas, or swimming pools. But it was big — twenty-four rooms, including four bathrooms and a butler's pantry, under colonial eaves and over a hundred curtains to be washed during the Depression by our mother alone.

It had a willow tree sweeping the summer road and a meadow we called "The Field." It had Sweet William, a special cedar tree which I never liked, and a poplar tree whose leaves shivered silver and green in the lonely ecstasies of the breeze.

Its wonder lay in the fact that it was surrounded on three sides by water: the harbor to the west; a three-mile pond to the northeast; and beyond, separated by a narrow dirt track, the Atlantic Ocean. We owned earth, sky, and ocean. Out my window, Minot's Light blinked on a clear evening and the Portland steamer headed its weekly way to Maine. Seagulls cried and the moon rose, a shattering glister on the choppy waves of night. When we went to sleep we could hear the wind around the eaves and the sound of Chopin and Brahms floating up from the front room where our mother was playing her Mason & Hamlin.

Now all of this would have been a useless paradise if it had not been found and lost under strange conditions. All the time we lived in this paradise, we were losing it. The bank did not believe we would never pay off the mortgage, even though four summer people, businessmen, jumped out of skyscraper windows in 1929. So we were allowed to stay, in hope. We knew, as children knew, but we did not know. How can you know from age six to twelve what one house is like if the only house you know is a house with horizons?

Our father was an autodidact, idealist, optimist, and stockbroker who had gone to Ohio University and Harvard Law School. The money he lost was the money our mother inherited from her father in 1921, the same year she lost her first child, a boy, who died within a few months of her father's death. Daddy was a devotee without portfolio, an adherent not of Horatio Alger but of John Dewey, who mirrored his Platonic/Aristotelian belief in Greece as the progenitor of America's values. He had to go back to square one.

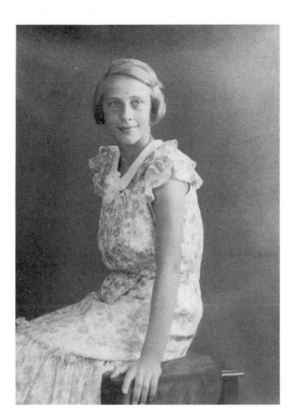

Daphne Athas at age eleven. Photo by Bachrach Photography Studio.

He started a ladies handbag business. Roosevelt's 1933 National Recovery Act (NRA), formed to protect workers, doomed it. He couldn't pay the newly regulated wages to the Greek immigrant women who cut the pieces of leather; so when that business failed he limped along, trying this and that, trial and error. Whistling in the dark.

He viewed himself as a successful entrepreneur who had achieved the American dream, not as an exploited bellhop, waiter, dishwasher, or shoeshine boy which he may have been in youth — we don't really know. But in any case, New England was doomed. Textile and shoe and other industries were moving south.

We knew only one thing: We lived in our house and the rules were changed. Without a maid, my older sister and I were assigned to clean bathrooms, living room, and hall. To dust the banisters, we slid down

them. To save coal my little sister and brother helped us pick drift-wood from the winter beach to burn in the fireplace. From third grade through grammar school we understood nickels and dimes but not money in aggregate. What was money?

The bank finally gave up on us.

Moving from paradise was an adventure in earthly demotion, and the Depression collapsed Time into Always. Never Ending.

In 1936 Daddy decided the South offered more opportunity. He chose Chapel Hill, North Carolina, because it had a state university we could attend for little money, and he established a beachhead where we would join him. He took our brother Homer, ten years old, with him — boys to the men's life. We girls and our mother stayed back in a rented house on a cliff in West Gloucester until he sent for us. Girls to the women's life.

It took longer than we thought. A year stretched toward two, and out on the Raleigh Road our father farmed tomatoes on the aban-doned farm he'd paid delinquent taxes for. In Gloucester we moved to a cheaper place on Rocky Neck, and Mother baked raspberry and apple tarts and blueberry muffins to sell to restaurants. My older sister and I started high school.

Rented houses signify expulsion from Xanadu and arrival in neigh-borhoods, but as long as we could see ocean, harbor, and sky, we felt we owned Thalassia. Someday, we swore, we'd buy it back. In the meantime we took the public bus, helped Mother knead dough, and got nearer to a conception of Hestia.

"Two years apart is no way for a family to live," Mother finally wrote Daddy.

Just before we left Gloucester, the Hurricane of 1938 struck and a sailboat torn from its moorings slammed against the seawall of the Rocky Neck house. We helped the neighborhood people, some fisher-men and artists, to lasso it and tie it to a piling. It was the exclama-tion point to our life. We packed everything and tied suitcases and boxes on the Pontiac to drive south to the Chapel Hill house our father had rented on Patterson Place. It took us two days down Route 1, and

Mother evoked the utilitarian adventures of *The Swiss Family Robinson,* written by a Swiss preacher for his four sons.

The day in October when my older sister and I entered Chapel Hill High as sophomores, there was a geometry test. We got zeroes. We couldn't think about houses then, we had to catch up. All we knew was that we lived in a neighborhood across from a Chi Phi house whose classical Greek letters meant fraternity. Our respectability lasted only a year.

That was when our father found the house we would live in for the next seven years.

In the South there were usually two towns, the white and the colored. These towns defied their descriptions, because the white town's houses were painted in colors, and the colored town's houses were never painted at all, and were colored by weather, no color at all, just weather-changing color.

Our house was in the colored section, though owned by a Greek widow we nicknamed Mrs. Kan-You-Carry-Us and Mrs. Kan-O'Kerosene, variations of her real name. It cost $18 a month. Daddy started a linen supply business there, renting caps and aprons to local Greek restaurants and delivering them on a bicycle until he got money enough for a second-hand laundry van.

The house stood on a knoll off Merritt Mill Road in the shade of three butternuts and three oaks, separated from the colored town by a four-acre field of broom-grass. Cameron Avenue's macadam surface ended there in a T at the one-line railroad track. The end of the white area was marked by a water purification plant, an old laundry plant, and a new power plant.

Merritt Mill Road was pale dirt, hung over, and suffused with the heavy perfume of thick-clustered honeysuckles. Once a week at noon a freight train heaved its way from Carrboro to dump a load of coal at the power plant. Mrs. Snipes (we called her Lucretia Pile for some unknown reason), a fat colored lady, ran a one-room store at the edge of the tracks. She sold pinto beans.

Sweat is a stunning reality. So is smoke and dust and so are freight

trains. No more singing grasses, no more symphonic waves, no more oceans, no more Chopin floating tenderly in a New England evening. But no ordinary neighborhood either. This house was so battered, so weathered that it constituted a new movement in our tin symphony, the Ugly Movement. We named the house, "The Shack."

It was there we met the rat who signified the bottom, where you realize bread, caves, and climate, and begin to see Hestia as a goddess.

Over the next ten years (1939–49) I finished high school, went to college, finished college, wrote a novel which was rejected, started another, got a certificate at Harvard to teach the blind, taught algebra at Perkins School, and got a job typing in the last months of the OWI (Office of War Information) in New York.

My sisters got summer jobs waiting on tables at Hawthorne Inn in Gloucester, and took off a semester to make money to pay for the next by working at Raytheon near Boston making war materiel. Homer ran away toward the end of the war, joined the army, and learned aeromechanics. We saved, begged, borrowed, and hitched rides to get back and forth to these destinations, even as the Shack remained the centerpiece of our lives.

Past the barn, past green, lascivious trees, past the trench-mouth red of eroded Carolina earth, the field of broom-grass separated us from neighbors. In the far distance, when autumn leaves fell, we sometimes saw the shambles of tin roofs against the honeysuckled dirt. A geographical horizon once more set us free to improvise.

There was a well, canopied by four rotten wood posts and a slatternly roof. There was an outside cabin that we discovered had been used as a kitchen in Civil War times. There was a shed we called a garage. There was a barn, bleached and bony, filled with hay and a dust-filled pump organ on which we played "Drink to Me Only with Thine Eyes." The sublime ecclesiastical sound penetrated through the hot motionless air, over dogs barking, over the shrieks of laughter from the distant shacks.

As a Do-It-Yourself family before it became vogue, we found there were three things necessary to do before moving into the Shack. The

first was to draw up a lease. The second was to put in a bathroom. The third was to swear on oath never to sweep the dirt yard.

Our father failed to have the lease notarized, probably because he did not want to spend the $2 on a justice of the peace.

The second item on the list seemed easy at the time. We were still at Patterson Place when I met my first boyfriend. His name was Wayne Williams, he lived in Carrboro, and his father was a plumber. Wayne had come up to me in the hallway one day and told me I was interesting. I accepted this as my due and invited him to our house. When he saw our books and piano and had his first philosophical conversation with Daddy over Parker House rolls and honey, he and I became inspired and then inseparable.

Since the Carrboro mill was closed down and hopeless millworkers were scrabbling for new war jobs in nearby Fayetteville, Mr. Williams and our father made a perfect trade. Mr. Williams would build a bathroom for which Daddy would pay what he could, and with which Mr. Williams would be pleased because of the extra money. Who paid for pipes, fixtures, and labor, Mrs. Kan-O'Kerosene or Daddy, I never did know.

The third, the Everlasting No, we had learned on the trip from Gloucester when we crossed the Virginia line and saw poor whites sweep their dirt yards. We did not understand why. It dawned on us only after we moved into the Shack that it was a versicle of futile accomplishment, the curse of the starving classes who knew how to order dirt but not to get rid of it. We swore we would never sweep dirt.

Some people believe that certain attitudes dictate the type of houses people live in. But I believe that the type of houses people live in do the dictating. Athalattia (the Greek word for *house away from the sea*, the Shack) began to dictate. It said to us: "You will not let anybody else do that which you can do."

It also said: "You will not attempt to patch me, fix me, or improve me, because I am manifest and proud in my putridity. I am even worse than those houses in which millworkers live in Carrboro. I have excellent hubris. I am a historic house. I am the first house ever built in this

town. I existed before the Civil War, and I never was a mansion. I was the poor house of a poor dirt farmer of the Piedmont who went away to fight against you, and lost. My owner was not only trash, he was a cuckold. His wife began running around with some other man. I contain the bullet hole where my master missed the lover as he was shaving over the kitchen sink, and hit me. I have an old tin roof upon which no cats run, only squirrels and chipmunks. I dictate the season of the year when the nuts fall down on my tin roof. They report like pistol shot. My porch is about to fall, nor shall it be mended. For it shall fall when it wants to fall, nor shall it be helped or hindered by you. For, you occupants, you will realize that you use me when I have been unused, you shiver in me through my holes, you laugh at my rottenness, you swelter in my lack of insulation, yet you do not own me. You merely rent me. And renting me, I stand or fall by my age and my pride."

Wayne had told us the history of this house, declaring it might be the oldest in Chapel Hill. We did not argue with it. Who were we to put even 50 cents into a house so rotten with such pride? Of course we were proud of its pride. What other attitude was there to take?

There was an upstairs room that was to be the bedroom of our mother. It was an excellent cozy large room with slanting walls from the hip to the roof. Unfortunately there was no inside stairway to it. If it was to be her bedroom, there had to be some way she could get into it other than being hauled up in a basket like Socrates to heaven in Euripides.

This room had one window right next to the old mud-brick chimney. Our father made a stepladder with wood he got from pulling the floor out of the shed. He propped this ladder against the chimney and nailed it to the rotten clapboards. My mother weighed 193 pounds. At night her exit to bed was a mass and litany. We all went outdoors with her and stood in the dirt at the bottom of the chimney where she would say her first goodnight. Then she began the ascent. The ladder heaved and we held our breaths. As she neared the top our fists curled vicariously like monkey paws. She would heave herself the final

heave over the windowsill and into the room. A few stones from the chimney shook loose and dropped, and we waited. We waited until a light appeared from that dark, fathomless hole into which she had disappeared. Then her head would come out the window again and she would say, full of the pride of accomplishment: "Goodnight." "Goodnight," we echoed as the window closed, and one by one we traipsed back into the house.

From the beginning, heating was a problem. There were two excellent fireplaces in the house. One was in the living room, buttressed by Mother's chimney, where her Mason & Hamlin stood. The walls and floors were covered with our oriental rugs but closed off in winter.

The other fireplace was in the dining room where we really lived, and mud bricks were perpetually dropping down it from the chimney lining. No matter how many bricks fell — we shoveled them out and threw them away — it always drew. But the dining room was still too cold. The fireplace wasn't enough.

So our father found a second-hand kerosene space heater, which we put in. We spent most of our time that year leaning against its four metal sides that were as warm as a dog's nose. But it had to have a ventilation outlet. Up to this time, we had not sunk, like many trashy folk, to the level of sticking a stovepipe out a windowpane, but now we had to. We hung the pipe from the ceiling, stuck it out the dining room window, and stuffed the broken windows with rags made from outgrown dresses.

From then on we became identifiable in school because we smelled of kerosene. It didn't matter so much in high school. But when I went to the university, the smell was the obvious reason I was never rushed by any sorority.

Beginning in high school we invited people to the Shack every Sunday night and opened up the icy front room, lighting a huge fire in the fireplace around which we all sat and drank cocoa. It was an eclectic bunch, both Carrboro and professors' kids. There were two college boys Daddy knew from the College Café, to whom he'd rented our outside kitchen. They always brought some of their leftist and arty

friends. There were also stray professors and curious townspeople. It was a small town then.

Daddy treated the company as if they were patrons of an esoteric Greek café, needling and challenging them, forcing them to give their opinions on Leibnitz, Socrates, John Dewey, Catholicism, goats, the British government, capitalism, Mrs. Eleanor Roosevelt, donkeys, nuns, or Lessing's aesthetic principles based on the *Laocoön.*

He preened, charmed, and shocked them, and we burned with shame and pride. Our high school friends were petrified by his sharp nose and foreign ways and awed by such irreverence, and after they left we would mimic their facial expressions. But new friends from college were entranced finding themselves outside the confines of their college and cultural rules in such antic, bohemian company.

Still our house remained freezing. We could not escape the drafts no matter what we did. So Daddy bought a $5 wood stove for the living room.

This began the period of the dissolution of the barn, a tempting heap of sun-bleached, knotted, rotten pine boards. Do you think we spent any money to buy cords of wood? Certainly not. The barn, like the house was foundationless, so we began ripping out boards from floor level where the wood hung only by rusty nails. Every day we would rip out one or two, working upward until a ragged gap was hollowed out of the barn's west side.

We stuffed that $5 wood stove so full it bulged, and then we lit it. It cracked and sputtered in insane rapture. Then it began to blush with shame, then to vibrate and shiver with heat.

We called this stove the red hot pot, and at a certain point of heat we knew not to put any more wood in. People who came to the house would stare at the hot pot with apprehension, their eyes enlarged, their hearts in their mouths, but after a few visits they came to know that we were its masters and would no more allow that stove to explode and burn up all our worldly goods than we would let ourselves explode. After four visits they stopped paying attention to it at all, other than to shade their faces from the hot glare.

It was only on these special occasions that we fired up the hot pot and luxuriated in its heat. Mostly we lived in the dining room where we did our lessons, fought, argued, mimicked, and where Mother sewed and our father shaved. We ate red kidney beans all the time. Mother kept an old fireless cooker pot (so huge that you could stretch your arm into it and your fingers could hardly reach the bottom) full of a mixture of these beans and corn, which we bought cheap from Mrs. Lucretia Pile. One pot would last a week and four days, counting one meal a day of the stuff. I would like to say that we hated it, but the truth was, it was good.

In February after Pearl Harbor was bombed, there was a terrific snow, which made the Southern town look like "O little town of Bethlehem" on a Christmas card. We were elated. But one of the prophecies of the house came true. We were in the dining room and my younger sister was aping how a certain teacher at school walked when suddenly there came a tremendous crash, one of those inexplicable phenomena that make you think: *End of the world.* The room shook wildly, but walls and pictures remained intact. We did not move. We sat quiet, like animals, our laughter and our motion frozen.

"What is it?" Mother dared ask.

My sister got up and took a step to test the floor.

My brother crept softly and cautiously to the window.

The porch was on the ground in a slanted rhomboid heap, a simulacrum of itself, slanted but perfect, ripped from the side of the house, nails squawked awry, broken timber beams, the floor caved in, the two supporting posts broken, scrabbled husks of foul wood mixed with dirty snow — all was spread upon the snow. Shingles had flown as far away as four feet. The place where the porch had been nailed against the wall exposed a delicate pale ancient yellow on the naked clapboards. The load of snow had been too much for it.

"Hooray!" we shouted and threw up our hands and began laughing, and for three days we laughed.

From then on, we burned up the porch, instead of the barn, in the $5 wood stove. Anyway, it saved the trouble of walking to the barn.

The porch lasted the winter. But since its stairway was gone, no one could ever enter by the front door again. As grasshoppers of Athalattia, and grasshoppers have faith — ants have only work — we began to believe that a natural phenomenon, a miracle or a catastrophe, would happen in some future when we had run out of hubris and needed an infusion of it again.

The summer of 1942 when U.S. troops landed on Guadalcanal, belief became prophecy; a natural event did happen. We were eating in the dining room when Mother looked up from her pinto beans and said: "Smoke."

We looked out the window. It was the barn. A small dark curlicue trailed out through one end.

We dropped our forks and with much shouting rushed outside into a windy, ecstatic, sun-searing day that promised everything.

"Shall we call the fire department?" asked Mother. By this time we had a telephone.

"They won't come," said our father.

She galumphed back into the house and called the fire department, but it said it never came out to that edge of town and that if it did it would do no good since there were no fire hydrants to plug into.

"The thing is not the barn," reported Mother, rushing back to tell us, "but the house. It will catch fire to the house."

A flame leapt up.

We surveyed the shed, a tinderbox, the outside kitchen, another tinderbox, and the house itself, inside of which were the grand piano, a wooden Hawaiian papaya bowl, a thousand books, and the carpet-bag she had inherited from some great uncle and tacked up on the wall as ornament, our bona fide for being enlightened Yankees, good fodder for flames.

Our father plugged the hose to the kitchen faucet and, pulling it out through the kitchen door, began spraying the wall, the shed, the trees, and the well canopy. Black people came up from their shacks and sat down by the blackberry patch at the bottom of the road beyond the reach of Jack and Leo, our two German shepherd (mongrel)

dogs. The spectators took out knives and began to cut watermelons and gaze with delight as the wind rose. If we hadn't been so worried, we would have applauded their false vaudeville stereotypes as pure genius disguises.

Water from the hose spattered the oaks, when all of a sudden the barn let go into a magnificent swirl of orange. The wind whipped it in an ecstasy of destruction. Fortunately, it was too far away from the shed and the house. We took turns watering the ground, the trees, and the buildings, until we were certain that there would be no contagion, and then we too sat down to enjoy the fire and brought out our dining room chairs and a gallon of lemonade.

The climax came when it caved in. A magnificent moment, the highlight of the day. It took two hours to burn straight to the ground. The next day we went to see what could be salvaged. The pump organ was completely ruined. Only the keyboard survived. It looked like a pair of forgotten false teeth lying among the charred stumps.

The next day we counted thirty-eight slivers of moldy watermelon rinds attracting flies by the roadside under the blackberry bushes, and thirteen charred beams of the barn that we calculated could serve as the next winter's firewood.

Living in such a place for so many years made it necessary to play a game of self-aggrandizement. We figured out who and when such and such famous persons were born and graduated from log cabins, who had read by firelight, who had almost starved yet been a success, and who, like Jane Eyre and Dickens characters, had had to break ice in their bowls in the mornings before washing their faces.

It was so cold that we never looked forward to Christmas vacation. Not only were there holes in the walls caused by the rotting of boards, the gnawing of animals, and general decay, but termites kept us awake at night with a continual buzzing sound. I imagined they had teeth. But they really do bite people as well as wood. Until the collapse of the porch and the burning of the barn we were sparing of every stick of wood we burned and every drop of kerosene we poured. Night after night when the stove was out we looked to light bulbs for warmth.

We put the stove out when everybody went to bed. It ticked fitfully, cracked like heart-flutter, then died and became silent and stone cold. Sometimes the wind used to howl through the toothless gums of rotten boards. The winter moon could be seen through the cracks. Stones began to crumble down the cold chimney from shivered birds, and dried mud spattered against some orange crates we'd put against the maw of the fireplace to prevent draft.

In these indistinguishable days of high school and college, I used to study in my parka, which had been bought years before at L.L. Bean's in Freeport, Maine, with a sweater under that. I stuck my fists up my opposite sleeves as far as they would go. My feet were huddled on a neighboring chair to keep them out of the breeze that swept the floor. The only thing exposed were my eyes, which were fastened to the page of my book, and my nose which stuck over the collar of the parka. When I was in college I put up the hood of my parka and mused that I was an Eskimo studying for a bachelor's degree.

Going to bed was always an operation, but you had the virtue of knowing that at least in ten minutes you would have warmed up your bed like a hot water bottle. It had another virtue too. You were so cold already that to take off every piece of clothing could not have made you colder. But getting up in the morning was plunging into an icy world where you shivered for half an hour until the work of getting breakfast and breakfast itself made you warm.

When we had first moved in, there had not been enough rooms in our Shack for all. My two sisters occupied the bedroom next to the living room. But my brother and I, devotees of a room of one's own, constructed ours in the large hallway that led to the bathroom. We nailed a framework of boards. Onto these we nailed a partition of curtains.

Curtains cover a multitude of sins. More sins were covered by curtains in our house than were covered by anything else, for our mother was a curtain addict. She covered the walls with them and told people they were old and precious tapestries. She also made bags with curtain material and became a first-rate scavenger in stores.

Homer's and my private rooms were instantaneously successful.

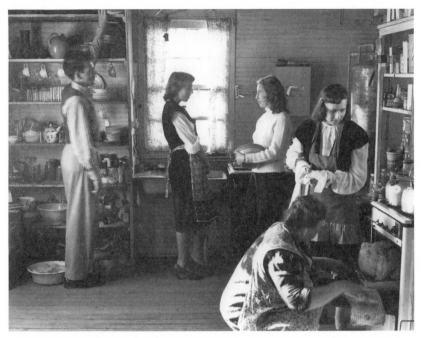

*The Athas family in the kitchen of the Shack, Thanksgiving, circa 1946.
Reprinted by permission from photographer Arthur Lavine.*

The wind howled through them in winter inflating our curtained par-
tition like sails, making it sigh noisily as if through a megaphone. The
boards of the floor buckled every time someone walked through and
sank our beds like two boats about two inches. The partition did not
extend to the ceiling, only to a point slightly above our heads.

It was here that I met the rat. I got up from the chair just as he came
out of a hole. He appeared on the strut where the curtain door to my
room was nailed. I was trapped in four feet of space with the rat two
inches from my face. I was afraid to move lest he move. We stared at
each other with loathing and awful fear. I had a coat hanger in my
hand. I remember that I made the attack first, slamming him with the
wire hanger. But he uttered a terrible squeaking scream and escaped. I
was left with the coat hanger which had touched him still in my hand,
and a feeling of vile and shivering fury.

My sister shot this rat just outside the kitchen door two days later with my brother's BB gun. It was a perfect shot and we were envious of her derring-do. But she boasted so much afterward that we told her it was a peculiar thing to do and that there was perfectly good rat poison that could have been used, so what was the use of wasting shot (though what it would have been used for nobody knew), etc., etc., and we never let her know we admired it.

The other animals concerned with the Shack were of a cheerful and charming nature. In the fall squirrels who pattered over the roof dropping nuts out of their mouths were our alarm clock. In the spring chipmunks capered there. One spring day my two sisters had to clear a chipmunk nest out of their room. Swallows were continually stuffing up the chimney. Once we found a turtle behind the mantelpiece clock. Birds were continually trapping themselves in one or another of our rooms.

Jack and Leo guarded the property like two devils, giving the impression that Mr. Rochester, Macbeth, or Greta Garbo lived within. The dogs were not allowed in the house, so they slept under it and let their fleas climb up through the floorboards. Every now and then we gave them a curative bath with kerosene, but they were splendid wild dogs and did not take to this treatment. They ate hugely without taking a penny out of our pockets because our father used to feed them bones he brought home from local Greek cafés.

Living in such a way in the U.S.A. of the twentieth century we could easily have become criminals, stupid, or insane. I learned in my college sociology textbook the statistics which predicted that any of us could become the one out of ten people who would end up in a mental institution. We compared ourselves with the Jukes and the Callicacks, two notable Appalachian mountain families who killed each other in feuds lasting longer than two decades. But in fact we were popular enough because of our antic enthusiasm, though we felt neither morally nor socially impeccable.

Sociology also steeped us in the quasi-scientific jargon of the dynamics of recreation. Statistics showed how many people spent how

many hours in what forms of recreation. We knew already how we wanted to recreate ourselves. We wanted to go either to movies or to Hill Hall to listen to classical music in the listening rooms.

Movies cost money. For Hill Hall we wanted food to accompany music. When a good movie came to town we used to hunt empty Coca-Cola and Pepsi bottles until we got 26 cents, the price of a ticket. If we couldn't find any, we sneaked around back of the grocery stores, picked empty bottles out of the crates, then went around to the front and collected the 2 cents you got for empties.

If that failed, we entered the Episcopal church and relieved the poor box by shaking it until the pennies and nickels jangled out of the slot. We ratiocinated that movies fed into our brains were better for society than donations of pennies to the common poor. We were out to de-hypocritize institutions. We curbed the moral impulse only at the point where we figured we'd get caught.

The Hill Hall expeditions were rare and carefully organized. We would swarm into the dime store, and while some of us would deflect the clerks' attention, the others would steal hard crackers with raisins in them and a type of chocolate candy filled with lumpy peppermint which looked like overblown cow turds but tasted good. Then we would pile on up to Hill Hall, cram into one cubicle, turn up the volume on Wagner and Beethoven, and write on the wall: "I died inside while listening to the Appassionata," simultaneously stuffing our mouths in our calculated transvaluation of values.

All kinds of projects were underway. The novel I had started in high school came to a stop. I couldn't finish it because I hadn't finished living it. We translated the *Memoirs of a French Visitor to the Court of Catherine the Great* because we thought it would sell (it was full of decadence and dirt). We typed theses, term papers, and plays, including some of the historical pageants initiated by Paul Green, produced later in key places in the Carolinas. I got a job reading to blind social work students and when I figured out I could get paid for studying required courses, I arranged to take the same courses (Shakespeare and Milton) as undergraduate blind students.

Mother got into the act by taking over my reading to the graduate social-work students just when they needed drivers to take them to clients in the boondocks for their second semester fieldwork. It was a full-time job. As time went on, having read all the first year social work out loud, Mother convinced Miss Iocca, head of the School of Social Work, to let her apply for a graduate degree. She had no BA; her education had been in finishing schools and the New England Conservatory of Music. But a year later she got in and after she got the degree, she had a full-time job as a child welfare worker. When a mistake on her birth certificate made her nine years younger than she really was, she was able to work for the next twenty years.

The Depression had overturned lingering Fitzgeraldean class values; but World War II overturned the class system. The war became the world, and the world became the war. Uniforms blossomed on campus like dogwood. Nobody could tell anymore whether you were rich or poor. The university transformed itself into an arm of the war machine and the college generation rushed forth filled with change on earth. No curfews. The fate of the nation resting upon you, your generation thrust forward. "Do Your Part," ordered Uncle Sam in the picture, his finger wagging deliciously, offering programs of training in medicine, navigation, meteorology, pre-flight, and foreign languages to meet the voracious needs of the professional war machine.

Brains counted at last. Everybody was drafted in spirit. Wayne got into ASTP (Army Student Training Program) and donned the army uniform. Richard Phillips and other friends joined V12, the navy student training program, and wore navy uniforms. Civilians were ashamed to be civilians, but in a paradox the newly inducted boys flaunted civilian attitudes and mocked militarism. We'd scorned Redcoats from behind stone walls, fought Hessians obeying orders; we were not a military country and didn't want to be, and mocked Sieg Heil-ing and Japanese bows and grins. American destiny was ignorant, mocking, ardent, plebian, critical, crazy, and anti-jingoism.

I graduated college in 1943. The watchword of the Depression, *Never Ending,* changed to *The Duration.* How long would the war last? It was

like mounting a precipice you couldn't see off of and feeling powerful in space/time. The great question mark. Who knew? We didn't know. The atmosphere was heady, that's all, and what did we care?

In my last year of college, two of our friends, Artie Lavine and Marion Gurney, decided the Shack was the perfect place for a movie location. It was a silent movie. The plot was about a Southern trash woman with a cretin daughter who falls in love with the hired hand. But the mother catches them in the barn and their romance is wrecked.

Marion Gurney, who wanted everybody to call her "Gurney," wrote the script. Two Playmaker friends of hers were to play the love interests, and we got Mrs. Kate Porter Lewis, one of the Playmakers' leading ladies, to play the part of the trashy woman. Gurney also was the director. And Artie Lavine, who planned to be a photographer, was to use his cameras and be the cameraman.

Things went fine until Gurney and Artie got into a fight. The movie broke up after shooting five scenes, and the Shack was littered with cameras, lights, wires, and electrical equipment. We had to pick our way carefully through the mess like high-trotters until the two came to take it all away. Then everything was patched up, but the movie was never finished. Still extant are some of the shots of the well and Mrs. Kate Porter Lewis standing at the doorway with her hair all messed up, beckoning with a wooden spoon, calling for her cretin daughter.

IN AUGUST 1945, Wayne, on furlough from his army pre-med courses at Washington University in St. Louis, came to visit me in New York, where I was working for OWI. We were walking down Broadway when he stopped by a kiosk and saw the *New York Times* headlines. "This is important," he said. But I didn't get it, so he had to explain fission to me on the street.

Since high school, I was always writing novels. In 1945 I had started another one. At the end of the war came the end of my OWI job and the end of that time away from home. In 1946 I was back in Chapel Hill to finish the novel. I was halfway through it and hope was eternal. My

sisters had come back from Raytheon to finish college, and Homer in New Mexico was getting his discharge from the army air force.

GIs were returning in force. In 1947 when my novel was published (*The Weather of the Heart*), the town was flooding with returned soldiers on the GI Bill. The population of Chapel Hill had more than doubled. Victory Village had become living quarters for married veterans. I had a part-time job slinging hash at the university in the snack bar in the basement of Graham Memorial.

As quickly as war had happened, our friends from high school and college, Wayne, Artie, Gurney, and others, melded with the new cast of friends: Max Steele, who returned from Trinidad and was beginning to write stories in the library, Jim Rathburn, a tail gunner over Italy who got the job as head of the student union at Graham Memorial, O.B. Hardison, who lived in a tent on campus until they gave him a dormitory room because he had a new wife, and Dan MacMillan and his brother who'd been dog soldiers in Europe.

Although Artie had returned from New Caledonia, he was in New York, doing photography, but Gurney was in town with an old friend, Lake, who'd come from Chicago and lived in a cinder-block cottage on Poplar Street in Carrboro.

One day during that summer we were sitting around in the dining room of the Shack, our feet propped on chairs, drinking lemonade, when a loud knock banged the front door. The porch was gone, fallen, and burned up a long time ago, so who could it be? Somebody, some stranger had had to climb up through tall grass to get to the door without stairs.

It was the sheriff with a fat face and a big brown-brimmed cliché Texas-type hat, and we were scared. The Negro landlord of Athalattia wanted his house back, he said, because he intended to live in it himself. Negro landlord? Mrs. Kan-O'Kerosene had sold it? "Yes, but besides that, the lease is worthless because it has not been stamped by a justice of the peace," added the sheriff. He told us he would give us one week to get our stuff out of the house, and if it was not out he and the town deputies would put it all out on the road.

Visions of our grand piano sitting proud and shiny on the white dirt road, surrounded by watermelon rinds! We were shocked back into our old crude fears of the Depression when we had had to turn ourselves into grasshoppers, borrowing from Peter to pay Paul.

Daddy went to work on the sheriff with a combination of preening and placating. He got the stay extended to three months. He had been looking a long time for land, saying nothing, and had found a piece north of Carrboro that was cheap. Mother decided to go to Boston and wheedle money out of one of the people who owed Daddy from the days of the crash. I went with her. She didn't get money but she got bonds worth $1,500 we never knew Daddy was owed. She sold them. The money was used for the down payment on the land.

Looking back over the last two or three years of collapsed time, we had grown thicker skins and skills against the outside world without realizing it, but we did not understand even then that in coming South we had followed the footsteps of homesteading pioneers in a different direction.

We made it a Do-It-Yourself move with my father's laundry trucks, packing and tying so many boxes and bags that they swayed. My mother cooked a gargantuan macaroni meal.

Our new friends on the GI Bill, Max Steele, Bobo Poole, and somebody else we didn't know, helped move the piano with no levers and no dollies. My mother watched them, her tongue hanging transfixed out of her mouth, her breath in suspension, horrified as burly boys creaked, groaned, and laughed under the weight. The remaining porch step broke. The boys, one, two, three, heaved the piano onto a waiting pickup truck to go to storage until we had built the new house. And then, before we were ready to leave the house forever, everyone sat down at the remaining table to stuff themselves out of the pot of macaroni.

Furniture is naked upon a van. Privacies are spilled out upon the public road. Springs and mattresses bulging over the side of the truck testify to sleep. And it is possible to sleep a thousand different ways. Cooking stoves perched upon bookcases testify to meals of countless

hundreds. Hideously pathetic, households without houses, households in transit, supposedly having come from somewhere, yet going supposedly to somewhere else. The whole dormant, racked, helpless heap of the personality's utensils and the bodies' aids look curiously nowhere.

We farmed out part of our furniture.

We farmed ourselves out. I went to my new friend Lake's house. Daddy put up a tarpaper shack under pine trees on the new property. Mother, working as child welfare worker in Alamance County, stayed weekdays in a room in Graham and spent weekends with us. My sisters bunked at friends' houses and so did Homer. All the new friends, with old ones, got into the act.

The posture of people's morality changes when the stone is rolled. You might say there is a different vision houseless than the vision housed. Gypsying is an encumbrance if you haul a grand piano on your back. But every one of us believed in Hestia.

Everyone builds their own Hestia. For ours we had mighty faith. And we gave sacrifices of time and energy. We wanted a No Name House, a Final House, a One's Own House, a House We Build, a house from which we conceived that we would never have to move again, unless by our own volition. A Respectable House. Even perhaps a Beautiful House. It was to be in the shape of a U.

The land was a six-acre plot on a hillside three miles from downtown. Virgin forest, with a rocky crag that led to a plateau below.

We plotted it out with sticks upon the ground. It did not look big enough, this house.

We suspended an electric light from a tree with a wire plugging into the highway electricity.

We cut down trees for the drive. We chopped down trees for the spot of the house.

We laid the first cinder blocks.

Did you have blocks when you were a child? Then you know what building a house is. There are the materials on the ground. We had to get 12-inch cinder blocks (for the foundation) and 8-inch cinder blocks

(for the walls). We had to buy large beams for the foundation of floors and roofs, 2 × 4's for the partition beams, and 2 × 8's for the ribs of the floor and roof. We had to buy twenty bags of Portland cement, ninety pounds each. We had to have a trough to mix cement. We had to have nine truckloads of sand. We had to have a huge pile of tongue-and-groove boards for floor and roof.

We contemplated the living room to be 50 × 22. Four bedrooms, one bath. Kitchen 18 × 19. Smaller dining room. It looked like nothing when it was a ditch in the ground. But it was huge!

We did the work ourselves except for the cesspool. We hired two black (still called "colored") men to dig this for $15.

People predicted we would get this house half done and then have to call in architects to get us out of the mess. "There were those two students down on the Durham Road," said Max. "They thought — " "Yes," we said, loudly nodding fiercely up and down to blot him out.

It was hot as Hades. We uprooted trees, dug stumps, chopped with axes and saw. We chopped out the driveway. It turned into a muddy bog. Our laundry truck got stuck. Every morning we arrived in our old Chevrolet and got out of its four doors like Little Caesar's gangsters.

My sister's boyfriend at this time was an Egyptian graduate student named Imam. Egyptians did not use levels for the Pyramids. By ancient tradition he forbore to use a level in building the walls of the house. When he waved with the trowel, my sister obediently followed him, carrying fifty pounds of wet cement on a piece of tin. The day he laid the end wall was the day Homer nailed in the subflooring of Imam's wing. Each evening Imam called on us to praise his work, and that evening we piled on our accolades as usual.

But that night it rained and when we came to the lot the next morning his wall had fallen to the ground. The Wall of Jericho had been pushed out by the swelling of the floorboards from moisture, but no trumpets had sounded.

"Your cement has holes in it like Swiss cheese!" Max told him rubbing it in. Max was a quixotic person who became carried away by his genius of characterization. He estimated that blind people could put

on cement better than sighted and persuaded us to call up our blind friends to come and help lay cement. But if they could feel to put on cement, there was the problem of how they would get around a half-built construction whose floor was still mere ribs of 2 × 4's you had to pick your way across. So Max got the job of carrying the prettiest blind girl, whose name was Daisy, over these death traps. He staggered on his long legs to get her to the right places on the wall, and though he teetered, she never suspected a thing.

Bobo Poole, the hefty English major, was the best pick-and-shovel man in the volunteer crew. While the walls were going up, the basement had to be dug. Every man at the university wanted a try at digging. The red clay hole grew deeper as the walls grew higher. When the basement got very deep, shovelfuls had to be aimed through the kitchen door space above your head. Aiming was as important as digging. Max always failed in his target and got shovelfuls of wet red clay bouncing back into his face. The reason Bobo was champion, Max rationalized, was because he spat before every shovelful which loosened up the clay. Thus he became known as Hock the Sound of Tar Heel Voices Spit Ringing Clear and True (Spit Spit).

During this time Max took a pretend-dislike to our father, not only because Daddy liked to boss the proceedings but because he lured Max into Aristotelian arguments. "We should put in trap doors and pulleys," Max told us. He suggested a trap door in the bathroom, so that when my father picked up his razor he would drop down into the basement, and another in the living room, where when he picked up a book, it would be suspended on a cable wire which would toss it up through the chimney.

Max berated us for building the house in the shape of a U. "If you had made it square it would have been much less work," he said. "It would be finished by now." The truth of this was maddening. He told us we looked like ancient cats on the walls, that we were wrecking our complexions, and that if we continued drinking lemonade we would become sour. Carried away with his ideas of trap doors, he wanted one for Mother too, to make her disappear when she opened the oven door.

We worked sometimes into the middle of the night. People living a mile down the highway complained at night of hammer blows. But we were determined to move in by Christmas. It was an aesthetic experience, working at night like a wide Romany fair. The night sky was dark. The forest was vast, hidden, filled with living birds and animals. The one electric bulb cast its glow along the tunnel of trees and lit up our faces. It was an exotic sensation being the pulse of the universe in the dark and immense night, with a symphony of sawing, pounding, hauling, and laughter. Our faces glistened with sweat from the gallons of lemonade we drank and we became animal-like, seeing ourselves as hogs eating at troughs of macaroni or baked potatoes.

Our father, discouraged from bossing, took to pruning trees. While we sweated to put in the foundation of the house, he was planting and gardening as if the place were an elegant eighteenth-century country seat. But in crises, he came through.

It rained at midnight. We had to finish putting the boards on the roof. A heavy cloud burst when we were perched upon the ribs of the roof one night. The electric light swung on its wire dripping with rain. Our father too pounded, high at the top. He laughed as rain cascaded off his chin. "Work!" he shouted. "Hammer!" he called. "We'll do it!" he said, and the smell of wet lumber and pungent earth goaded us on, until we felt we had become ragged balls of yarn drowning under the waterfalls rushing off the eaves.

The site was a stage where we performed this *pièce de théâtre*, we the players, the audience the people in the town who were curious. We built it more than a decade before the communes of the Sixties. Professor Raymond Adams of the English department lent us a saw, which we wrecked. Every week he paid a visit, nodded dryly, and left. Dr. Huse, who taught romance languages, conceived of us as students in his course on James Joyce. Weekly he led his wife to our site. They praised, and then he sat down to read a half hour of *Finnegan's Wake* out loud.

We kept a constant supply of beer on hand which we doled out when members of our crew accomplished certain things. At the second row

of cinder blocks, Imam forgot to stagger. The row went completely around the house before we discovered it, but instead of tearing it out, we put in a half block and hoped nobody would notice. Still we had the discomfort that goes with ruining perfection.

Mother would never come to see the progress of the house. She was afraid to.

The tops of the windows caused a crisis. We had to take off the day to scavenge junkyards in Raleigh and Durham to find cheap angle irons.

The windows caused another crisis. We had ordered steel ones from Montgomery Ward. But when we were notified that they had arrived COD in the Carrboro freight depot, we could not pay for them. In ten days they would be sent back, so we sent out an SOS. Gurney saved the day and we got them out of hock.

We blew out the tire of the laundry truck, hauling shingles fifty miles from Sears, Roebuck. They weighed a ton. Homer and I jacked the truck up, put on another bad tire, and rolled slowly to the site.

When we arrived at the roof we were near victory. All three sections of the U were different sizes. This meant that each of three roofs had different slants. The roof over the kitchen was so steep you could not lie on it to shingle, and we had a bitter argument on how to hip the other two. We solved it by compromise. Each section is hipped a different way.

We got so we could run along the ribs of the roof like chimpanzees. All except Max who got a fear of heights after he realized what a dangerous feat he had done with Daisy. From them on, he stayed on the ground and retaliated by telling us we looked like crows in a nest.

Shingling the roof was a delight. We were not crows then, but delicate birds flapping three-section shingles. We used pretty tacks instead of jaw-grinding nails. It was refined work. We created poetry with those shingles. It was late November. The sun shone down through the red and yellow leaves. Every Saturday afternoon we brought the radio out and listened to the football game and became connoisseurs and plenipotentiary critics of each play and every player.

When Mother came to visit, it was done. She didn't say a word, simply looked.

There is no Hestia now for any hearth. There is no need, for there is a large fireplace, nearly six feet wide, where in essence Hestia has resided since 1950 when we moved in. It was still unfinished. But a house is never finished. If we did not defeat nature, we at least sifted her outward manifestations into bottles and wires catapulting our ideas into antic reality and into our lifetime since. When something changes, change the walls. Add this or that. Trial and error.

Hearths bespeak sentimentality, but having created Hestia, we ended our need for barns to burn. There are six acres of woods. We never cut a tree if it wasn't necessary. The house sits still in the woods, noble, a cinder-block sphinx, between its paws a patio. Its windows are serene. Its curtains are eyelids. Its roof is a magnetic miter cap. Its running water and electricity are still an enigmatic smile in a wilderness diminished by development and demystification.

It brooks no rats.

It has insulation and good foundations. It has a perpetual symphony of birds and pine-tree music, but the inside of the house contains no animals.

It is a hidden house, in which the dream of our lost house, the *donnée* we inherited, lives still. It set us free to explore our own lives, for when it was finished, America at last opened up from the days of Depression and war, and we were free to leave, to go on our own, to begin our separate destinies.

It still holds out its wings for souls to visit. "Come," it says, "for I contain a hearth that defies category."

Carrboro, Carrboro —
The Paris of the Piedmont
America Abandons Richard Wright

CARRBORO LORE IS HARDER to come by than that of Chapel Hill because it doesn't have an artistic tradition. Its fate as Chapel Hill's servile underdog has always forced it to pick and lick at an image.

In November 1986 Mrs. Frances Shetley stood up at a Carrboro Preservation Society meeting and told how it felt to go from Carrboro Elementary School to Chapel Hill High in the Fifties.

"For the first time you were in with kids who had been to Europe, whose fathers taught in the university. The teachers warned you, 'Sink or Swim.'" These were almost the first words my boyfriend Wayne spoke when he appointed himself my tour guide to the South. He was delineating the high school class hierarchy in order of descendance: 1) professors' kids; 2) town (merchants') kids; 3) country kids; and 4) Carrboro kids.

The orange buses in which Carrboro kids came to school were called in those days "trucks," which by extrapolation tainted them as "truck kids." He told me these things in an objective voice taking no umbrage, which made me take him seriously.

Before World War II Carrboro oriented to Calvander, White Cross, and Hillsboro as a more or less honest Southern mill town, unsullied by proximity to the intellectual oasis in the cultural desert. But by the

time Wayne paraded me through Carrboro like an insect on a leash to inspect it (the same route which, forty-eight years later, the preservation society used for its historical house tour), its independence was reversed, and the tracks represented its horrible umbilical cord to Chapel Hill.

Wayne at fourteen had already separated himself from the stigma by moving to a 9 × 12 shack his father had built in the backyard. It was called his *little house* and had walls patch-worked with Sears, Roebuck wallpaper samples. He had dozens of books, jars of chemicals, paints, paper, drawings, and *objets d'art*. He slept out there before the hippie sleeping-bag era, and came into the house for meals. His real house had tongue-and-groove walls, which I considered the epitome of Lower Depths even though our Shack was also tongue-and-groove. Pictures of his grim-faced ancestors with beards, sawing wood in the mountains of Tennessee before the Civil War, looked down. There was a round, galvanized washtub in which the family took a bath once a week, filling it with kettles of water heated on the stove.

"You mean you don't have a bathtub?"

"Nope."

I was shocked since his father had put our plumbing in, including the bathtub which had claws for feet. As the war machine revved up, Mr. Williams, who had been a fixer before being reduced to odd jobs, had gotten a job at Fort Bragg, and some years later, finally, he did put a bathtub in.

The aspect of 1939 Carrboro when I first knew it, still in the doldrums of the Depression, was of a town of people with the freckled Scotch-Irish faces of Walker Evans photographs sitting on porches with glazed stares. Summer vibrated. Tin roofs cracked. Streets were dirt, and the sidewalks, eroded, slid into them during rains.

Fitch's lumber pile dominated the town, so we climbed it in bare feet to feel the pulse of hell. Even suffused in pine resin at the top, we inhaled the Carrboro of dust and dogs. The dogs, replicas of their masters, skulked in the dark spaces beneath the foundationless houses,

only venturing out to attack when you passed. They yelped when you picked up an imaginary stone to aim, retreating before you could throw it.

I was glad that our Shack was technically inside the Chapel Hill limits, which spared me from the onus of being from Carrboro. Past the knoll off Merritt Mill Road, later called Knoll's Development, was the black tin town with guitars, laughter, and screams wafting up on hot Saturday nights we called "Sociological Conditions." Except sometimes when we belted out the word "Niggertown" like any white trash, defying our straitjacket of liberal hypocrisy and claiming the virtue of self-mockery while beating the class one step below.

Blacks were theoretically equal, of course, but we didn't know any blacks. The only way you could know one was to go out, find one, and start a conversation. There weren't any in school, so you'd have to do it in the street, and they would suspect your motives, besides which, whites would suspect you. Only daring misfits did such a thing.

One day on McCauley Street in Chapel Hill, Walter Carroll came running to tell Wayne and me how he had made friends with a black boy named Lincoln, who, he said, was an intellectual, fifteen years old. "He's brilliant. We spent the whole day walking in the woods and talking! He writes plays!"

Walter was the nephew of UNC commerce school dean, D.D. Carroll, for whom Carroll Hall is named. He was a street urchin. His mother and father were dead, and his sister Loretto, married to J.O. Bailey of the English department, was writing plays for Playmakers staying up late for rehearsals of her *Job's Kinfolk,* a now-forgotten folk play about three generations of millwomen. Walter was unsupervised, did exactly what he pleased, sat on curbstones, failed arithmetic, played hooky, was a year or so behind in school because he had stayed back in the third grade, but already he spoke in the rhythms of Paul Green's *Hymn to the Rising Sun.* My commerce with blacks was eloquent and operatic but peripheral, having come mostly from railroad-track encounters, so I was both envious and impressed.

Some time later on an eerie moonlight night Wayne and I were

walking from Carrboro to my house. With us was Artie Lavine, a college freshman at that time whom I'd introduced to Wayne. I was a freshman too, which did not break up my cabal with Wayne, still in high school, but strengthened it.

Wayne had invited Artie to see his little house and I, a pretend-expert on Southern habits, had joined him in showing off the South. As the proper, well-behaved son of a New Jersey Jewish doctor, Artie knew nothing more of railroad tracks, Negroes, or Southern mores than I had when we'd first arrived in Chapel Hill.

As we walked, we vibrated with the moonlit tracks and began improvising sounds. Wayne cackled. I made soft, maniacal laughter and then switched to moans. "Oooh, ah," I moaned. Wayne concocted a strangled scream. "Yell," I whispered encouragingly to Artie. He was not the daring type. It made him extremely excited when he opened his mouth and roared.

There was the bang of a door and a burly black man rushed out of his house with a shotgun. Artie's roar froze to paralytic silence. Without missing a beat Wayne and I switched to talking in low voices about a phony Latin assignment. The black man stared, then catapulted down into the woods where he thought the sounds had originated. Lights went out in the cabins. A fat old woman shouted into the hollow: "What for's all that noise?" We didn't answer. We skedaddled as fast as we could to the Cameron Avenue crossing where Artie left us, shocked at his own actions.

Wayne had to pass back that way to go home. The next day he reported to me that he had asked a clump of black people standing by the track: "What were those screams I heard?" They told him: "Some crazy man's down there in those woods, and he's got a woman down there, and she's a moaning."

Another night when I left Wayne's to walk home, Mrs. Williams said worriedly: "What if some old colored man accosts you?"

"I'll pull religion," I said arrogantly, fantasizing. "I'll say: 'Are you washed in the blood of the Lamb?' and he'll be too scared to try rape."

It makes sense that a black belt did then and does now separate

Chapel Hill from Carrboro. Carrboro was on the eve of a turbulent change, but in 1940 it was the lull before the storm. We had inherited from the Thirties the vocabulary of strikes, Communism, and Roosevelt, with words, now extinct along with their context, like pellagra, proletarian, New Masses, New Deal, Colored People, and Reds.

Frank Porter Graham was president of the university, Howard Odum the center of Southern sociology, Professor Koch (known as Proff, with two f's) the pusher of folk plays, and Paul Green, before his historical pageant phase, at the apex of Pulitzer fame for plays of passionate social justice, sharecroppers, and blacks. With that outmoded vocabulary we dedicated ourselves not to the common good, but to subversion, our goal being to overthrow and destroy not merely the boundaries of Carrboro, but its religion and morality. And the possibilities were palpable because of Chapel Hill which offered for the taking its library, its lawns, its social idealists, its philosophers, and its artists.

The guns were roaring in Europe, and in the summer of 1940 Ouida Campbell, who lived one street over from Wayne, became our conduit to the Inner Sanctum.

She was three years older than Wayne and had taken care of him when he was a baby and his mother had to do errands. She was pure Carrboro, with long reddish hair draped like Veronica Lake. She had dropped out of her freshman year at college because of money, dated graduate students, was a crack typist at 149 words a minute, and was writing a novel called *Hope Is a Woman.* She was Paul Green's secretary.

"Paul said this . . . Paul did that . . ." she used to say, taking a drag of her cigarette as the three of us conspired those stifling summer nights on the porch. In the streetlamp her too-generous mouth moved all over her face, forming at lungful the Greek mask of tragedy, and when she let out the cloud of smoke, her husky voice was intense, transforming her into our advance scout into the world of artists where we would someday follow.

"She is beautiful," Wayne told me before I met her. "She looks like the Botticelli Venus. And she has this terrific singing voice."

Ouida Campbell in the Forties when she was working in New York.

"What do you mean, beautiful?"

"Well, she has this orange hair and cream white skin. And she has freckles. And it's not that she's pretty. She's striking."

Botticelli's Venus rising out of a mill town where the mill was shut down, where dirt roads stunk of dust and dogs, and where people cut through toepaths from backyard to backyard? Beauty was elemental like ocean, seagulls, geese on the pond, and foghorns. There might be wild forces in Carrboro but they were redbugs biting and rednecks squatting in squalor speaking hideous grammar.

"What kind of singing?"

"Blues. Ouida has an Electra complex."

She sang "Beale Street Blues" and "My Momma Done Tol' Me."

Ouida's mother was a bony postmistress named Flossie; her grand-mother dipped snuff and showed us how you spit into the Campbell's Soup can with the right plop; her father, a handsome drinker, had walked out on the family on Ouida's high school graduation day, leaving her to wait in vain on the platform in her white graduation dress.

Ouida had a brother, W.R., who was a handsome drinker too, and he dreamed of the navy, while she dreamed of the Vieux Carré and of New York City.

But these self-dramatizations had substance. She was not ashamed of, had digested Carrboro, talked about it gallantly, like Ann Sheridan on the wrong side of the tracks in *Kings Row*.

In addition she limped because she'd had polio as a child. It was not called polio then but infantile paralysis, and it took twice the time to say the two words whose syllables exuded doom. The scourge floated on the American psyche the way Franklin Delano Roosevelt floated in our Warm Springs fatherhood fantasies. Ouida's bad leg was as shapeless and red as a ham on a hook, to her glamour what salt is to hot chocolate. You'd see her limping, always alone, to work or to meet some date at night.

She had a bad reputation, was known as "the mattress" in times when reputations mattered. Perhaps it was because her boyfriends were always Jewish graduate students, or because she talked freely, romanticizing them in the vocabulary of bohemian Provincetown, like Carlotta did O'Neill, not physical details, but emotional nuance. Carrboro minded the mystique more than the deed.

That summer of 1940, Richard Wright came to Chapel Hill. Newly famous from his novel, *Native Son* (optioned for a theatrical production by Orson Welles and John Houseman), he had chosen playwright Paul Green to collaborate with. Because blacks couldn't stay on campus, the university rented an attic room for him on Sunset, kitty-corner from the current piercing and tattoo parlor on West Rosemary, which clashes ironically with the upscale Greenbridge complex of the twenty-first century. He slept in shorts and sweated in the summer heat.

He and Paul Green worked on the play in Bynum Hall during the day. Ouida typed. Despite his fame, only the artist fringe of the university and the graduate students knew of or cared about his presence. But Ouida lived in the secret world of progressive theater, sitting on a keg of dynamite before it exploded, for Orson Welles and John Houseman were going to produce and direct.

At first she told us a little, but then it became hush-hush. Clifford Odets came down from New York for a visit. He was attracted by Ouida. I had just graduated from high school and needed money for college in the fall, and Ouida got me a job for a Lillington friend of Paul Green, researching some old graveyard epitaphs in the library. She whispered she had to be careful now. She couldn't talk about the play.

She went to New York one weekend and Wayne and I wondered if she was meeting Odets up there. She didn't tell us and we didn't ask, but Wayne and I liked to fantasize they were having a fling. And we still spent our conspiratorial evenings talking in the Carrboro summer night.

The final act in the collaboration of Green and Richard Wright was coming to pass, and with it, the course of Ouida's imminent departure from Carrboro, for this experience was a great opening in her life, and she told us that her dreams were about to be realized. She decided to celebrate by giving Richard Wright a party at her house the night the final act was finished.

Wayne and I didn't expect to go, for this was Ouida's life, and we were her merely stage-left confidants. She threw her hair back talking about it, her enthusiasm spilling over. It thrilled her mother and grandmother to have such famous people in their house. And her brother, W.R., too. At last her family would meet Paul Green and Richard Wright.

W.R. went down to the poolroom that night and as he chalked his cue — he too was on brink of graduating from Carrboro, for he had just enlisted — he openly talked of the party, which was scheduled for Saturday.

Playwright Paul Green and Native Son *novelist Richard Wright. Courtesy of the North Carolina Collection, University of North Carolina at Chapel Hill.*

On Friday morning the rednecks sent word through the grapevine. Somebody warned W.R.: "If you bring that nigger to Carrboro, we're going to kill him."

Ouida had to tell Paul Green, Paul to tell Richard Wright. It scotched the deal, and the party never came off.

A few months later, Ouida left for New York, did some modeling, studied singing with Josh White, a famous black singer of the time, fell in love, and wrote us back about his black hand on her white skin. Wayne got out of high school and joined me in college. Walter Carroll was about to win the first Kay Kyser Scholarship to the university.

Native Son opened in 1940 with Canada Lee and was a smash hit. Beneath its success lay tensions between Orson Welles and John Houseman. Welles prevailed. Even more compelling were the quandaries raised by Wright's friendly collaboration with Paul Green, the

differences in their two views of Bigger Thomas, protagonist of *Native Son*. Paul, the liberal white playwright, wanted to present Bigger as a redeemed hero, a black Christ with whom audiences could identify. Wright, the younger black novelist, had created Bigger as an ignorant, unredeemed, pitiless black martyr in the America of the Forties. Green's view prevailed and Wright became haunted by the difference in visions repeated in a later movie version he had a part in.

Ouida wrote a mature well-balanced account of their collaboration entitled "Bigger is Reborn," which was published in *Carolina Magazine* in 1940. The Japanese bombed Pearl Harbor and war began. Ouida got a job as a cryptographer and was sent to Guantanamo Bay. She came back to New York, got married and then divorced. W.R. went into the navy. The years passed. Walter went to Yale Drama School, and Wayne and I went on to our careers.

In 1946 when the war was over, Richard Wright left America for Paris, France.

In the late Sixties and Seventies the gentrification of Carrboro began with the opening of the Carrboro Arts School, the advent of the Saturday Farmer's Market, and the transformation of the old mill into Carr Mill Mall. It was proclaimed the coolest town in the country after Seattle, and earned the moniker, "Paris of the Piedmont." Ouida married a graduate student, had five children, and disappeared in America.

It was in 1958, after I had published my second novel, I met Richard Wright in London. His wife, who had become an agent and my English agent, had somehow arranged our meeting, which took place on a summer afternoon in Hyde Park. We sat on some kind of lawn chairs, facing each other, and, never having met him before, I was awed but recognized him at once. He spoke in those rhythms of *Hymn to the Rising Sun*, which Walter Carroll had breathed, which were the syllables of the Carrboro of my childhood and the expression of the myth behind life.

Wright looked from the cool grass of England back to the lawns of Chapel Hill from the windows of Bynum Hall, marveling over the

anachronism of red clay, dreaming of a South past black and white, of an America past bigotry, and knowing his revolution, from which he had been absent so many years, was lost in evolution. He seemed a man marooned in French intellect as he cradled gently the emotion of past persecutions, wishing, almost, that he could hate as he used to hate.

He read me a section of one of the last things he wrote, a translation of a French work called *Papa le Bon,* which he called *Daddy Goodness,* and it sounded those old repetitions. In his handsome brown face I saw the benign, sad contours of the title in English.

When I asked him about Ouida and about Carrboro, he said: "Oh Carrboro, Carrboro, how could I forget it?"

"Do you hate it?" I asked.

"Well, it was very embarrassing," he said. "And I was scared. They threatened my life. I was sorry for Ouida. And for everybody. But no, I don't hate it. You must understand that that was just my experience there, that's all. When I think of Carrboro, that's what I think of."

Time makes hermit crabs of us, and we carry the world around on our back as our shell of reality. The tune we first hear is the tune we hear forever. Richard Wright died a year or so later. The university confiscated the Old Well as its commercial shrine. Twenty years later, Paul Green died and the Paul Green Theatre was built and opened its doors with, by his stipulation, *Native Son.*

Carrboro, a long way from its days as the Joan Crawford of chips on instead of pads for the shoulders, clops on the fence between commercial strip development and bohemian gentrification, its greed accompanied by zealously affected innocence as well as true ignorance. Hundreds of old Carrboroites still live and work in Chapel Hill, secretaries, businessmen, professors, some cooperating with the juggernaut, others amazed at the extinction of their personal reality.

"What should the image of Carrboro be?" the preservation society asked, as if Carrboro had neither sunk nor swum during the rest of the 1900s. Even in the twenty-first century it has seemed an impossible question to answer.

Daddies and Donkeys, Gods and Gadflies

The Last Questions of Horace Williams

THE YEAR HORACE WILLIAMS died, 1940, was the year I started college. Thomas Wolfe, who died two years earlier, wrote Williams into national memory as Vergil Weldon in *Look Homeward, Angel,* creating him as an icon in the annals of the university's history. It was also the year we moved into the Shack, the year I made my last ditch stand to get into Radcliffe, and the year Wayne joined the Literary Guild. He etched a Tree of Truth on white paper in pen and ink and at the bottom of the trunk put a bough labeled "Emotion."

His low opinion of Emotion amazed me, and began our lifelong debate on the split between church and secularism, religion and reason. Our arguments stemmed from the idea that man is the measure of all things. But in the twenty-first century with *faith* venues consisting of mega-churches, movies, TV stations preaching creationism and in ramped-up techno-visions of the conflicts Horace Williams expressed in his life and thoughts, the affect has changed.

Williams was born in 1858, and was brought up during Reconstruction in Gates County near the Great Dismal Swamp when food was hard to find. He was tall and tough physically, with a shrewd, red-clay personality and a smart, stubborn, mercurial mind. He was driven to books to pursue the truths of life. His mother saw no future for him except to go on to higher learning. So, with the aid of the Methodist

church, enough money was scraped up to send him to Chapel Hill where he shoveled coal to help with living expenses.

He lived in unheated Gerrard Hall and was older than most of the students, a perfect Other Figure, wearing threadbare clothes and practicing a frugality his classmates made fun of. Yet as a member of the Di-Phi (Dialectic and Philanthropic Societies, the heart of the vibrant student culture then) whose rooms are at the tops of New West and New East, he made his mark. He argued with parabolic humor. He outstripped the rest of the students in classes. He took anyone on in argument, including professors, and his honor papers won him a reputation for integrity and acuity.

Contemporary students are mostly unaware of him or the place he occupied in the student body's heart. They know the almost-defunct airport with his name, but they are generally not aware of the Di-Phi rooms, where the debates of nineteenth-century humanism were argued, freely open to them on condition they request the key and permission from university authorities. When they enter, it is into a museum inspiring awe, shiny antique desks sitting empty and silent, as a portrait of Thomas Wolfe stares down on them. In its museum semblance, it is easy to dispense with.

The argument against classic humanism has increased exponentially in the cyber age, altering the complexion of the nation and its institutions of higher learning. Attacks on individual views by religious organizations using professional PR and mass advertising to effectively distribute their attitudes through tax-free corporations are legal and ostensibly democratic but reflect Horace Williams's individual thought processes and teaching methods in the distorted projections of a carnival funny-mirror.

After graduating from the university Williams went on to Yale Divinity School. But he knew he wanted to be a teacher not a preacher. Socrates was his model. He may have seen divinity school as the most practical way to pay for graduate studies. Finishing at Yale, he went on to Harvard. When he got his degrees he married an independent Connecticut girl, a painter named Bertha, whose mother and father

had died. They came back to Chapel Hill where Williams started his teaching career.

His students over the years (1890 to 1940) became leaders of the state and nation, ranging from educators like Edward Kidder Graham and Frank Porter Graham, both of them presidents of the university (the latter becoming a U.S. Senator and a mediator at the UN), to political figures like U.S. Senator Sam Ervin, chairman of the Watergate Committee, governors, and mayors, and writers like Paul Green and Thomas Wolfe. He held them in thrall, and through them his influence spread.

A concatenation of events connected to Horace Williams is the reason my father chose Chapel Hill as the place to reset our fortunes during the Depression. One summer day (perhaps in 1936), Daddy met a philosophy professor from UNC named Dr. Stephen Emery who was visiting his widowed mother in Pigeon Cove, across Cape Anne from Eastern Point. Whether because Dr. Emery taught philosophy or because he described Chapel Hill as the "Athens of the South," unconsciously reflecting the Socratic method Williams promulgated, the arrow was pointed. With the money Daddy had given my sister and me to deposit every Friday in our primary school savings accounts, he was able to pay for the train trip south with Homer.

In 1940 North Carolina was still the Bible Belt. Wayne confided that when he was ten he had been "saved" in a revival tent. I couldn't believe it. I went with him to a movie one night at the Carrboro Baptist Church, where the Century Center now stands. At the end of the film a whitish stick figure of Jesus in cliché pose ascended into the heavens. Swelling choir music did nothing to offset the ludicrousness of the dead cut-out in its robes that you knew moviemakers were pulling up out of the frame on an invisible string. I laughed. Wayne refused to defend it.

Our family had gone to Congregational Sunday school as a gesture to conventional religious training, until Mother found out we were coloring Christ with crayons. She said Jesus was a good man who led the world in doing unto others what you would have them do unto

you, and we should follow his example. Mankind was becoming better and better over time on the earth. She knew that was true, because if it wasn't, what good was living?

Our father was probably happy to liberate us from well-intentioned church activities. He sneered at the superstitious side of religion and his version of the Bible came at the dinner table in his portrayal of St. Paul, a Hellenized Jew, preaching to the ignorami (sailors and decrepit old ladies) in Corinth that they would meet God in the land of milk and honey so they should be glad to die and get their miserable lives over with.

Daddy contrasted this with the story of Prometheus, the hero who saw how humans were treated compared to Zeus and the rest of the crew on Mount Olympus. Mankind had no fire to get warm with or to make light against the darkness of night, so Prometheus sneaked up to Olympus and stole it, snatched a burning stick which he gave to humans. For this act Zeus ordered him chained to a rock on the edge of the sea for eternity where vultures came every day to peck and eat his liver. Our father toned down the vultures, but out my childhood bedroom window I could see Brace's Rock where I imagined Prometheus chained, with seagulls substituting for vultures. Although I preferred *Grimm's Fairy Tales* with Jack the Giant Killer, the little guy outwitting ogres, I was affected by Prometheus's serious heroism.

Daddy never used the word God, except in an objective way. Sometimes in the middle of a walk around Niles Pond in Massachusetts, he would spot a particular artifact (such as a muskrat's nest or a duck's webbed foot, or a plain old oak leaf) as an example of some natural scientific phenomenon having to do with origins or processes. The word *knowledge* from *I know* is *gnorizo* in Greek and *ignorant* means *the lack of knowledge*, the curse of a lazy, uninquiring mind.

He disliked the gods of Laws and Punishments. He imitated Greek Orthodox priests nasally *pee-pa-po*-ing Byzantine chants as he walked around the dinner table waving his hand back and forth, pretending he was holding a censor full of perfumed frankincense which he swung toward our nostrils to cast its holy smoke. Of course we loved this, and

when he told us the ignorant bowed down to appease God because of their feebleness and fear, we exulted in our superiority.

Abasement to gods made people become craven, Daddy said. Mankind in classical times was wily in appeasement-worship, giving Zeus the fat of grilled sacrificial oxen but hiding the best hot meat behind their backs to eat themselves. As if Zeus didn't know! What fools! Abasement meant you were one pitiful sucker. You defeated yourself if you succumbed to fear. If you didn't have an inquiring mind you wouldn't learn anything. You'd never read books and find out what made life worth living.

The name *God* became embarrassing to me. I never uttered the word for fear it would show me as weak, lonely, needy, or naked. Jesus, according to Daddy, had imbibed the ideas of Aristotle and Plato and His word was spread by his Hellenized disciples all over Asia Minor. Daddy said the book of John was the most beautiful in the Greek New Testament. It showed Jesus in a light of knowledge which illuminated the truth: If you loved your neighbor as yourself you would not have wars. Romans and other ignorant barbarians killed Jesus for preaching that. Greeks called people who didn't know Greek (such as Persians, Medes, Romans, Jews, or Scythians), and talked a gobbledygook (*var var var*) that sounded like barking dogs, barbarians. Daddy's vision of God was not "Fear Thy Lord," but "Laugh and play with your god." In thrall to this persuasion, we had no fear of God or his wrath, even though by no means were we spared from American Puritanism.

In addition to Prometheus, he told us Aesop's tales of foxes outwitting themselves and greedy crows dying of thirst because they were too dumb to stick their beaks down the narrow bottle tops where water waited to be drunk. He mixed these fables with logical reasoning in kindergarten Aristotle and Plato, which made good sense and flattered our vanity. Daddy portrayed Zeus as playing with many wives instead of raping many girls. Zeus also had many famous children, like Athena who owned an owl, and Apollo who drove the sun across the heavens bringing night and day. Even American Indians had their Great

Father and just because they were considered savages didn't mean they weren't human. Daddy refused to let one god be the only God.

Before we moved from Patterson Place to the Shack, Billy Basnight, who lived two houses down, used to play with my brother, Homer. They were about eleven years old. Billy told Homer he liked Daddy because he was bald and had great big yellow teeth. He liked it that he knew everything, read books, and was an authority. Daddy reminded him of God. Billy believed in God. Their family had to say grace before they ate. Homer told him that he would certainly like to believe in God too but he couldn't. However, if Billy could get God that minute to turn the hill behind the power plant into a cookie, Homer would believe in Him.

I had not known that Homer had this preoccupation with God, but for me that year when I was sixteen, Chapel Hill was becoming my crucible. I was realizing we had lost Hestia and money but gained a university library, a strange geography, and new friends with unfamiliar habits to match their accents. I looked around to learn what was real and supposedly normal. I needed to check what was true against what I had stupidly assumed.

I felt compelled to define everything in my unfamiliar new life — sex, beer, and stealing, in addition to God, mothers, fathers, and churches. What I was or should be I took to sound-boarding with Wayne. There were always books we could check ourselves by. We were in dead earnest, unashamed, ardent, and obsessive. At the same time we knew we were ridiculous and melodramatic, but what did we care? The code of "cool" didn't exist then.

The father examples around us became irrevocably identified with God, like Billy Basnight's Daddy-analogy. In the fatherworld it didn't matter what kind of father you had, ineffective, absent, tyrannical, benevolent; some kind of universal ideal was ubiquitous, even though the ideals often clashed with each other in the same father.

I began collecting comments inadvertently uttered by my new friends.

"Anytime somebody tries to put you down," Dick Phillips used to

say, "there's one thing that can stop them dead in their tracks. Just say: 'My father thinks so and so,' and back it up with a quotation. That'll cure them." I was bowled over by the devilishness of this advice, and shocked even more that it was true.

"Remember, it's just as easy to fall in love with a rich man as a poor man," Mary Smith's father used to tell her to discourage her infatuation with Walter Carroll. Of course, this was cynical, but what could you expect of a divorced father remarried to a nurse, even if he was a professor of history?

"My father found the twenty-eight languages easy," Mollie Holmes said self-deprecatingly about her father who was reputed to be master of twenty-eight languages, "because they all derive from Sanskrit." Her portrait of Dr. Holmes as handsome and powerful was so worshipful I was stunned when I first saw him striding in the procession from the back of the Episcopal church to the chancel looking like a whale, his round, pasty face protruding from the black choir robe that flapped behind him like a whooshing tail. Later I learned that behind his back everybody called him Major Hoople (a comic strip figure of the day).

"I never knew my father," Walter Carroll used to say, describing how his mother died in Baltimore in a small, white room with a crucifix above her bed. It turned out he feared he was illegitimate. Whether it was true, I have no idea, but his uncle D.D. Carroll hated him, Walter said, because he was embarrassed by the bohemian side of the family. Which was why Richard's father, Brooks Phillips, became Walter's surrogate father.

"My father congratulates me when I get C's," Mary Louise Huse said, mimicking him in W.C. Fields's syllables. "All teachers are unimaginative drones and ill-informed drudges, spewed out by defective Schools of Education." I loved Dr. Huse's insults because they seemed like Wasp versions of our father's attitudes.

Wayne remembered sitting in a field of high grass in the summer when it was hot and bees surrounded his father's head. But he was not afraid, because his father worked in a mask among bees near white

hive boxes he made for them in his backyard. Though his face was invisible with bees buzzing so near, his father told Wayne through the mesh curtain that they knew their ways and formations from ancient times and you should never jerk or move too fast and scare them into stinging you. Wayne compared him to a story Daddy told him, written by the Greek poet Hesiod.

Wayne loved my outrageousness and statements of wonder at how people could believe so much sanctimonious church baloney, but he had lost his Baptist faith, he told me, and it was since he'd met me. I agreed but protested that it wasn't my fault. He admitted books might be responsible too, but that only made him read more. He seized on every book like a magpie, ravenous for the truth, plugging into every new idea without discrimination. He was far more modern than I was. He brought me both Thomas Wolfe and Virginia Woolf, exhorting me to read them. I didn't like either. Thomas Wolfe was too darkly poetic about death, and Virginia Woolf was so far into her inner sensibility that there were no borders and I got lost in that mentality. I wanted plot.

My turn-ons were Dickens, the Brontës, Dostoevsky, and Tolstoy, all of whose great visions were capable of drowning a reader in floods of emotion. But you were always saved by plot, which is built on cause and effect.

The day in late February 1940 when Wayne introduced me to Ouida Campbell was the day I began my self-conscious speculations about the fatherworld. Wayne maneuvered Ouida to the point in her graduation-day story when her father abandoned the family. She was a self-dramatizing nineteen-year-old about to become Paul Green's secretary. She was trying to understand herself. I was an ardent, unworldly sixteen-year-old ready to be shocked.

"You all come on in!" she said expansively, a smile bursting out on her face, the kind that changes assumptions in an instant.

She led us from the parlor down a hallway smelling of Carrboro mold to a bedroom with a big double bed covered by a white bedspread with white nubbles on it, and there she told us to sit on the bed.

I had been brought up knowing it was bad manners to sit on people's beds, but there were no chairs, so I did.

Wayne raised various topics: typing, writing, writers, playwriting, and the Depression. Finally he got her onto the subject of her graduation day.

"Honey, my daddy is handsome," she said. "You haven't seen a handsome man until you've set eyes on him. I adore my Daddy. Not only do W.R. and I favor him but we have his habits too." She threw back her head in a boastful laugh. "Bad ones and good ones alike. Daddy's always been a roisterer." The word *roisterer* lifted her out of the Carrboro category.

"He can do anything. He did carpentry in Mississippi, traveled around the country, and then came to Carrboro to work in the mill. Which is where he met Flossie at a church social. A pretty, thin flower of a girl so smart he fell in love with her," I couldn't imagine calling your mother a flower, especially a turkey-necked mother, "and they got married, and W.R. was born, and then I came along, and then Charlie and Jimmy, and I was his favorite."

She was hitting a plateau of rhapsodic melody. North Carolinians in those days built up their monologues launching them toward incantation. She had the eloquence of Walter Carroll, but she was more down to earth and female. Also more contemporary. She knew how to pull the *I* of her Southern *Ah* in (to show that Southerners were not dumb) and she knew when to belt out true South. "He'd come to Carrboro because there was work here. But then the mill closed. Maybe that's when he got to drinking. And roaming around, and, well, he met somebody else, we don't know who. Poor Chickabiddy. But my Gawd, can you imagine leaving us on my graduation day?

"I had this gawgeous white dress — Daddy insisted I go buy it and gave me the money — and I was sitting up there on the platform, waiting for him to come. Well, honey, I waited till the cows came home. Honest to Gawd, he was so proud of me, and I knew he was proud, and he'd seen my graduation dress, and he kept saying how gawgeous it was. So there I am, *Pomp and Circumstance* playing, the whole shebang,

and I keep looking at the clock under the balcony in Memorial Hall, you know? And he never shows up, he just never shows."

"You haven't seen him since he's been gone?" I whispered.

"Not once, not a wee biddy peek. He dropped out of the world. Just disappeared like smoke, the big sorry son-of-a-bitch. And I can't even hate him. I feel sorry for him. I love him, Goddamn him to Hell. Broke Chickabiddy's heart, and there wasn't any money." She took a last drag of the cigarette and held it in her lungs, but this time softly, and she caught herself in the oval mirror by mistake, looked away, and blew it out with determination to make the point.

"So I had to drop out of college my freshman year and go to business school. But I'm going back, you watch. As soon as I've saved enough money." Her denouement was more effective than any climax could have been.

In a male bastion you have a multiplication of fathers, identifiable fathers, professors, and deans. What shocked me the first day of high school was how the kids addressed the teachers as *Sir*. "Sir?" Billy Koch asked, trying to stall when Dr. Farrar ordered us to turn to page 58 for the question on Byron. Such deference struck me as girlish or ante-diluvian, and Dr. Farrar answered with such snide pity I felt like Jane Eyre or David Copperfield in their freezing classrooms. I asked Dr. Farrar could I do my book report on *War and Peace*. He said no, a high school senior was too young to understand. But I did it anyway, skipping the last thirty-five pages of Tolstoy's rants. If Ouida could rise to stardom from Carrboro, I could report on *War and Peace*. Dr. Farrar was forced to give me a decent grade.

Miss Penny was the only woman teacher in the school with the altitude of the men teachers, and the kids were afraid of her. Two or so years after I left, she moved to Broughton High School in Raleigh where over the years she became a famous teacher and won numerous teaching awards.

The men were professors of education at the university and in the early Thirties had taken a cut in pay. As students, we were the fodder for their students to practice on. Sanford Stein, one of our practice

teachers, was a college senior who wrote the gossip column in the *Daily Tar Heel*. He was the first person I heard of who got killed in the war.

Shortly before graduation Jo Burt Linker, Billy Thompson, Tommy Odum, and other boys (not Carrboro kids from whom you'd expect that behavior, but professors' kids and town kids) put a stink bomb behind the clock in Dr. Farrar's classroom and set it to go off during last period. At the appointed hour a rotten egg smell leaked forth and started seeping through the room toward expectant nostrils. There were gulps. Somebody made a sound between suffocation and laughter. Suddenly the culprits ran out the door. Other kids followed.

I froze in my seat, but Dr. Farrar, with his Norwegian folklore face (long before *Lord of the Rings*), his mane of white hair, looking imperturbable, acted oblivious to the smell. Outside the kids were staggering around the schoolyard, lowering their faces to the ground, gagging with laughter and pretending to vomit, and through the window he waved them back.

"Stink bombs," he said drily, as soon as they once again were seated. "The best laid plans of mice and men will be foiled," he said, his snub nose shiny with delight at using rhetoric against them. "This is to inform you that you suffer and I do not. I have no sense of smell!"

Mr. Munch with his one arm (the other amputated when his automobile tipped over and he had it outside his driver's window) had saved me and my sister from zeroes in geometry. His stump was so elegantly and reassuringly hidden in its coat sleeve that it gave him the dash of a pirate mixed in with his humble Christ-like demeanor. Mr. Munch always helped any serious student who required it.

Mr. Gwynn, our Latin teacher, had a Southern farm-drawl, which sounded sensational in Latin, a secret mocking triumph over anyone who thought Latin was a dead language when it had been transmitted complete with Southern accent in the humanistic era of American education.

Mr. Giduz forbade anyone to call him *Doctor*, though he'd graduated from Harvard. He was swarthy and short rather than white and

tall, came of Portuguese extraction, and had no PhD. He immersed us in French, forbidding any other language including English in the classroom, so it became second nature, even in bad accents.

When Wayne called Daddy *Sir,* I liked it, maybe because I was beginning to sense that Daddy needed a grown-up son in a family with three older girls and a young son.

The minute I graduated I wangled a car ride up North where I had an appointment with a lady at Radcliffe who had interviewed me on our porch at Patterson Place. She told me kindly that despite my excellent record, I was too young (sixteen at the time) to get a scholarship. They didn't give them until you were eighteen. "You have plenty of time," she said.

In Gloucester I crash-landed on the Halleck sisters, two middle-aged artists who'd lived up the street from us on Rocky Neck. For the first time since we'd moved to the South, I walked out to our Thalassia on Eastern Point and took a good look, realizing how quickly and radically that life had disappeared. I stayed the summer in Gloucester without remembering how I afforded it, except I had a job tutoring somebody something, and I wrote Wayne sending him detailed descriptions from my new reality of the Birdseyes and Pooles, the people I had grown up with.

"That was a terrible calamity about the 'Radcliffe venture,'" he wrote back, commiserating. "*I am glad.* Chapel Hill is not such a bad place. One can find all kinds of people here and an education may be acquired here as well as at Radcliffe. Maybe you could do as I intend to do. I want to go to Harvard, but I think I shall get my AB or something of the sort here and go to Harvard for further education. I feel this will be more practical."

In his next letter, as compensation for Radcliffe he wrote a poem:

Across the water a breeze is dancing:
The moon glimmers on the water,
 Making myriads of jewels
Repeating itself many times in mellow light.

Wayne Williams in the Army, circa 1943.

Below it, he etched the moon glittering across the water in pencil on green paper. He also described heat lightning, which "made the horizon look like a reflection of Europe." The Nazis were buzz-bombing London. And in the next paragraph, he said: "I would like to read that book of the wandering Jew."

Mother had a huge old volume of *The Wandering Jew,* a nineteenth-century novel by Eugene Sue whose frontispiece was an etching of a woman stretching her arms out over an ocean and whose last page was an etching with a man stretching his arms out across that same sea, leading you to wonder whether they reached each other or remained in a state of longing.

"The Jesuits have always been of interest to me," Wayne wrote. I hadn't realized that book had anything to do with Jesuits. I'd thought it was about romantic love, not about God. It sits in my bookcase to this day. But I still have not read it.

Wayne's thoughts centered on religion and Horace Williams. In the

Thirties when the Carr Mill closed, Horace Williams bought up a slew of company mill houses cheap. Wayne's family lived in one of them. For years Wayne walked to the old man's house with an envelope containing $14 for the month's rent and looked through the screen door longingly at all the books. Sometimes Dr. Williams said hello from behind the screen. Wayne wrote me that summer that for the first time he had succeeded in engaging Horace Williams in conversation.

> Dr. Horace Williams is a wonderful man with amazing intelligence in some fields. His book is a reflection of him. If you haven't read it, you should. He went to the UNC then to Yale, then to Harvard on a Harvard Fellowship. He does not believe in doctrinal religion or dogmatical religion . . . He has been very sick for a long time and his brilliant mind was affected for awhile, but he seems to be well enough now. He has to have a nurse.

On July 27 he enthused:

> I have joined the Literary Guild of America. Through this I hope to enlarge my Library and aquire [sic] some of the best of books. As a bonus for joining I get a volume containing the Bible, the Koran, the Talmud, and the religious literature of all the most important religious orders in the entire world. I think that it will be one of the most important additions I might add to my books.

He angled his thoughts back again to my failure to get into Radcliffe:

> Your life will only be begun when you finish college, and you seem to think that all will be ended when you start. Getting a Bachelor of Arts degree here will not keep you from returning to Gloucester or Cambridge. It will only be an episode. If you are ever going to be a writer, you will need to know more than just Gloucester. . . . And you don't have to like a place to live joyfully there. . . . It's mostly the personal outlook rather than the location.

He copied words from his Dr. Williams's autobiography to put in the letter: "To be a Christian is to live spiritually. . . . Hence I reached

the view that spirit is that which is selfcontained, selfexpressing, self-originating."

> He reached almost the same conclusion that I did. I believe that the real religion is that which comes out of a person's mind and soul, to fulfill the spiritual needs of that person. . . . His autobiography is really inspiring to hard work and other things. . . . I think I am related to him. [Both their last names were Williams.] He is an egotist, but he is a very fine man, and is not at all proud and arrogant. One would think of him humble at first meeting him. I have fallen into a one-sided friendship with him.

I must have told Wayne that I prayed — I would never have admitted such a thing to others — but maybe I phrased it in a noncommittal way such as: "I certainly wanted to pray, because I want to know the meaning of life and I wouldn't mind praying if I could find out that Truth," such reservations being the flip side of adolescent absolutes.
He wrote back:

> Where do you look for God? Where is your prayer directed? Always people say God is above. I do not believe so. Why not look in your own soul and in the souls of people who have not stifled and killed him? Is it not more likely that he be there than in the sky?

Returning to Horace Williams,

> [He] is about 73 years old. He has a very distinguished-looking carriage (not horse-carriage, ha ha) with shoulders erect and head high, though age shows in his white hair and mustache. He was born the son of a country doctor in Virginia, but he does not say when in his autobiography, as this is hearsay evidence (unquote). He is a very interesting person with whom to talk.
>
> Can you think of infinity? Can your mind be made to conceive the immensity of eternity? What came before the past — and before this. Where did God come from?

He answered by quoting from the Upanishads, with two pages of Prajapati. He said that Horace Williams had written that the Upanishads

were "discussions of the character of God . . . which gave him more good than any other scriptures." He quoted pages of creation myths of the ancient Hindus.

Hopping blithely over the disconnected dots he switched to my ruminations about friends:

> Damn Yankees are not at all unwelcome in the South. New England is a sort of Magic Door in my imagination. Your tutorship will probably be a great help to you. It was a great chance to improve yourself and line your pocketbook in one blow. . . . I think the people in Carrboro are, as a whole, one of the most despicable, low-class conglomerations of people in the universe, but I like to live here, if they'll leave me alone. Excuse writing please, Wayne. P.S. "An atheist is a person who has lived without meeting a crisis which has given him a need for personal power from some source inside him."

When I got back to Chapel Hill, our family had moved into the Shack. Homer and I were putting up the framework for our bedrooms, nailing it into the hallway to the bathroom when Daddy passed by, looked at our work, and told us that we should nail the boards onto the other wall. He criticized the angle at which we had turned the nails. His advice led to a full-fledged argument.

Ouida's incantation on her father's desertion had loosed the floodgates of the fatherworld to a clash of orders and a loss of borders in my mind. How could a Daddy be two such different people? I wondered. How could *Daddy* be the word for a father like ours when it was also the word for Ouida's father? Our Daddy was foreign, had an accent, and acted like Zeus because he had an education. Our Daddy was not a Southern *Daddy* nor did we have an extended family of uncles, aunts, grandfathers, or grandmothers, only ourselves, three girls and a boy, for which the word *family* signified a nuclear family and a standard of behavior which must be maintained as a megalith of honor, an icon, and a dolmen of respectability.

Number One: Our father would never have abandoned our family.

Number Two: Our father would certainly not have run off with another woman.

The word *Daddy*, therefore, I reasoned, must have a class dimension. We called him Daddy in the house and he felt like our Daddy then; but in public, we referred to him as "our father" elevating the word *Daddy* to a general class of being, analogically similar to the proscription against sitting on other people's beds. Look at how in church everybody said: *Our Father Who Art in Heaven, Hallowed be Thy name* . . . I liked even better when it was translated, *Our Father Which art in Heaven.*

So I looked around to see what other kids called their fathers, and I noted immediately that upper cliques elevated their daddies to *father* in public. Mary Louise Huse and Mollie Holmes whose fathers were professors always used the words *my father* — not *Daddy* — on high school premises and other public places. Harriet Sanders's father was also a professor, but of sociology and social work, and she said *Daddy* in public because she wanted to show that he had worked up from a hardscrabble background to reach a high position, and she was "common people."

Wayne too was a populist and called his father *Daddy*, but I knew Mr. Williams. I went to his house. I saw him as a genial, square-headed plebian with a rubbery walk, completely different from our *Daddy*, because he had only a fourth grade education and worked as a plumber. He may have gone to fewer grades than even Ouida's father, and wasn't half as good-looking. But at least he had not ditched Wayne's mother.

Still a lot of our classmates at Chapel Hill High addressed their fathers as *Daddy.* So what were fathers actually supposed to be? The only way I could find out was to start asking friends, "What do you think a father is?" I asked them one by one. Sometimes I worded the question: "What do you think a father is for?" Most said that fathers were breadwinners. But what about family standards? Yes, they said, fathers decreed, but mothers put it into words and action around the house. Fathers brought in the bacon, the majority said. Mothers were the culture and behavior mongers.

Being a breadwinner was a moral imperative in new territory. I tried to get the lay of the land, to understand American society, and to figure out if it was true Daddy was a bad breadwinner. The life we were living had less and less relation to what he preached, to what we had been led to believe. You can't exist in an irrelevant, despicable, and necessary way. So every night when he put Edward R. Murrow on the radio, broadcasting from London, the hugeness of impending war revealed we were becoming the central act of our own life dramas, and that Daddy with his ubiquitous presence was receding into some lonesome background.

Ouida's graduation incantation had caused an architectonic drift in my ideas. She was living proof of the gateway to the wider possibilities of the fatherworld. Wayne and I started experimenting with beer and sex (kissing) in the Episcopal close. We wrote our reactions down on paper. We used key words like *compensation* from Freud, and *futility* from Dostoevsky. We didn't ask our parents about *orgasm, desire,* or *violence,* for we were possessed by these urges and plunged into them full steam ahead though we didn't go all the way nor murder anybody; we went to the rare book room and read Havelock Ellis and Krafft-Ebing. One night afterward we stood dazed on the library steps under the moon and vowed to search for the answer to life, i.e., the Truth. But Truth as an aggregate was a challenge to prove.

Shakespeare's seven roles for man express that ontological longing is greatest in adolescence in the years between thirteen and nineteen. Infantilization has raised that age to twenty-five in recent decades since people live so long. People in the First World experiment with age augmentation and answers to the meaning of life through cults and TV orators who minister to large audiences, and from ages forty-five to ninety there is a panoply of new religions, crystals, yoga, medicines, vegetarianism, and drugs. Take your pick. Not only do they offer various meanings of life, they give hints on how to prolong it. But in every life, people form habits and make life decisions accordingly. Habits trump intellectual investigation.

I was the lone girl in college classes. The professors and my fellow

students were all men. My role was gratifying, and alienating, for if no dirty jokes could be shared, neither was I the sweetheart of Sigma Chi. The boys kept their distance. My tragic failure to get into Radcliffe disappeared immediately from my mind when I started college. I didn't even think of it as I became immersed in my new life.

My self-help job in the library, typing subject headings on catalog cards, had me working all hours. To keep warm after the library closed, I got in the habit of doing homework in a small, ground floor classroom in Peabody Hall (the philosophy building) where I left my books and papers overnight. I began to consider it my office.

Wayne unhitched himself from high school identity and met me in the library every afternoon. Eventually when he entered college, he took over a small classroom across the hall from my office, and if we missed each other at the library I could find him or he me and nobody knew the difference. If the building was locked, we came in and left by the window, taking good care to keep it unlocked. Unlike most college students, we had no curfews.

At home, change to attack-mode became inevitable.

"What good is preaching without money?" I asked Daddy.

Our mother tried to defend him, but I paid no attention.

"All you do is tell other people what to do. You can't make money," I said in front of the whole family.

He met my assaults with lofty indifference, his blue eyes congealing in their sockets deep and icy. He bore my accusation in silence until finally, sick of my rants, he uttered a loud, calculated, finely honed belch. Who could resist such a Marx Brother comment on the world? It wasn't even personal. I laughed as loud as everybody else in the family and it sounded like the inane laughter of gods.

"Daddy is always right though," Mother would warn us.

But he had no need of gun mounts or weapons, just as he had never needed to spank us. His drawn breath, the inhalation of his terrible warning sound *Eeeeegh!* was more effective than any punishment. His bastion was stance and silence, and his threadbare existence proved his power. He was the only one of our family with any principles

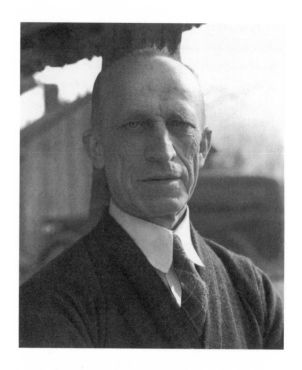

Daphne's father, Pan C. Athas. Reprinted by permission from photographer Arthur Lavine.

or morality left, and he succeeded by being an out-and-out failure. I needed an excuse against such presence for I was infected with the world. Honor makes you lose your clout and I rubbed my arguments in his face, talked back when he pontificated, and sneered.

Thinner and older, my father's nose was growing sharper and his presence turning monumental in failure. He was achieving the height and loneliness of Brace's Rock. The more pity I felt, the more merciless I became. Now that war was coming, changing the rules, there was nothing for us to do but make our own way. He didn't fit in American society. It was increasingly obvious. Misgivings spread over us like mildew, and the more peacockian he acted, the greater the danger.

Breadwinners in America are interlocked into Puritan values — work, like cleanliness, being next to godliness. But what did Daddy say? He loathed the sight of donkeywork, and he didn't want to see us do it. "Bite the Hand that Feeds," he told us. He'd seen Greek peasants stoop lower to the ground, too tired to stand. He'd also seen the

sweatshops in Massachusetts. He knew this kind of work burned you out, while we, who had not grown up as peasants or factory workers, were bound by the necessities of the new reality, listened, agreed with him, and went on working.

Work was money. He saw work as exploitation which the Puritans in Europe before him kicked out of sight when they sailed from Europe and then *did* when they got to America. His accent separated him. "The trick is to use your brains and organize," he would say, looking up from Thucydides while we scrubbed or did the dishes. "Let the donkeys work." He held earnestly to this theoretical blueprint. "Take opportunity."

But what opportunity? We children had become adept at scut work. Homer in particular had gained an affinity for the practical. At twelve he could handle machinery, fix gas pumps, change tires, and build steps, while our father stood next to him, directing, watching with a half-grudging admiration the son who could do the things he was no good at.

Every day in his neat, threadbare suit, Daddy polished his shoes with the rag he kept stashed behind the bookcase. Greeks always polish their shoes, no matter how poor they are. He would get into his battered blue laundry truck to deliver the coats and aprons of his linen supply company to the greasy spoons, pretending he was bringing home the bacon. We watched with admiration, disgust, and fury as his truck left each morning

Rebellion was contagious, and if Ouida had inadvertently started my personal rebellion, Wayne was the next domino.

"I despise Daddy," he announced after a night of drinking beer. (I had been inspired by the term *chug-a-lug*, had never heard it before, and wanted to see what would happen.) Wayne was always saying he despised his father, but this time his eyes were smoky and he lapsed into Carrboro pronunciation which smeared the former vision of his father as a wise beekeeper. He described the fight, line for line.

"He said I was drunk. I wadn't drunk. So we drank a few beers. So what?"

Up to this moment Wayne had walked a fine line between perfunctory politeness and contempt, but now he repeated his explanation as if his father were a two-year-old.

This glimpse of his only son's cave-in to drink brought the inevitable. Mr. Williams saw he'd been too easy on Wayne, disguised from himself his failings as a father.

"You know you 'sposed to be in by eleven."

"Who says so?"

"Me, and it don't help arguing none when you're drunk."

"Who says I'm drunk?"

"Don't help to lie none either."

"I'm no more drunk than you are, and I'm not lying either! You have to respect someone to lie."

Mr. Williams reacted predictably. "From now on, you'll come in no later than 'leven o'clock at night or — "

"The hell I will!" — the first time Wayne had ever used a swear word.

"I won't have no cursin' in this house, you hear?"

"Or what?"

"You're not more than sixteen years old — "

"Or what?"

"I tole you — "

"Who are you to forbid?"

"I'm your Daddy and so long as you're in this house you'll mind what I say, you hear? You'll get in here good and ready by 'leven o'clock every darn evenin' or — "

"Try and make me."

Which is when Mr. Williams grabbed his shaving strap from the back of the chair.

It was Wayne's turn to be shocked. But he kept calm. He said he felt the eye of a hurricane. He grabbed the chair where the strap had been hanging and moved back against the tongue-and-groove wall, balancing himself. He thrust the four legs into his father's face and shook it like Androcles. He'd learned technique from Carrboro dogs.

"Make me!" he dared, knowing when you're attacked and the dog has your pant leg in its growling teeth, you pick up a stone; and when you aim, the dog unfailingly skedaddles howling under the house, its tail between its legs.

White as a sheet, Mr. Williams faltered. So Wayne put down the chair.

"Don't you ever do that again," he told his father in a very soft voice, "or I'll kill you."

Mr. Williams dropped the strap and took a step backward. Wayne noticed how caved-in his shoulders were.

I wanted to dance around a toadstool in ecstasy for not only was Wayne delivered out of Egypt, his first step was planted in the desert toward the Promised Land, and he'd done it as a Roman gladiator rather than as a Moses-follower. I gloated at the picture of poor Mr. Williams, the feckless lion-turned-dog, and saw that it was the solution for me too, so I couldn't get enough of Wayne's declarations of freedom and kept after him to tell me his latest reactions.

Our father would become Wayne's father. Our father needed a son like Wayne who read books. I read books, but I was a girl, and it wasn't the same. Now Wayne could be his son, and I would still have my real father and Wayne's obligations to Pharisees and lower Slobovians would be over, and he could gain a Free Father with sense enough to tell you to go to hell in your own hand basket. He would become a philosopher, and I could share the burden of what I had to be.

But after a week he had calmed down. I was afraid he would retreat.

"Are you still mad at your father?" I asked anxiously.

"No, I'm not mad." He sounded sad instead.

"What is your attitude then?"

"Good riddance," he said. "I could gloat," he went on, "but why bother? I despise him. He's a poor ignorant fool, pretending fourth grade millhands are perfectly good people. But he's ineffectual and lacking imagination. He's weak."

Yes, I agreed silently, for you couldn't condemn such people for their shortcomings, you had to consign them to another universe. They

were trying to stifle, hamper, and impede your life, weren't they? So I wasted no time on Mr. Williams either. But while I could see his face gray and shoulders bent, as Wayne described him in retreat, at the same time I was ecstatic at Wayne, the gladiator. In later years I couldn't wipe out the delusive memory of actually hearing the blow of the razor strap, the something that did not happen.

But in the days following, alone in the stacks, I was overcome by futility, the emotional state after such a high. I pondered the sadness of retreating fathers. It was during a football game. I had to write a term paper. Howls of students cheering our first touchdowns in Kenan Stadium came to me as Roman mobs emitting roars of victory. But what I really wanted was Universal Truth. I remembered how Tolstoy had Pierre ask the meaning of life in *War and Peace* and poked through the card catalog for clues. I found a card that said Tolstoy's *Confessions*. I didn't know he had written a confession! I got goosebumps.

In the stacks I found the musty volume and the first line was, "I was baptized and brought up in the Orthodox Christian faith . . . but when I left the second course of the university at the age of 18, I no longer believed in any of the things I had been taught." Tolstoy wrote this when he was past fifty, famous, and happily married with children!

"What will come of my whole life?" he asked himself. "Is there anything in my life that the inevitable death awaiting me will not destroy?"

Mankind is like a traveler, he went on, quoting an Eastern parable. The traveler is being chased by a monster and has fallen down a dry well where he catches himself on a twig. At the bottom is a roaring dragon, death. Above is the monster, death. As he holds on, two mice approach and gnaw the twig. He sees on the leaf some drops of honey, the pleasure of temporal life, which he reaches out and licks with his tongue.

In spite of the bleakness of this tale, I was seized with joy. Another roar went up in the stadium, so loud it must have been a final touchdown, and the fact that Tolstoy could be dead and be saying this to me through a half-century's divide was awesome. Not the Truth of life. Not an answer. An analogy.

I looked at his photograph on the frontispiece. He was fifty years old and had Slavic cheeks, a frown and a beard, and the blunt nose and wide, solemn mouth of a seeker who wouldn't stop seeking, he kept staring at me. I stared back, thinking he could have been my father if I had been a Russian living in that century. Since he was as egotistical and as much of a fool as Daddy I kept this line of thought going, but of course he was a Russian noble and a landowner, and Daddy, as far as I knew, was a peasant. (When I went to Greece much later, I discovered Daddy actually did own land there.)

Tolstoy was more juicy though, and openly demonstrative. They were both brought up in the Greek (Russian) Orthodox Church, which my father mocked and Tolstoy was contemptuous of but longingly passionate about. Tolstoy wanted Christianity to be true. He wanted Christ to be divine. He wanted to believe but he couldn't. His plight was mine.

Through the crumbling leather, through the tissue paper, yearning, passionate, whole-hearted, and logical, Tolstoy was speaking to me, and he wasn't embarrassed! He had all those children too, and he called them Darling and Dear, petting them and kissing them. He was both demanding and extravagant. He and his wife, Sophia, fought like cats and dogs and then made up and wrote notes of hate and love, full of Dears and Darlings. Tolstoy cried when his small son died, but at the same time he spoke and thought philosophically. He could comfort.

Our father, though, could comfort too. He loved little children and had bounced us up and down, seducing us with magic games when we were small, and once when I was eleven, before he left for Chapel Hill, I fell on my head ice skating on Niles Pond and he grabbed me up and hugged me so hard it hurt, strangling my sob before it could get out of my throat. "It all comes out in the wash," he explained.

That refrain, those words, were his Homeric hymn to life. When he said them I saw the clothesline on a brilliant winter day full of white sheets, the raiments of the immortal gods in Aeolus's winds flapping against the sky and sun. It was the nearest thing I could imagine to belief in God. They were equivalent in authority to the greatest of the

powerful Protestant (from the verb, *to protest*) hymn, "A Mighty Fortress Is Our God." Once he said them, I forgot my trouble immediately and went on my merry way.

If he did not call us Darling or Dear, he called us Achilles or Aphrodite so that we absorbed attributes that belonged to Greek gods and goddesses, marks of affection from that unknown side of our heritage, more powerful than the delightful, wicked, witty, high-minded stories he told us, which were ultimately didactic (from the verb, *Didasko, I teach*).

To the same degree as I wanted more of Wayne's rebellion against his father, I wanted more of Tolstoy's fatherhood for myself. As I had polled the high school kids, I now trolled the *Reader's Guide to Literature,* which was kept in the circular bookcases underneath the chandeliers of the library's main reading room. I needed to find out what authorities said of Tolstoy.

I read two days straight. Not one of the authorities said the same thing. Each was related but different. One tipped right, another left, one criticized his prejudices, the other called them lucid reasoning. One focused on social passions, the other on psychological validity. What a revelation! Each reader wrote from inside the borders of his own skull. Each commentary was as singular as a snowflake. There was no absolute truth. Extend this to God and it changed the course you must pursue to find your individual belief. The one could not fit the all.

Toward the end of his life, Horace Williams made a speech at his fraternity, Phi Kappa Sigma (founded in 1850), located on the corner of Pittsboro and Cameron. He was frail and his voice squeaked when he stood up. "Young men," he said, "they now have a thing called the flying machine, and when you fly over the state, you don't know when you cross the state line, and in your lifetime the world is going to shrink to the size of an orange."

The Horace Williams Airport was named after him less because he embodied the dialectic spirit of the university than because he bequeathed it that land.

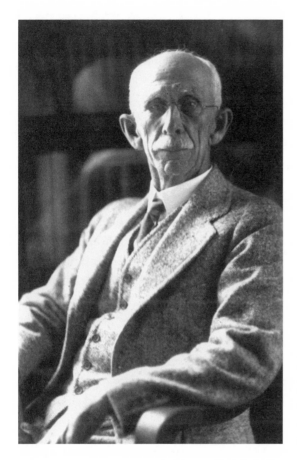

Horace Williams.
Courtesy of the
North Carolina
Collection, University
of North Carolina
at Chapel Hill.

He was a money-grubbing capitalist who was not called a Carrboro slumlord until he was dead. Always at war within him was the love of money versus the love of the ideal, though it never bothered him. It was the teacher/philosopher who dominated the university curriculum in its heyday. Long after his death, his will was dredged out of the files and it was discovered that the philosophy department was to profit from his estate, not the larger university. The irony is implicit in days when money dominates higher learning.

Pictures of Horace Williams make him look like a turkey, with a high forehead, protruding ears, and a long neck. He personified the

unlikely mix of money-shrewdness and idealism, the special legacy of Chapel Hill to the world. But he ignited his students to worship. They carried his Christianity and Socratic method into their careers as leaders, judges, reporters, teachers, and governors.

What remains are stories. Unlike many of his students, lots of people hated the old geezer. Collier Cobb, who later started an insurance company, was one. As a high school boy he'd raked persimmons in Horace Williams's yard to feed Horace Williams's pigs. He'd load bushel baskets for which he got 10 cents apiece. When Old Horace (as he became known) came to inspect, Cobb felt the philosopher's horned finger dig into his chest. "Do you call this sorry thing full? Now go back to work." Only when the baskets were so stuffed that persimmons rolled off the top did Old Horace pay, and then it took him five self-dramatizing minutes to loosen the dime from his pocket.

Persimmons went not only to the pigs but to the tables of genteel widows like Mrs. Julia Graves, Mrs. Klutz, and Mrs. Thomas who ran the boarding houses on Franklin and Rosemary streets in the Twenties and Thirties, where young faculty and professors' families often ate. The town was small, everybody knew everybody, and gossip was raised to an art over persimmon pudding and iced tea.

These stories about the older Horace Williams come from Cornelia Spencer Love's *When Chapel Hill Was a Village* and from Phillips Russell's *These Old Stone Walls*. Love tells how Horace Williams was hauled into court by the town because he wouldn't pay his water assessment. It happened when the town wanted everybody to connect to its water system. He and Bertha always hauled their water from the spring separating their place from the Umsteads — called Roaring Fountain, which didn't roar — and damned if he was going to get it from pipes and pay.

In the end, the town judge forced him to. The town ladies relished his defeat. They saw it as a story of come-uppance for his long-suffering wife. She supported him in his tight-waddery. But on the sly she figured how to circumvent him and not have to haul water in a pail any

more. Since Williams gave her no household allowance except to pay a cook, she got rid of the cook and saved till she got enough to pay the water assessment.

Although the ladies patronized her as a poor, oppressed wife, she was really hoisting Horace on his own petard. Piety went a long way in those days, and the ladies clucked in sympathy in front of her and observed under their breath behind her back that she was a rotten cook. She paid no attention, kept on painting, and those paintings are in the collection of the Horace Williams Foundation.

Now that the world is conscious that it has shrunk to an orange (not because of the pre-World War I, Proustian romance with the airplane, but because of space travel, nuclear proliferation, and the Internet), we think of Horace Williams in terms of ontological questions rather than land ownership. But since the university's female student population reached and has held a 60 percent majority of the student body for upward of ten years, questions have changed.

A reporter in the February 7, 2010, *New York Times*'s Style Section interviewed a band of sorority girls without guys drinking in a basement bar. They talked about varied attitudes toward the scarcity of men. The article generated many letters to the *Daily Tar Heel*, mostly from women, some identifying with what they took to be a problem and others who found the discussion trivial, irrelevant, and insulting, as if they were coeds of the Fifties who'd come to college for a M.R.S. degree. Chancellor Holden Thorp wrote a letter to the *Daily Tar Heel*, assuring students they were one of the greatest student bodies of any university in the country.

"What is a stick?" Thomas Wolfe had Vergil Weldon ask.

"What is music?" the real Horace Williams asked Benjamin Swalin, founder of the North Carolina Symphony when he first hit town as an assistant professor. Wolfe tried to figure it out too. Considering how much the North Carolina religious leaders hated Horace Williams, Wolfe asked: "Why do the Baptists fear this man? He has taken the whiskers off their God, but for the rest, he has only taught them to vote the ticket. . . . The ticket is monogamy, party politics, and the will

of the greatest number. . . . He is nothing more nor less than a Hegel in the Cotton Patch!"

But what does Thomas Wolfe mean by "more nor less"?

A definitive picture of Dr. Williams appears in the biography, *Horace Williams: Gadfly of Chapel Hill,* by Judge Robert Watson Winston (1860–1944) published in 1942 by UNC Press. Winston was one of Dr. Williams's students, a precocious achiever who graduated young and made a career for himself as a lawyer, state representative, judge, and writer. (He wrote biographies of Andrew Johnson, Robert E. Lee, and Jefferson Davis.) In 1924 he retired from his law practice. At age sixty-three he reentered the University of North Carolina as a freshman, to "redo" his whole four-year course. He wanted to reorient himself, he said, for he viewed his successful career as too easy and his knowledge too superficial. A version of our current attitude, *There's gotta be more to life than this.* Under the penumbra of Horace Williams's influence upon him as a youth he set out to explore Dr. Williams (and himself) in more depth.

The biography, full of the anecdotes and stories of his old age, traces the career of Dr. Williams, is sharply observant, and makes several striking assessments.

Dr. Williams, like Socrates, was a teacher, not a writer, Winston concluded. His writing was lacking cohesion — prose awkward, spirit wanting, exploration of philosophy ending at Hegel as the end-all and be-all. His writing was a failure. At the height of old age, Dr. Williams sustained himself in his belief in the universality of oppositions. But his belief had turned into a religion. It provided him an ecstatic plateau of connection to the world. He gave up his explorations of oppositions and entered a *pulpit-preacher* phase rather than the *teacher-seeker* platform. He preached the doctrine of reconciliation of the irreconcilable. His method was still questions. Questions are always dazzling in parlor conversation and on podiums directed to the confused hearts of longing listeners. People are dying for an object upon which to lavish their devotion. He was now free to rest on his laurels. He had become a parlor god.

But Old Horace was lonesome. Bertha had died in 1922. He played solitaire in his study. At age sixty-five, he fell into a late, strange romance. In the classroom "his eyes fell upon the strong, beautiful face of a young woman sitting by the side of his friend and pupil, Madge Kennette" (from *Gadfly of Chapel Hill*). The twenty-seven-year-old woman, Miriam Young Bonner, was from Beaufort County, a descendant of Colonel James Bonner, who founded "Little" Washington, NC. She had an MA from the University of California, had been a Fellow at Columbia, taught in schools in California, and was teaching at the North Carolina College for Women in Greensboro.

An ardent correspondence and social engagements led to a friendship. On her side it was "that of a daughter for a congenial, sympathetic father," and on his, the dream of "an old horse and a young horse hitched up together" (from Williams's letter to her).

When Miriam Bonner went to London to study in 1927, he followed her. "When she rejected his proposal, unable to give up losing her friendship, he proposed to adopt her as his daughter and sole heir. She consented...." writes Winston. "'My dear Mrs. Bonner,' he wrote to her mother, 'I wish to thank you for letting me have Miriam as my daughter. She brings light and joy into my life. She will not love you the less. I was very lonely, she makes me fully happy.... She will contribute in many ways to my work.'"

Williams had the adoption papers drawn up in London, and some weeks later when they returned to New York they were issued legally. Williams and his adopted daughter came back to Chapel Hill. It did not last. There were righteous complaints and plenty of gossip in town under the liberal surface. Miriam nursed him through a bout of pneumonia and when he was recovering announced that she was returning to California. "For good?" "Yes, for good," she told him, and the next decade she spent teaching in New Jersey, New York, California, and North Carolina with Women Workers in Industry.

Her absence did not end their connection or the spate of ardent, begging, and analytical letters he sent her: "You have the strange power to make me happy...." He wrote, "Dear I love you, not your body....

How our future shall shape itself I do not know. . . . I went to Duke Thursday evening and talked on Logic to the Math Club. . . . Now Dr. Emery [Stephen Emery] and I are going for tea with the Gilberts. . . . They all came to hear me in Duke. I thought it was nice."

For ten years he sent Bonner monthly checks, and when she married, he told her in a letter: "Tell your husband if he will be appreciative, gentle, and affectionate, then no man in California will have a more companionable helpmate." The couple had a son. Dr. Williams wrote: "With such a mother he has the right to be unusual."

THE HUMANISM OF the nineteenth century has receded into the past without comment, leaving a thin gray line. Who revolts? In the Age of Information, are there too many facts to pay attention to? Are the mounds of irrelevant information too thick to ferret out the question that fits? Have Treblinka, Nagasaki, Hiroshima, Srebrenica, Gaza, and Darfur killed serious hope in mankind's development?

The cyber world has made people turn their awe, reverence, and worship upon processes of fact, speed, and systems, while the general public, despite Tolstoy's bleak parable, keeps the search going, people grabbing greedily, violently, superficially, and sentimentally for the Truth of Life.

Twenty years after making the naive vow on the library steps, I wrote it into my novel, *Entering Ephesus*. If questions of humanism are as dead as the cutting-edge intellectual generation believes, I wondered why. I asked Lydia Millet — a UNC alumna, the brilliant author of *Oh Pure and Radiant Heart*, in which Robert Oppenheimer, Fermi, and Edward Teller return to earth and cruise around the West in a bus with rowdy God-lovers eating hotdogs and drinking Pepsi without complaint — but the question was moot. The book and the bus trip itself are the answer. I also asked Bibi Obler, assistant professor of art at George Mason University. "Because people believe Humanism has become treated as an absolute," said Obler. Adam Jagajewski, Polish poet, professor, and journalist, in his book, *A Defense of Ardor*, talks of

poetry as "an operation I'd call humanistic if that word hadn't been damaged by frivolous overuse in university lecture halls."

Truth is not an aggregate substance any more than human life is a fixed unity of ages and races.

Our lives were so interwoven that Wayne and I remained parts of each other's vocabularies. We could not separate even when our lives separated. While he was in the army and I in New York, through his stint in China and mine in Europe, past his marriage and family and my career, the friendship persisted because few shared such a twin-ship of literature and adolescent angst. It is documented in its lonely wonder and we still honor it. "Why is it," I wrote him once, "that analogy can be as thrilling as an answer?"

"Can it?" he wrote back.

The Finite Life of Memory

Overleaf:
Daphne Athas and co-workers,
running GI service clubs in
England, circa 1956.

Betty Smith Looks Homeward

Mothers and Writers

"I'M FROM THE North too," Nancy said in the high school corridor in 1939. "My mother is a playwright." I'd been in Chapel Hill only a few months and was a year behind Nancy in her sister Mary's class, and it turned out that Mary was to become my main friend. But I was allowed to accelerate in spring 1940 and graduated with Nancy. We tied for salutatorian. None of us knew then, in the beginning, that three years later, in 1943, *A Tree Grows in Brooklyn* would make their mother, Betty Smith, famous.

Nancy had a habit of jerking her head in spastic sync with her smile. She had turnip-yellow skin, like me, which set us apart from the ubiquitous Wasps, and the sweater and saddle shoes she wore would never make her a sweater girl. "I'm going to be a writer," she said. Since I had the same ambition, it sealed our identification.

I met Betty for the first time when I went to see Mary. They lived in the middle of three Goldilocks cottages, still quizzically ogling each other on east North Street. At the time, 1940, they were a drab olive-green and looked like tourist cabins, the motels of the Depression era.

I knocked. The door opened a crack and Betty said, "Yeah?" scowling through a cloud of smoke. Her cigarette and the single syllable hung in a suspicious half hitch.

"I'm supposed to pick up Mary."

She retreated at once as if it were the first time she'd realized her daughters were old enough to have friends. Through the crack I saw a

rangy, hollow-chested man who looked like John Ireland, the B-movie cowboy, leaning against the mantel. Bob Finch was Betty Smith's collaborator and longtime lover; they'd written more than thirty-seven plays together, according to Nancy, which made it legit rather than disreputable.

But Betty was the first mother I'd ever known who was divorced, the first mother who had a man to all extents and purposes living with her — there was no term then for live-in boyfriend, and he rented a room nearby for appearances or independence in their premodern collaborative arrangement — and the only mother who was a writer.

Mary jumped up from a sofa to open the door, and when I turned around Betty had vanished. Her smoke lingered like the smell of a bear in an abandoned cave. The ability of such a gloomy presence to disappear at will was scary. She used to walk to the post office, her eyes glued to the sidewalk as if she didn't exist. In my mind women writers didn't disappear like Circe. They weren't Brooklyn housewives with hips. They were forthright, ugly, childless, single-minded, and bluestocking, and they stood their ground, like Louisa May Alcott.

But where could Betty have disappeared to? There was hardly room for a kitchen or bathroom in the cottage.

The two girls were reticent about her. I could tell they didn't like having Bob Finch around all the time, but they never said so out loud. When you saw him in the street, he also kept his eyes glued to the ground. He drank, it was rumored, and had a tyrannical mother in Montana. Once Nancy said: "Bob Finch is the love of my mother's life." I was shocked, unable to imagine my mother with a love life but impressed by an admission capable of being so literary-sounding.

If Betty was a forbidden topic, Nancy was her self-appointed articulator. She and Mary were the two-headed dog guarding the temple gate. Nancy's anecdotes in Depression-derived lingo came straight from Betty's mouth, I could tell. Her mother got up at five to write; her mother bought the week's groceries at Fowlers; Fowlers gave them credit when they couldn't pay. In 1944 Betty used these exact words

to explain their penny-pinched life to the newspapers, adding: "You ought to be able to dedicate a book to a grocery store."

Nancy felt responsible for Mary too. She said she was going to get an NYA job (National Youth Administration, an FDR jobs program to help college students pay tuition) to set a good example even though their father, George H. Smith, professor at Yale, would pay part of her tuition. They visited him summers. Mary was lazy, not dumb, Nancy said. Mary agreed and laughed it off. She despised Nancy a little.

Mary had inherited her duck walk from Betty and was youthfully brave, a Debra Winger before the type was invented, complaining, gay, wistful, forthright, and romantic with a smoky, blue gaze that gave you a stitch in the side because the end of time floated in it.

"The more I think about it, the more I see how big a part *time* plays in the world," she wrote me at age fifteen. Having no phones, we used to leave notes along our beaten paths. "It *is* the world. . . . You see, I won't be on this earth *too* long and neither will you. Will someday the Daphne that I knew be dead long before her body? Will a new Daphne capture and hold prisoner in the soul the Daphne that I know?"

I have the note to this day, for I saved every scrap for posterity. So did Wayne. We compared the *bildungsromans* of our lives to Thomas Wolfe, Tolstoy, Horace Williams, and the Brontës. But Mary didn't save anything beyond the occasion. She even used to squander her notepaper by quoting lines of songs — "None but the lonely heart" and "Oh the sound of the Kerry dancing!" — much to Wayne's disgust though he forgave her because of the magnetism of her sadness.

She loved her name, *Mary Smith*. She launched it into the air like a kite, where afloat it became the apotheosis of Everygirl. Betty Smith was a generic name too, and the fact that she had married a George Smith first and then a Joe Jones blew our minds later, for it exalted the Common Man, a bequest of the Depression. It meant America, and in miniature Chapel Hill, because of the ideas of Frank Graham, Howard Odum, and Proff Koch. One day years later a stray dog, with long, muddy, whitish hair hiding its eyes, came to the door and Betty Smith

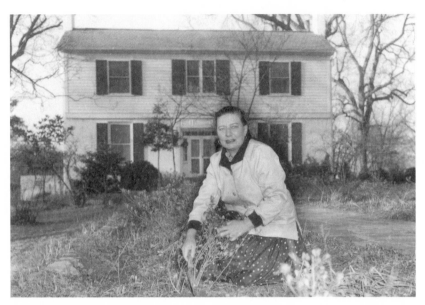

Betty Smith in front of her house on East Rosemary Street in the late Fifties.
Betty Smith Papers, Southern Historical Collection, Wilson Library,
University of North Carolina at Chapel Hill. Reproduced by permission
from Nancy Smith Pfeiffer.

fed it and named it No Name, the ultimate reduction of the democratic to the universal.

I used to go around mouthing, "Betty Smith, Betty Smith, Betty Smith"; and then, "Mrs. Smith, Mrs. Smith, Mrs. Smith," trying to call her what you called mothers. I kept this up till Mary fell in love with Walter Carroll in 1940, the year I entered the university. Wayne, Mary, and Walter were still in high school. Mary and Walter had met at the senior play, acting opposite each other in Chekhov's *The Boor.* They became the prototype for Wayne's and my mythology of love. We defined love by them.

It was the time in Walter's life when he began living at 400 Mc-Cauley Street with Brooks Phillips, a new editor at UNC Press who came to Chapel Hill after a bitter divorce. He had been professor of

literature at Piedmont College, a small Congregational school in north Georgia begun by liberal ministers. Richard, Brooks's son, came from his mother's in Baltimore to go to the university in 1940, the same year I started. Brooks was in straitened circumstances when he set up housekeeping, and he wrote Richard lovingly, describing 400 McCauley Street, making a graph to show which room would be Richard's, which Walter's, and which his own.

Brooks was bald and shy as a turtle, and, like Betty Smith and Bob Finch, he too kept his eyes fixed on the ground while walking to and from the campus. Was there something about literary people, I wondered, that caused them to be divorced and pretend invisibility?

Richard was tall, blond, and disciplined, a Nordic presence next to his father for whom he always showed a respectful affection. Brooks was quiet and benevolent, a slightly embittered, intellectual dreamer-poet who presided over the household, and became like a mentor to Wayne and me.

Walter's sister, Loretto Carroll Bailey, had arranged for him to live with Brooks. She had fallen in love with one of Brooks's former students, her marriage to J.O. Bailey having come to an end. She and her new lover were leaving town, so Walter needed a place to stay.

Loretto was quasi-famous for two Southern protest plays, *Strike Song* and *Job's Kinfolks,* which Playmakers staged in New York under the auspices of the Federal Theatre Project in the early 1930s.

She and Brooks were part of the wave of poets, writers, photographers, and documentarians of the Appalachian poor which included James Agee (*Let Us Now Praise Famous Men*), Erskine Caldwell (*Tobacco Road*), and Lillian Smith, a student at Piedmont in 1916, who in the Forties won fame for her novel, *Strange Fruit.*

Wayne and I alternated between the masculine house of writing on McCauley Street and the feminine house of writing on North Street. We were unaware of that masculine/feminine dichotomy at the time, though. Living at home, free to stay up till all hours at 400 McCauley, was irresistible. It was the opposite of my freshman classes in which I was the only girl.

At Brooks's, I was still the only girl, but the masculinity was ardently literary, independent, serious, irreverent, and surprising in its graciousness. It made no restrictions on the attractions of sex but Brooks somehow sublimated that thrill into the thrill of literature. It was there I learned to be in love indiscriminately with Richard, Wayne, Walter — all three at once — with Brooks encompassing the deity. He was interested in all our writings, and we often read papers or poems out loud.

One Saturday night Brooks called my poem "feminine." I'd never thought of writing as having a sex, and I was mortified and resented it. Yet, against my will, I felt pleased.

Walter came in from a date with Mary — Betty expected her home by eleven. He showed us his latest painting. Desperate, thin, dark, he played his guitar with a blend of Heathcliffian arrogance and hurt which made us sing along with him passionately. After midnight Richard came out from studying and drank wine with us. He talked about Walter's latest play. He knew how to flatter Walter with praise laced with criticism and treated him as a younger brother.

Walter and Mary's romance was tortuous. One minute Walter was going to build a log cabin where he and Mary would live forever while he chopped wood; the next, jealous or feeling slighted, he was going to leave forever and get a job on a Chesapeake Bay oyster boat. He made eloquent avowals in the rhythm of Thomas Wolfe: "Then come. My great dark horse, come! for we are dying in the darkness and we know no death . . ." etc.

Richard believed Mary was a questionable influence on Walter. After awhile Mary sensed his wariness, so Wayne and I became her anchor point. Betty also was considered a threat because she called the curfews. Why, we wondered, would a person living in sin want picket-fence respectability? In one of her notes Mary wrote how Walter came and got her one night from the library to go to Danziger's, how they sat in a back booth listening to "La Paloma" and drinking cider, and how when she got home, she lied, told Betty that they had been at Danziger's not alone, but in the company of Dutch Poe and Decatur Jones

too, "only to find out (from Betty's) icy tones that 'Decatur had come by,' requesting my whereabouts. P.S. The cider is very good at 10 cents per glass."

Walter resented but deferred to Betty. He was susceptible to mothers. Betty was in thrall to him too, for what more passionate boy-playwright could her daughter hope to fall in love with? Behind her scowl Betty understood love with dark sympathy. She hadn't gotten along with her mother either, according to Nancy, and had left Brooklyn and even then hated to go back to visit. She did, though, as a duty.

The general opinion at 400 McCauley Street was that Betty was a Depression hack. She wrote plays for money, birthday plays, Christmas plays, second-grade plays, which Samuel French published.

Who'd want to be that kind of writer? We were reading stuff like *War and Peace, Jean-Christophe,* and *The Last Puritan.* But our stock rose in inverse proportion to our condescension. She could not have been aware of our opinion, for she began viewing me and Wayne with favor. Perhaps she thought we were a steadying influence in her worries about Mary and Walter. Despite our posturing we were flattered. One evening she invited us to North Street to read us Thomas Wolfe's *Only the Dead Know Brooklyn.*

She never knew what to say. We never knew what to say back. She had baked something gooey, cookies or candy filled with chocolate and nuts, which she brought on a platter and set next to Wayne as if he were Old King Cole. He became glib immediately and gobbled till the pile disappeared.

Betty's scowl, I saw then, was not some vast anger, but a permanent *weltschmerz* learned unconsciously from her immigrant grandparents who came from Bavaria. I recognized a similar knowledge in my father, whose wrinkles also were as horrendous as God's. Aging Wasps become venerable, but aging foreigners turn into monoliths of wrath or sadness. She had swarthy skin and a ripe, strong mouth, and her nose rose out of her hair and scowl to command thick cheeks. Her upper lip was dusky, her trembly growl beat the essence of Brooklyn into

Thomas Wolfe, and I almost felt sorry for her, eyes glued to the page, vulnerable to our merciless examination.

The story tells of a half-soused giant of a man (the Wolfe persona) in the subway, asking directions to Eighteenth Avenue and Sixty-seventh Street. The narrator, a Brooklynite, says: "It's in Bensonhoist." The giant has a map which causes the narrator to think: "Duh guy is crazy!" The story is in dialect.

There's a lot of place-naming: "Canarsie an' East Noo Yawk an' Flatbush, Bensonhoist, Sout' Brooklyn, duh Heights, Bay Ridge, Greenpernt. What's he want to go 'deh' for?"

The giant says he wants to walk around. He's already walked across the fields to where the ships were and gone into the Red Hook Bar. The Red Hook Bar's "a good place to keep out of," the narrator warns, he might get lost. "Whatcha gonna do wit a guy as dumb as dat?"

"No I wouldn't get lost. I got a map," says the giant and then asks the narrator if he can swim. The narrator says he got pitched off the dock when he was eight years old and learned.

"What would you do if you saw a man drowning?" asks the giant. Jump in and save him, the narrator answers, and tells how he saw somebody drown once at Coney Island.

"What becomes of people after they've drowned out here?" the giant asks. "Where?" "Out here in Brooklyn." "Yuh can't drown in Brooklyn. Yuh gotta drown somewhere else, in duh ocean, where deh's wateh."

The giant keeps saying, "Drowning. Drowning," until the narrator gets off at the next stop. "'Drowning,' duh guy says, lookin' at his map. . . . Duh poor guy. I got to laugh at dat. Maybe he's found out by now dat he'll neveh live long enough to know duh whole of Brooklyn. It'd take a guy a lifetime to know Brooklyn t'roo and t'roo. An even den yuh wouldn't know it all."

We didn't think much of the story — it didn't go anywhere — but we were hypnotized by her Brooklyn syllables and on the way home tried to make Chapel Hill names do that. Franklin Street and Cameron Avenue were mundane. Gimghoul was so good it sounded fake. Battle-Vance-Pettigrew (dormitories then) made a warship on the

grass. Old East. Old West. South Building. Why wasn't there a North Building? we wondered.

The utterance of these names set us hungering, for the story had the ocean in it and I had come from the ocean originally and wanted to get out of this stinking dump and go back. Wayne had never seen it and he wanted to go too, but we were trapped. No money.

On Friday nights, Playmakers put on productions of original plays, to which all the townspeople came. Betty Smith was often a judge. At one Friday night Original Plays, Betty put her Fowlers' grocery bag on the floor by her seat, and when she returned it was gone. She ran up the aisle, her face red, a vein in her temple pulsating. She looked as tragic as a gypsy. Has anyone seen my groceries? she asked no one in particular, about to cry. Her breath sounded heavy, sort of a frightened snorting. Proff Koch announced the (theft?) from the front. I felt a hysterical laugh, for I'd been typing graduate theses (10 cents a page) for tuition money, and sometimes I'd buy a sandwich at the Y for 10 cents so I could steal a candy bar when the clerk's back was turned.

The next Tuesday when I went to the house, Betty was ironing a blue denim skirt, squinting over her cigarette, letting her ashes drop, not noticing, and pressing them into the hot blue cloth. Had they gone hungry, I wondered.

Mary wanted to show Wayne and me a secret place she had discovered. It was called Coker's Hill, and we had to promise never to tell a soul. To get there we had to trespass on Old Man Coker's land — he was the botany professor who lived in the mansion across North Street. We climbed over his stone wall into a path overgrown with Tarzan vines that hid us from the mansion. The path led downward to a barn where, Mary warned, there was a horse, and if it whinnied, we were dead. She led the way. The horse wasn't in the barn; it was in the field standing against a barbed wire fence. It studied the wire perplexed, patient with its brown eyes, trying to figure out how to get out. It looked up, so we crept past quickly and threaded our way through some honeysuckle to the far end where we dropped to the ground, stuffed our laughter into the leaves, and rolled under, triumphant at

having fooled it. We followed the path into a ravine until we came to the edge of the woods.

Before us rose a bare hill.

"Here it is — Coker's Hill!" whispered Mary.

It was a crown of grass like the Wyeth painting where the girl crawls upward to infinity. Not a tree nor a bush, nothing to separate us from the sky.

"Now keep your eyes on the sky," Mary said. We did, placing our feet on the cool velvet grass — nothing but the sky before us — climbing, one footstep after another. We raised our arms for wings. Each step elevated us to a new frame of vision, different from the one before, like being on a ladder to heaven. It was overwhelming, the ozone. We wanted to scream.

Instead, on the top we sat and breathed. Mary said she and Walter always brought the Victrola and played the "Italian Street Song." Wayne said Beethoven's Fifth would have been better. Coker's Hill reminded Mary of what she called her "Top of the World" poem. She quoted it and later wrote it down in a note to me:

Oh gallant heart defeated
Now gazing toward the west
Where this day's splendor crumbles
Disastrous and unblest
Look — till deathlike darkness
By stars be glorified
Until you see another dream
Beyond the dream that died.

The prospect was actually to the north. It turned out the secret was universally known — Ouida Campbell showed Coker's Hill to Wayne and me a year later on a picnic with six of her boyfriends where we drank (beer). We never let on that we had been there before and felt shame.

The fact that this was the only place in Chapel Hill (other than the Seat at Gimghoul) where you could see infinity made me nostalgic

again for the ocean. Names were like leaves. They beckoned, yes, but they blotted out the eternal.

With sky Mary became inspired. She swore she would get out of this hell hole and go to New York and stand in Times Square and shout her name. She urged us to go with her or meet her there.

"Let's us go, Wayne," I said. "We can hitchhike. To Gloucester, to the ocean."

"Yeah! Fall break!"

"My God! I'll be at my father's in Shelton. You can stay with me!" said Mary. "I'll meet you at the New York Public Library by the lions!"

Incredibly, my mother in reaction to her Victorian upbringing of chaperones and funerals encouraged us. She believed "young people need adventures."

A month later with $20 apiece (some of the money I'd been saving for tuition), Wayne and I walked to the top of Strowd's Hill and stuck our thumbs out. It took us a day to get to Norlina. At dusk we sat on a stump in a field where some railroad tracks stretched parallel to Route 1. A black woman came out of a hovel and gave us some greasy sausage and watched us chew each bite, her children peeking from a distance. "Where you gon' sleep?" she asked, indicating her haystack.

It took us two more days to get to New York. In those days you had to go through the center of every city on Route 1, hours of lights, stops, traffic, losing your route sign.

In the grinding cab of a trailer truck at sunset the New York skyline emerged pink and fearful through Jersey gas-fog. Night fell and a million square eyes of skyscrapers testified to a trillion people behind them, which sucked the yolk right out of our souls. We were deposited, anonymous, under the screeching *Om* of the El with a night to spend before our appointment with Mary.

The problem became where to sleep. We knew bums slept on rattling subway cars, so we tried it, taking the line to the Battery, and the ferry in the middle of the night to Staten Island, washing the filth off our hands in the salt water of New York Harbor (no horizon at night),

and then back, to Saint Patrick's (the name *cathedral* promising God and asylum) where there were shelves of concrete outside the gothic abutments. But it was cold and we fell into phantasmagoric dreams.

"Wake up! The cops are after us!" I shouted to Wayne, and we ran, escaping into a porn movie on Forty-second Street where in the audience silhouettes of men wiggling under hunched shoulders moved toward us like spiders. The porn was worse than the police. "You dreamed it," Wayne said.

Next noon in a chilly wind and frayed, we awaited Mary (in the reading room, not by the lions guarding the main doors; it was too cold) as a savior. She was dressed to kill, with heels. We wanted to leave for her father's immediately, but she had to visit her grandmother in Brooklyn.

We followed her into the subway and came out on a broad avenue blowing with gum-wrappers. People scurried by. Was this Sout' Brooklyn, duh Heights, Bensonhoist? It was as sad as the end of the world. This North was not my North. We came to a building where we climbed a flight of stairs to a dark, nondescript apartment that smelled of fishballs and had lace doilies, upholstered chairs, and gewgaws on a sideboard. The clock ticked.

Mary disappeared down the hall and while she was gone we heard voices in back. We were dying to collapse into the fat furniture and sleep, but didn't have the guts, and the moment we decided to, Betty's mother and sister appeared. Neither one resembled her. The old lady had dun-gray hair, the sister henna, and they acted perfunctory, treating Mary as if she'd been there only yesterday. They were polite, but stared at us with flat eyes and talked with flat voices. There was something unspoken, off limits. They didn't mention Betty.

The old lady brought some tea and laid it on the polished table with old, white hands, much whiter than Betty's. Both acted as if we were non-persons, like baggage that has to wait till it's taken away. The old lady left Mary to pour the tea and disappeared down the hallway without trace. (Two years later, reading *Tree,* I could make no connection between this woman and Katie Nolan.) The cookies tasted like

manila envelopes, and Mary laughed a lot, her husky voice curling at the corners. We left as matter-of-factly as we'd come. Out on the windy boulevard Mary said: "I'm always glad to get out of there."

This trip was the dividing line of our lives, for we accomplished what we'd set out to do, gone North, seen the ocean, lived on it a week, and done it on our own. If we could hitchhike, we could do anything. Friends looked at us with new respect.

Four months later I was driving my father's laundry truck along Cameron Avenue and saw Nancy walking. In a reversal of hitching, I picked her up. "My mother is writing a Pulitzer Prize novel," she informed me. I oohed and aahed but secretly thought, "What else is new?" and reported her boasting to 400 McCauley that evening.

Nancy was always calling Betty's play, *So Gracious Is the Time*, a classic. It had won a prize. It was a Christmas play about abortion, with lines like, "Nobody's old lady ain't giving nothing away. So if a fellow wantsa live, he's got to look out for himself." "O Holy Night" was the background music at the end when the couple argues on the cold New York sidewalk in front of the abortion clinic. The girl says: "I will be happy all my life if I have a child." The young husband answers: "People like us have the right not to have children"; but she says: "No one wanted me. I was born. I didn't ask for the feelings that made me love you. No one ever wanted to know when I was hungry. . . . But it's my right to have children." He (with the stage direction, bitterly): "It's the only right the poor have."

Wayne and I were defining ourselves by the literary parent houses of McCauley and North streets. We were torn between theater and prose. The syllabic rhythms of the Depression theater which suffused us were what Arthur Miller in *Timebends* calls "the thrilling lyricism of the thirties." We believed ourselves to be radicals but were sixteen when the stagnant Depression began to blurp with the bumbles of war.

In fall 1941 when Mary and Wayne started college, the only thing Wayne and I could rail at with impunity was the fakery of the Playmakers — we both admitted that we preferred prose, even though the

drama of Walter's eloquence and Betty's profession were alluring. But we liked to curse our destiny at being so damn poor we had to work for every cent of our tuition.

We didn't have enough money for vacation. At page 100, I quit the purple novel I'd started in high school about growing up by the ocean and showed to Wayne and Ouida — who under the influence of Ellen Glasgow's *Barren Ground* gave it the title *Strange Ground*. I had gotten a thesis to type for money; Wayne read 206 books in Ab's — the Intimate Bookshop started by Milton A. Abernethy in the Thirties — and stole 38; Walter painted an oil of the potbellied stove of 400 McCauley; and Mary started a note to me which turned into a 21-page volume she gave me, along with a pair of gloves, on New Year's Day. Its entries defined a fate we had not anticipated, for we had no idea the Japanese were about to bomb Pearl Harbor.

> Dec. 4. I drempt [*sic*] last night someone was trying to take something very dear to me. When I finally woke up I realized it must have been Walter. I know I love my mother very much; but never have I drempt that she was being taken from me. Is it because I am sure my mother will always be waiting for me? Is it because I am scared Walter will not?
>
> Dec. 5. Walter and I are in a tiff again. What about I don't know. I intend to ask Richard today. Today's paper states that the Japanese American Situation is on the verge of Total Collapse. I wonder what will happen if the United States and Japan go to war.
>
> Dec. 8. The days have slipped by so fast what with the attack and consequent war with Japan. . . . I don't ever want Walter to get mixed up in it for fear things would never be the same again if he did. . . .
>
> Dec. 9. Oh what's the use of talking. I'm so scared of something that is beyond me.

As it turned out Walter was rejected by the army as 4-F, psychological. Richard went into the navy V-12 a few months later as a pre-med student, and Wayne into army pre-med in the ASTP. The reality of war, with civilian students disappearing, the taking over of frat houses by military, the navy preflight school, French cadets, uniforms, new

*Artie Lavine,
inscribed "To All My
Favorites — With love,
Artie."*

buildings in construction, created a brew of possibilities. America
needed us. There was a hiatus before anyone had to report to boot
camp.

By spring break our group had money enough to get to the ocean,
but only to Charleston, and South was not North. Mary wanted to
come. She was scared though, so I overrode her objections with glow-
ing tales about hitching, and Artie Lavine suddenly decided he wanted
to come with us. It rained. Not till noon the next day when the clouds
finally cleared and a cold wind sprang up, did we move, and then it was
too late for Mary to tell Walter or Betty, so she left notes.

Hitching with four is different from two. By late afternoon we'd
only gotten rides enough to get across the border into South Carolina
at a wide space in the road called Moncks Corner. We sat by the edge
of the road improvising insults on that name.

"I wonder if monks live here. No. Monkeys. It's a swamp. Rednecks live in swamps. Red-necked monkeys, red-bottom baboons. Celibate in Bible-land. Rednecks with baboon bottoms celebrate in Bottom-land," Wayne riffed, relishing his derision of Southern trash since he'd risen out of it. Mary and I laughed inanely. At his cleverness. A pickup truck came by, slowed down, and did not pick us up. Artie disapproved of bad-mouthing lower classes and a split opened between us. It dawned on Mary what she'd done in leaving home. She was afraid of Walter's reaction. She was discouraged. I could feel Wayne vacillating too. But Artie, whose ambition was to be a famous photographer, was determined to take pictures of the Battery and eat at Henry's.

Dusk came and the wind died down. We'd been in Moncks Corner three hours, and at last, there came a bleat of tires. The police car slowed down and a cop leaned out and asked where we were going.

"You all better get in, you'll never get a ride this time of night, and we'll take you where you can get warm."

"Where?" we asked, petrified of his treacly smile. "The 'town hall,'" he said. It turned out the town hall was a large room with wooden floors smelling of Lysol, with wooden benches like a gymnasium and a jail cell at the end. But they didn't lock us up.

"If Walter and my mother knew I was in a jail, they'd die!" Mary said.

At 2 AM the police brought in an old cave-chested drunk with wisps of gray hair who cottoned up to Mary. "You sure are a pretty little old girl." He drooled and said he had tuberculosis. He was carrying a white box with holes in it, and Mary asked him what was inside.

"A bunny rabbit."

It was a big, dirty-white rabbit with pink, broken-down ears, and there was hay in the bottom of its box. Mary, delirious with joy, asked to take it out of the box, and the cops flocked around to watch her play with it. One cop even went out to pick some crabgrass for it to eat.

At 4 AM the old drunk gave it to her. A present. Which meant how could she hitch with a bunny? And how could she give the bunny up? Wayne conspicuously squandered 10 cents on Nabs and said if he'd

had the money for the bus he could-have-would-have carried her with the rabbit back to the Hill on Trailways.

"Whoever entertains the idea of turning back, that person will never accomplish his goal in life," I warned. I stressed the word *entertains*. I didn't expect Mary to have ambition, but Wayne was different. I wanted him to have ambition like I did. Come hell or high water I was going to make Charleston, and Artie was too, because we were the type of people who did what we set out to do, whereas Wayne even with his steel-trap mind was an endomorph with a temptation toward sloth. He agreed that he lacked push in our sense, but at the same time he said he puked on Puritanism. "Our destiny is on the line," I said.

At dawn Mary counted her money. Between her and Wayne there was enough for the bus, so we parted ways, Artie and I jeering them as quitters and sybarites. As the cops took us out to the edge of town in a patrol car, we caught one last view of them, lined up in a row — Mary, the box, and Wayne — waiting for the bus, smiling.

Artie and I made it to Charleston. We ate crab soup, the cheapest thing at Henry's, but the heart had gone out of us. It was freezing cold, and we disapproved of slave markets. Only a handful of Gullahs with baskets were there. Artie took pictures of the water off the Battery and we talked about how when we got back we would gloat.

But the caw got stuck in our throats because it turned out that Mary'd had hell to pay, not only from Walter, but from Betty who'd been taken sick with kidney trouble and put in the hospital. The radiator had broken down, Nancy said, and tactfully added that everybody considered me the ringleader. Mary'd been forbidden to keep the rabbit, and had to take it to Hogan's farm where she could only visit it.

"Ringleader!" I moaned to Wayne. He pooh-poohed the whole foo-foray, but once Walter got it into his head you were the enemy, I knew that was the end of my friendship with him. So for days I lay low, praying not to run into him.

A week later near Bynum Hall I saw Betty coming down the Playmaker steps. It was raining. On the wet asphalt she looked like a lone

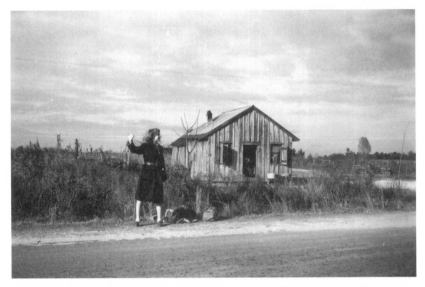

Daphne Athas hitchhiking. Reprinted by permission from photographer Arthur Lavine.

duck. I would have slunk away but it was too late. She'd seen me. I knew she wanted me to come get under her umbrella.

"When Mary disappeared last Thursday I was very worried," she began in her low, tentative voice. You could talk back to your own mother, but with other mothers you had to be polite, and her rhythm was picking up. "Just leaving that note. All I could do was imagine the awful things that could happen to her out on that road."

I began to feel somewhat sorry, because she stared beyond the umbrella lid to the gray sky beyond.

"Walter didn't know where Mary was either, and only Nancy was there. That night I woke up and looked over at the radiator in the darkness, 'cause there was no way to get in touch, and when I reached out, the radiator was busted, stone-cold. Water leaked all over the floor in a puddle."

I ratiocinated that she drank as much as Bob Finch, and that's why she got kidney trouble and ended up in the hospital, but it was the word *busted* that broke me down. Tears or laughter, I didn't know which.

"It was so dark, the only light was the incandescent hands of this little clock on my windowsill by the curtain, and it was freezing," she continued, still not looking at me. "And suddenly I felt this terrible pain, I couldn't get out of bed, was doubled over. And No Name started crying, so I called to him."

Something located behind my shoulder blades made me almost blurt I was sorry, but I knew it was because she, who'd once thought me worthy of reading Thomas Wolfe to, would henceforth not.

"I ended up in the hospital. Nancy tried to get somebody to fix the radiator. Nobody would come. I kept thinking of Mary out there, God knows where." She paused. "I know you didn't realize, why should you, and Mary didn't either, but she shoulda thought how worried a mother would be."

Because of the piled rhythm, her speech seemed momentous. Whether her scolding was a gift or sheer self-absorption, it didn't matter. I knew from my father, who'd come to America at age sixteen probably, that I was witness to the self-circumscription (indifference) of a loner who expects nothing and blames nothing. I was catalyzed by inspiration for I was an agent in her chapter of ritual and she was some sort of giant. She'd had to quit school at fourteen, when her father died. She'd gone to work. She'd made her way in the world, stood in a hall outside a classroom to get an education, and now the words she used had nothing to do with personal feelings against me, but everything to do with impersonal fate.

But perhaps she did sympathize, for she gave me a sidelong glance and said: "I hear you're writing a novel." This remark felt to me like a mark of bestowal, like the flick upon the shoulder of the knighting sword.

In 1943 when *Tree* came out, I rushed home and told my father: "Guess what! Betty Smith's written the biggest bestseller since *Gone With the Wind* and 86 million copies are printed and it's going to be translated into twenty-seven languages. And she's made $175,000 already!"

"Well, good for the Jews of Brooklyn, Lon-G-Eye-Land, New York!"

he said, less in the spirit of anti-Semitism than of Greek chauvinism, for the motto, "It takes a Jew to beat an Arab, but it takes a Greek to beat a Jew," was a twist on reality. That day our electricity had been cut off.

"She's not a Jew!" I said. "She's a Catholic."

"If she's a Catholic, I'm a Jap."

"She is too! Her ancestors are from Germany and her real name is Elizabeth Wehner, Nancy told me so!" I'd seen the name in the Michigan literary magazine when she'd won the Avery Hopwood Award, but I never got straight till she was dead that on both sides her heritage was German, for she herself at times claimed Irish heritage as well. "And I happen to know they go to Mass!"

He laughed for the next three days. Other people assumed she was Jewish too, but well-mannered Chapel Hill put it sophisticatedly in dependent clauses. There was a sense of amazement. The quickness and dimension of her success were staggering. It was a phenomenon similar to a rock star today.

The novel I'd started after having ditched the purple *Strange Ground* was almost finished. I called it *Eastern Point*. But Wayne and I were shaken. At 400 McCauley, awed now, we wondered if we'd been too dumb to recognize that Betty Smith was a great writer. If not, why had she shot to fame? We were earnest about this question. Sure, you couldn't help crying at Sissie Rommely and Johnny Nolan, two of Betty's main characters in *A Tree Grows in Brooklyn*, but was it art, or were new definitions necessary? Her phenomenal rise showed that writing could change your life. It had changed a person who'd had her groceries stolen, and it would change ours too.

So, after I finished writing my novel, *Eastern Point*, I asked Betty Smith to read it. I was the person whom the Chinaman had saved and the Chinaman is responsible ever afterward. She said she was too busy.

She was being interviewed on national radio, going to New York, to Switzerland, being quoted in national newspapers, talking to Elia Kazan about the movie version. Nancy said her mother wanted Lloyd

Betty Smith (right) celebrating in New York with daughter Mary, Walter Carroll, and Richard Phillips, about the time A Tree Grows in Brooklyn *was published.*

Nolan to play Johnny Nolan because she'd always loved Lloyd Nolan. He was her favorite actor, and she'd marry him if he knew her or asked her — but he was too old. Then she saw James Dunn cry in a movie and she knew he was the one, even though the studio was afraid because he was an alcoholic. But he stopped drinking and played it, and his career skyrocketed.

She was writing an article for *Pageant* about how she saw a man on the subway reading *Tree* and asked him about it. He said his one dream was to meet the lady that wrote it, and when she said she was that lady, he told her no, she couldn't be because that lady wouldn't be on a subway or look like her and be talking to him.

I was stunned by her refusal. A Uriah Heep of awe, I contemplated my opportunism and cringed. Why had I asked, taken advantage of her changed position in the world? Newly wise, I sent it to Houghton

Mifflin and got the rejection back in a month. I read it in the back of the laundry truck, my mother driving, my sisters on each side of me. The novel showed promise, it said, and went on to discuss the characters by name. It urged me to send them my next novel. I was devastated. But a week later I prided myself that it hadn't been a form-rejection. Besides, there was a lot more to worry about. I was graduating from college.

Betty Smith and Paul Green engineered a scholarship, named for Kay Kyser, for Walter to enter college in playwriting, and in May 1943 just when I was leaving town Walter and Mary were getting married. A fairy tale had ended and heartbreak was to come.

The next two years, when I was working in Boston and New York, the literary scene in Chapel Hill changed. Under the influence of Betty's success, nobody defended folk plays any more. Proff Koch died of a heart attack swimming off Miami, and Paul Green mustered nationwide support for tourist pageants called *symphonic dramas.*

Playwrights like Foster Fitzsimmons and Josephina Niggli started writing novels trying to be bestsellers like Betty, and novelists like Noel Houston and James Street moved to Chapel Hill. Walter went to Yale Drama School in the same class with Julie Harris, and Mary had a baby.

In 1946 I came home to finish the novel I had been working on since *Eastern Point* had been rejected. The new work didn't have a title.

Much had changed. A telephone had been installed, an anomaly, in our Shack. Wayne was still in St. Louis. A new four-year medical school was being planned for the university; appropriations came through in 1947 to build a hospital. (Up to this period the medical school had been a two-year institution.) When Wayne got out of the army, he planned to spend his first year on the GI Bill, if he could get accepted into the two-year med school. Half the time Chapel Hill felt like retread even as the rush of GIs came crowding into town. The atmosphere felt old one day and excitingly new the next. With new friends mixing with old familiar ones we understood we were teenagers no longer and these, the early twenties, are the years when artlessness drops off and friends start being alone with their destiny.

Walter and Mary came back. Finished with Yale, Walter got a job with the *Durham Herald* as a reporter, but he was constitutionally unable to stop his wild and wandering ways, searching and drinking with intensity, and Mary went into hermithood just as Betty was coming out of it. Brooks moved to Washington, Richard was at NYU Medical School, and 400 McCauley was disbanded.

One day the phone rang and the voice said: "Hello, this is Betty Smith." Her growl was so familiar I slid back to childhood again. "I hear you're writing a novel. I'll read it if you'd like me to."

Remorse, second thoughts, or retrenchment? For the first time in my life I called her Betty. I said, "But, Betty, it's only half done!"

I walked up the unfamiliar flagstone path to deliver the manuscript. While I'd been gone, Betty had bought the old Mangum house on Rosemary Street. "Go save it from being a sorority," someone had told her. She'd gotten, not the picket fence, but a neighborly stone wall, and she'd planted the tree she'd vowed to plant every place she lived.

Despite the old Chapel Hillians' groans at the architect's changes, the designers' colors, the inappropriate, pretentious Georgian garden in back — "Old Mrs. Mangum must be turning over in her grave" — they'd claimed Betty Smith for Chapel Hill. She told the papers: "When I first came to Chapel Hill I got off the bus and saw the dogwood blooms, and when my daughter asked me, 'How long are we going to stay here?' I said, 'Forever.'"

Nancy opened the door. She was down on a visit from New Haven. She took me on a house tour and just as we paused at the threshold of Betty's office, the generic writer's study, white shelves, new books, I heard the click of No Name's paw nails on the hardwood floor of the hall and turned to find Betty standing with a bunch of carrots in her hand. She didn't know what to say. I followed her to the living room where she showed me the foreign editions of *A Tree Grows in Brooklyn*.

I never saw my manuscript again. It still had no title. She gave it to Jessie Rehder, the scout for Appleton, who gave it to Ted Purdy, my future editor, and they asked for an outline, and a year and a half later in

1947 it was published with the title *The Weather of the Heart,* a quotation from W.H. Auden. The title was the inspiration of George Davis, an influential editor of *Mademoiselle* and *Harper's Bazaar* who started February House, the communal place in Brooklyn where Auden, McCullers, Jane and Paul Bowles, Benjamin Britten, and Gypsy Rose Lee wrote their books at different times in those days.

From 1947 to 1952 when Betty was trying to live up to her role as Chapel Hill's success, she claimed no role in helping me start my career. She never spoke to me of money, agents, or work. But behind the scenes I saw that she was a hidden catalyst (a benign Miss Havisham) of my life, a cross between doyen and mascot. She introduced me at a Bull's Head tea.

The literary great white father was still Paul Green. Betty imitated his Southern accent once saying how shocked she'd been when she first came South to hear him say that people called him an *impo'tant* man. She couldn't see why he'd let a rumor like that proliferate.

Bob Finch was no longer around. What had happened to him or why I never knew, and soon Betty married Joe Jones, a writer on the *Chapel Hill Weekly.* The newspapers presented it, quoting her, as the perfect romance. She'd written to compliment him on an article he'd written about the army and he'd answered back suggesting they meet near his base at Norfolk. She went, they did, and bang, four days later, marriage!

In 1950 there were weekly meetings of the Chapel Hill writers at Paul Green's house. Walter and I were invited. Joe drove us in Betty's big black car. Her scowl, clicking off and on in the passing street lamps, made her presence more palpable to me than at any time since North Street. The tires bleated, the darkness was fraught, and we were rolling, rolling. Walter's sarcastic, glittering eyes caught mine. She called Joe a "birdwatcher" and said wryly he wasn't interested in anything but birds' nest eggs. Joe smiled good-naturedly, but Walter and I felt the tide of our childhood rise up threatening to overwhelm us.

Paul came to the door, looking like a black falcon disguised behind his cracker-barrel voice. At our third meeting Noel Houston read a

chapter from his novel-in-progress. It was from the viewpoint of a nine-year-old boy watching an eleven-year-old girl climb a tree, her underwear flashing in the moonlight. "See what I can do!" she shouted from the top, and she mounted the trunk and rode the rough bark down slowly in a delicious paragraph punctuating her precocious orgasms all the way to the bottom.

Noel, the Dylan Thomas of Chapel Hill, fat, sensitive, drunkenly raunchy but minimally poetic, was in disgrace. Paul was shocked, Betty disgusted. She didn't want to be responsible, she said, rounding me and Walter up outside, for exposing young people to such booze and dirt. So Walter had to pretend he wasn't a boozer, and I that I was pure as driven snow and not slurping up every gory detail. That was the end of Walter and me and the writers' group.

Betty functioned in two major modes: writing as behavior and motherhood as habit. She took on the role of mother-advisor to the university's writing courses, honored, she told the newspapers, to be invited to teach. Her candor, misunderstood a lot of the time, turned out to be shrewd, for she knew truth makes people think you're joking, the more so when you're earnest. *Tree* forced her life into expansion, motherhood syllogized into writerhood, Success as Specimen. If I can, you can. She dispensed hope and habit. Pay attention to things and conquer.

"Is it possible to teach creative writing?" she was asked in an interview.

"Yes, but if you are too scholarly, if you know too much, you get in the way of the writer. Of course these writers here [Chapel Hill] have had the full college course. But they write in spite of it, not because of it."

"What books do you suggest your students read?"

"If you want to write like, oh, some modern person, like Salinger (I don't like him), read Hemingway. But if you do read people like Zane Grey or the quick writers, you write confession stories. Read better than you write." She told how she was trying to read *War and Peace* then, but couldn't get through it, but that people should read *Crime and Punishment* because it had plot. She was weak on plot, she said.

About the writing of *Tree*:

I didn't write it the way it happened, I wrote it the way it oughta have been. Thomas Wolfe went to Brooklyn to write about North Carolina. I came to North Carolina to write about Brooklyn. But when I first read him, I knew he'd gotten Brooklyn wrong. He didn't know it and I did.

She continued her bittersweet track with *Tomorrow Will Be Better* in 1948. But she took a beating for *Maggie Now* in 1958. Reviewers had turned sour on her insistently autobiographical fiction. With *Joy in the Morning* in 1963, though, she turned it astutely around and the U.S. State Department ordered thousands of copies for distribution in the Third World because of its portrayal of the passion for learning. She wished she'd written them in reverse, she said, publicly wistful.

In 1952 I went to Europe, and when I returned I lived in the North. When I came back to Chapel Hill in the mid-Sixties the signposts I had grown up with were there still, ubiquitous, but the messages were unfamiliar. Coker's Hill had disappeared, not because of speculators, but because trees had grown up upon its baldness and made it no more a bare hill from which you could rise to the sky. The old campus was the same, but incomprehensible.

Mary and Walter were divorced, married to other people. One or another of their grownup children used to come and stay with Betty. Their son Johnny was the spit and image of Walter, but a ghost version. In *Wuthering Heights,* Catherine Linton and Hindley Earnshaw are watered-down copies of Cathy and Heathcliff. Were Nancy and Mary then the split cells of Betty? What did the fission of an archetype mean about replications? The word *fission* glaring up out of the Hiroshima headlines at Wayne in New York has influenced all thinking since. Is Borges right about multiplicity?

One of the traps of memory is that it ignites one's loyalties to activate a formative vision. Whenever in the later Sixties I met Betty at elegant dinner parties, it felt like meeting one's private elephant at Hallmarks. I had an obsession to prick through the hide, to make the

eyes on each side of the trunk recognize — not me — but the universe I occupied with her. I wanted to name it.

She had divorced Joe Jones in 1951, and in 1958 married Bob Finch. It was the happiest marriage of her life, according to Nancy, but it lasted only a year and a half. He dropped dead by the staircase at her feet. From Nancy's description I envisioned him rolling down the whole flight to the spot in the front hall where Betty had stood when Nancy had taken me on the house tour. But I'd gotten it wrong. The papers quoted Betty: "It was a warm day. He was upstairs writing and called to me to bring him a cold beer. When I got up there and he took the beer, he fell at my feet."

Now Betty had her eye on Alain, a French doctor who escorted her to parties. He had an accent like Charles Boyer's. One night when I found myself sitting next to her at a dinner party, I brought up the subject of Puerto Ricans and poverty.

"No. They have welfare," she said over the flickering candlelight and the wine glasses, and she showed how she used to eat in Brooklyn as a child, jutting her elbows around her plate like ramparts. "Once I had a meatball, and my brother made a joke. So I laughed, and my meatball was gone." She speared the imaginary meatball in a lightning motion, mimed it into her mouth. "You have to keep your eyes on the plate."

She had thickened with age and grown more girlish. Shrewdly seventy, she smiled like the Cheshire cat, for no matter how ridiculous the world, she played the litanies like a pro. Newcomers expecting celebrity conversation were disappointed. After dinner a lady said: "I expected her to be — I don't know — something. But she is boring, boring," giving the word the exasperated emphasis of Chekhov, unable to appreciate Betty's talent for adversity over success, or the fact that triumph makes merely generous what poverty has made splendid.

"She's having trouble writing now," Nancy said on a visit. "She can't remember how to sign her name on a check."

One night when Alain had to work late I was asked to pick her up

and take her home from the dinner party. I had a big white Galaxy, and driving in the dark through the rain I kept looking sideways at her, seeking in her scowl magnified by raindrops in the streetlights, like those nights we'd driven to the writers' group, the unnamable sign I knew her by. We talked inconsequential things about the weather. The night mutated to a large silence. When Alain met us at the door she came alive, for she was of the breed of women who wake up only in the presence of men because they paradoxically believe only in women, in women's superiority with their pathetic bondage of strengths. She was too grateful when I walked her to her door at evening's end and said she hoped she hadn't inconvenienced me. She said it two or three times.

It was only when I got home and opened the door, making the lights come on inside the car, that I saw what was lying there. On the passenger's seat. A dollar bill. I took it between my fingers and held it up to the light. Had it fallen out of my purse? No. I knew she had left it. But what was the meaning? A tip? An insult? Gas money? Declaration of independence?

The marvel of the dollar bill I recognized very slowly, with my forty-year hysterical impulse to laugh, was that it proved the secret society before food stamps. Who can imagine it, really? My generation didn't know it even, for the war had shot us past the old names of things into fission. Wayne and I had believed we were radicals, but we were mistaken; we were only subversives. We'd been born five years too late, for no one who did not grow to adulthood in the Depression could know. This was a late initiation, a sign, possibly, that we walk about with monoliths in our midst, people who once knew bare cupboards and bare bones.

In the late Sixties the town cemented over the grass in front of the post office and erected a knee-high iron-rope fence around the flagpole. The link-chain looped through hollow tubes of black iron posts. One day on my way to Huggins Hardware I met Betty standing, not looking at the flag but at the fence, pondering the loops with a perplexed look. "Hi, Betty," I said. She paid no more attention to me than to the ashes she'd ironed into the blue cloth. So I went on. When I came back she was still there.

Two days later I saw her again studying the chain with that patient look. I realized where I had seen the expression before. It had been on the face of the horse in Old Man Coker's pasture.

"Where are you going?" I asked. "Home," she answered, so we walked down the cement steps to Henderson and she took off in the direction of Rosemary Street.

A month later when Nancy was in town, I visited. A couple of actors from the drama department lived with Betty, looking out for her. Betty came in and sat with me on a fat, brocade sofa and said, disgusted, but matter-of-fact, "I can't sign my own name any more, not even on checks," and she got up to give the gray cat some milk. No Name was long gone.

People got used to her at the flagpole. Among the anonymous crowds who'd moved into the area, there were always the Chapel Hillians who knew her. And they always set her on her path. One day Tony Harvey, an editor at the university press, saw her there and asked: "Where are you going, Betty?" "Home," she said, so he walked down Henderson with her. But when he turned on Rosemary, she said, "No, that's not the way," and pulled her arm away. "But where do you want to go?" he asked. "To my mother's house," she said.

They went down Cobb Terrace looking for it. "Don't worry. We'll find it," he reassured her. "That looks like it," she said, pointing to a gray house. But when they got near, she said, "No, I think that's my brother's. It must be the one next to it," and they went forward. "This one?" asked Tony. But that was not the one either. They spent a half hour exploring the vocabulary of city blocks, staccato speak, Carney's Junk, the candy store before the boulevard of blowing gum-wrappers, the territory of the butchered and reconstructed real. After they got tired, they walked back to Rosemary, and Tony left her at her door.

"Betty Smith was the saddest person I've ever known," Maggie Dent told the papers when Betty died. Ola Mae Foushee wrote that she never smiled. But the world of any writer stalled in self-absorption doesn't stop. It becomes monolithic.

"Such great agony in childbirth," Betty once said in an interview,

"nobody wants to sit around and listen to it. But in a book, I can write all of the gory details. That's what I think that I like best about writing. Somebody listens to me. As a shy child in a big family, it was always 'Keep quiet, keep still, we're not interested,' and also in the neighborhood. 'She had always got so much to say, all of the time.' So I got so I didn't say anything. I wrote it."

In her coffin at Walker's Funeral Home they'd made her look, on the puffed lining of white satin, like Goldilocks, but hadn't been able to wipe off her scowl totally; they'd converted it into a fold of concentration. She looked less vulnerable than when she'd been reading Thomas Wolfe aloud, and I thought she might sit up straight and answer the question of what becomes of people after they've drowned in Chapel Hill where there's no ocean.

Her funeral took place at St. Thomas More Church on Gimghoul which disproved the Jew/Catholic argument of my father, who died two years later in 1974. When I saw the coffin closed, it certified to me that only the dead know Chapel Hill. Because our town is so well documented, our forays into memory don't constitute nostalgia or legend or history per se, but the same old mystery demanding its vocabulary, a frontier with promises, discoveries, surprises, shocks of recognition. But really its syntax hasn't been invented. Not even yet.

I discovered in the university library's North Carolina Room a subject-heading card in the catalog that read: "Betty Smith. Penciled notes on last pages of Thomas Wolfe's *Of Time and the River*." Of course I looked them up. She'd written them in 1936 before I'd arrived in Chapel Hill, before I'd met Wayne, before she'd read us Thomas Wolfe, before she'd come to the fence that separates the individual from the generic. In her familiar round letters, in pencil so light you had to look twice:

Birth.
Pre-birth. Go your way, I'll go mine. Hilda.
Christening Lizzie.
The child without a name. The agony of the name through school.
Discovery it was Elizabeth.

It made me remember again that writing is, at base, naming.

The Princes and the Paupers

A MONTH AFTER my family arrived in Chapel Hill, I saw an ad on the Playmakers bulletin board for people to act in a radio play. They would pay. It was still 1938, and I knew they wanted college, not high school, students, but I figured I could make my voice pause and tailfin like Helen Trent.

At the tryout I was taken to a creaking studio room in Bynum Hall with polished floors and a table with a microphone. Wires straggled into a dark space behind velvet drapes. A woman about forty posed there, whispering to two students on stools. Her black hair, bobbed in the style of the Twenties, glittered like a raven in the spotlights. She was wearing Cuban heels with the arched, easy posture of a New York pro who doesn't have to insist on stardom because she is one.

She listened as we did the scene. I played a woman who had stolen a comb from a dime store. A student with a beard played a detective who had just caught me. He accused me, saying his lines so slowly that I fell into his rhythm, protesting my innocence in pear-shaped tones, loading my syllables with guilt.

The woman didn't say a word, but she smiled at me. As I left, the graduate student whispered: "You were good. Lillian Prince says so." I didn't get the job, but I did get carried away with Chapel Hill in its Chekhovian profile. (It turned out that the play was by Betty Smith, way before *A Tree Grows in Brooklyn*. Years later she told me they weren't used to high school students and therefore didn't use them.)

William Meade Prince and his wife, Lillian, had come to Chapel Hill in 1936 from Westport, Connecticut, where they had lived on an estate. The *Greensboro Daily News* noted it: "Prominent Illustrator

Returns to Chapel Hill." He was famous, had illustrated the stories of Arnold Bennett, Hugh Walpole, William Saroyan, Philip Wylie, and Roark Bradford in magazines like *Collier's, Country Gentleman, Cosmopolitan, Ladies' Home Journal,* and *Saturday Evening Post.* She had played *Blithe Spirit* with the Westport Players. In the Forties she played the Conjure Woman in *Dark of the Moon* on Broadway, and then Queen Elizabeth for eight years in *The Lost Colony.*

They had retired to Chapel Hill. He'd been brought up here, in the rectory of the Episcopal church, where his grandfather was minister. He'd lived an ideal small-town childhood of schoolboy pranks, and he'd had a craze for circus animals which he drew in notebooks.

Compared to such plebeians as Paul Green who, after his Broadway plays, Pulitzer, and Hollywood movie work, had started outdoor historical drama and developed Greenwood — an affluent neighborhood on land he owned on the southeast edge of Chapel Hill — or Thomas Wolfe, who'd bequeathed Pulpit Hill to literature and red-clay attitudes to the Playmakers, the Princes represented gentility within competitive success. They were flush with money and manners. Glitter clung to them. Newspapers reported their doings.

Lillian Prince posed in her garden for the *News & Observer* next to a piece of statuary she'd brought home from Italy. The article quoted her as saying a Southern drawl was an asset in the theater. They had a black poodle named Zaza who was to them what Fala, his famous Scotch terrier, was to President Roosevelt.

William Meade had a pale smile and a mustache, became head of the art department, and had a famous collection of model sailing vessels. He went to Europe for the war department and made drawings of wounded servicemen in hospital beds.

It was rumored that Lillian drank, but it was fashion, not alcoholism, and it made her grandeur more Fitzgeraldean. They bought one of the first houses in Greenwood, and William walked to the post office with Zaza daily, talking with everybody along the way. Like the Windsors, they were our royal couple and, also like them, childless.

Chapel Hill was also the ideal place for families to be poor in. I

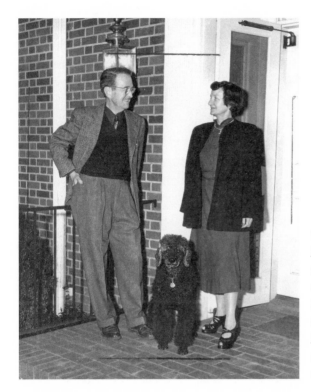

William Meade and Lillian Prince with their poodle, Zaza. Courtesy of the Southern Historical Collection, Wilson Library, University of North Carolina at Chapel Hill.

realized poverty in the Shack. I had known it academically in Glouces-
ter where we'd spent nine insulated years rehearsing it in our big white
house which I imagined resembled the Princes' situation in Westport.

I WAS FIVE years old when Wall Street crashed, and my nose came
level with the dining room table where my mother was cutting some
navy-blue cloth for a dress. My father was standing by the sideboard
saying something in an embarrassed voice about banks closing and
repeating the words "Central Trust." The huge silver jaws closed
down on the cloth and then opened wide for another bite. When he
said, "No," and a question followed about being wiped out, the table's
oak surface vibrated in a groan, blotting his words out. The scissors
paused, the hush lasted a minute, and then the jaws bore down again,

saying, *yawg yawg yawg,* until the dark blue cloth slithered off each end of the table.

But nothing happened. The willow tree did not move, the pond lilies still came out, the foghorn still bleated, and the bank didn't believe we wouldn't pay on the mortgage. My mother had tears in her eyes when she said she could no longer bring us a toy each day. "We can't afford it." We were shocked because the only time we'd ever seen her cry was when she crashed the Marmon through the back of the garage, so we protested, "We don't mind," and we didn't.

The only reality was "picking driftwood" to burn in the fireplace to save on coal. Every day throwing cork flotsam and broken lobster pots in piles on the sand to haul home later, we pointed red fingers at the four mansions whose owners had jumped off skyscrapers. They were dead millionaires, while we were live church mice, ergo we were worthy of living on Eastern Point.

This foretaste of the class system was riddled with inconsistencies though. As crown princes playing cops and robbers behind the sculptured bushes of the San Simeon-ish castles, we were already imposters. Robert Morris, the son of the caretaker of Nottmans, had the key to that mansion, and he sneaked us into the banquet hall which had mirrors shrouded in sheets. We promised not to tell, so as not to get him or his father in trouble. He taught us baseball. When Robert wasn't around, we used to take our dolls in a red cart to the secret pergola overlooking the harbor. We also broke into Sleepers mansion further down the point during a spring thaw and ate stale cheese crackers to symbolize our occupation. Sleepers, now called Beauport, is open to the public with guided tours of rooms where Henry Sleeper entertained the King of Norway and Teddy Roosevelt.

We looked down on Robert for saying "ain't" and "youse guys." He taught us the word *bushwa* too, which neither he nor we knew came from the French Revolution and the word *bourgeois.* He wasn't on the same social scale as the other Pointers — the Birdseyes of Birds Eye Frosted Foods, or the Pooles of Poole's Pianos — but we were not supposed to publicly admit the difference.

In winter all four families cooperated in what was not then known as carpooling, the Pooles, Birdseyes, ourselves, and Robert's father, Mr. Morris, taking weekly turns driving us to Plum Street Grammar School. One day when Mr. Morris was driving along Niles Beach, we passed some WPA men with caps, earmuffs, and rakes. "Look at them damn bums!" he scoffed. "They thrown tin cans in the waves and now they're trying to hit 'em with stones!" As factotum, he had assumed Nottmans' attitudes but kept his own lingo.

Robert was our imaginary buffer against East Gloucester kids, especially the Portuguese and Italians, named in tandem because they beat you up and were Catholics. Protestants were better because they were descended from original settlers and didn't have to confess sins to a priest and then go out and sin again the next day. But they still spoke bad grammar. If you don't have money, grammar is the ultimate criterion.

These anomalies lay in our own family. We hardly pondered what Daddy thought; we accepted his opinions without understanding their origins. He scorned decayed European royalty. He taught us to fold the American flag properly. We knew he disapproved of the Eastern Point yacht club, but what did he think when its Wasp members hired seventeen-year-old Joe Puglesi, the son of Italian immigrants, to keep people off the point? Joe Puglesi was dressed in a khaki uniform when he manned the stone gate entrance at Niles Beach to keep people out. He looked like Mussolini.

One afternoon Mother hired a high school girl named Pauline to babysit. She took us to the public part of the beach where there was sand, parking, and crowds instead of private rocks and seaweed. To get home we had to walk through the stone gates, past the sign, *Private No Trespassing,* the irony of which made us scared that Joe Puglesi would never let us go back to our house.

With his pimpled fat face, Joe Puglesi terrified us. His name was pronounced *Police-ee!* We knew its spelling, and the monstrous *pug* syllable added terror to his image. He was not only Mussolini, but a "pugnacious Pug-dog" killer. We were astonished when he smiled and

said, "Hiya, kids. Djouse have a good swim?" After that we were always ecstatic that we could get through and others couldn't.

One summer years later when I went to Gloucester for a visit, a Portuguese woman told me: "It's strictly illegal, you know, all them *No Trespassing* signs your crowd put up to keep people from driving to the lighthouse."

My hybrid vision of life was confirmed. Hadn't we broken into the estates with impunity? We knew in childhood what the rich know and the nouveaus don't, that if you want the bleak and royal sea to be yours, keep your roads overgrown with weeds, lumpy, and potholed, so the *hoi polloi* will think it's worthless and forget. Hidden kingdoms are based on ruse and forgetting.

IN THE FOURTH grade at Plum Street Grammar School there was a girl named Gertrude Parsons. She looked like a washed-out Orphan Annie, with dun-colored curls and eyebrows as low as the eaves of a thatched hut. Instead of white holes, she had blank eyes, instead of spunk, implacability.

"What country does Bombo live in?" Miss Fatty Wonson asked. Bombo lived in the Belgian Congo, and an Eskimo was the next chapter. I raised my hand, but Miss Wonson chose Gertrude Parsons.

Gertrude Parsons sat like a dog. The first settlers to Gloucester did not build their houses on the sea, but on a stony plateau called Dogtown Common, with no view of the sea, dwarfed by giant boulders made famous in the paintings of Marsden Hartley.

Was she refusing, or didn't she know the answer?

"Where does Bombo live, Gertrude Parsons?" repeated Miss Wonson.

People who don't know answers usually twitch or blush, but Gertrude Parsons did neither. She didn't look right for the way she acted. She was like milk, slick and dense, which, when you pour, is heavy as lead and turns out to be lye. I wanted her to be a real Dogtown stone or a real dog, because they are what they are.

She lived on a granite outcrop overlooking the docks of Gorton Pew. We'd seen her pulling a string of younger, orange-haired children

along like vermin to Kelly's grocery store, a blank look on her face. Once out of the blue she whacked Constance Kennefick for picking up the purple glass too soon in hopscotch.

She talked when you didn't expect her to, and never spoke the rest of the time. In fifth grade she told Norma Tarbox, "I don't want to play!" when Norma Tarbox hadn't even asked her, and pushed her to the ground. It wasn't a joke. She never laughed. At recess she always went to the coal hod at the edge of the schoolyard and stood in the wind and didn't look at anybody.

I overheard Mrs. Poole tell my mother, "That family is unfortunate with all those illegitimate children." I wanted to know what illegitimate meant. My mother answered: "Having no father," and "It's not Gertrude Parsons' fault," which meant we had to be hypocrites too.

In sixth grade I found out she was dumb. There was a 63 in a circle on her history paper. But the teachers had stopped bothering with her by then. One day Miss Stewart mentioned George Washington and the cherry tree. Gertrude Parsons opened her mouth and said loudly that George Washington was a liar and someone had made up that story. We all knew this, but she repeated it three times. And the fact that Miss Stewart blanched white and didn't argue made the kids afraid. For they despised Gertrude Parsons. A fabric of silence knitted itself around her and they forgot about her even in her presence.

One day in eighth grade, we noticed she wasn't there. She had been gone for four and a half months! Would people fail to notice if I disappeared too? Mrs. Poole said Gertrude Parsons had been adopted. But who would want to adopt her? When I saw her brothers and sisters kicking each other at Kelly's, I rehearsed her extinction in pulsations, like a repeating rifle. I tried to fantasize her with a new family walking down Fifth Avenue in New York. I couldn't, so I forgot about her again.

CHAPEL HILL MERELY complicated the class system. Our shack consolidated our pubescent ideas of ultimate comedown. Despite our father having led us here because it was the "Athens of the South," we looked down on it from the bottom.

We started our odd-jobs before we left our big house, Thalassia, on Eastern Point. We had two money-making schemes from which the four of us made a hundred dollars a season. The first was picking pond lilies and selling them to summer people in town. Every morning we went out in our rowboat. We got to know every pond-lily patch. We got to spot every pond lily that was white, and every pond lily that was brown or had been chewed by a muskrat. We picked them early while they were still sleeping, before their petals had opened. Then we tied them in bunches and stationed ourselves on three street corners in town. The petals opened. People bought. We rated our customers as suckers, the good, or the crumbs, depending on how they acted toward us.

Our second scheme involved eight English bells, manufactured in Whitechapel, which were rung by novice bell-ringers before they graduated to big bells in church steeples where they rang out changes. (For knowledge of this subject, read Dorothy Sayers's *The Nine Tailors*.) It was supposedly an ancient art. The bells were owned by Mrs. Runkel who had been our piano teacher. Mrs. Runkel got us engagements to play them in the summer hotels; instead of string orchestras the old ladies sitting on the wooden porches listened to us ring the bells. "Do you Ken John Peel, Oranges, and Lemons." Even straight changes. With harmony. I don't know if the people loved the bells, or whether they just loved the idea of children ringing them.

When we moved into the house on Rocky Neck we helped Mother make tarts and muffins to sell to local diners. Once when she had pleurisy, I kneaded the blueberry muffin dough, horatioing my alger. It took elbow grease, but we discovered radio for the first time. It opened up a new world to which we became addicted. We attached our fates to Orphan Annie's. We were comforted by *Ma Perkins's* doughty spirit. *Our Gal Sunday* asked the question: Can a Girl from a Small Mining Town in the West be Happy as the Wife of a Titled English Lord? Yes, she could. The world opened us to dreams of glamour.

We learned to dub our rented saltbox on Rocky Neck *quaint*. We learned to make something out of nothing from the artists who came

Mildred Spencer Athas and her daughters next to the Pontiac just before leaving Gloucester for Chapel Hill, Fall 1938.

those immemorial summers to paint on the beach wearing white hats and sneakers. We lurked behind their easels, whispering about their paintings, judging their daubs of lighthouses, rocks, gillnetters, and waves. Who would buy this piece of fish-stinkery? we whispered, if we thought the painting was bad. But we learned the tricks of artists. They were the only nonrich people who spoke good grammar and they spun gold with their visions.

What was baronial in Gloucester was colonial in Chapel Hill — i.e., democratic in the Jeffersonian sense. The lawns, hedges, the Old Well, the arboretum which imitated the pergolas and sea walls of the estates were dedicated to students. Could the library really be ours? Although we went to the stone bench at Gimghoul to pine loudly for our old life, we had to admit there was hope if, millenniums before, there had been a sea called the Triassic licking the Fall Line.

On December 5, 1938, two months after we arrived in Chapel Hill, Franklin Roosevelt came to town to give the commencement address to an accelerated graduating class. As Wayne and I threaded our way through throngs of townspeople on the wooded path to the stadium,

Franklin Delano Roosevelt at UNC (possibly at Woollen Gym) with North Carolina Governor Clyde Hoey and UNC President Frank Porter Graham seated behind him, 1938. Courtesy of the North Carolina Collection, University of North Carolina at Chapel Hill.

it began to rain. Silver, horn-shaped loud speakers wired to trees told us loudly to go to Woollen Gym.

Inside, high up in bleachers above the platform, the klieg lights hot on our wet shoulders, we watched the figure lurch upward on metal crutches, oars of the ship of state riding the waves of Hitler's takeover of the Sudetenland by the Munich Pact. He aimed his head toward us, and in that frail moment at the sound of familiar soaring syllables, we became witnesses to a mere man, president of our country, and knew Franklin Roosevelt was not the harborer of stone-throwing deadbeats, but the tutelary saint of our college education. The NYA was his program that provided student jobs, and we planned to get on it, work our way through school, and get rich so we could buy our old house back.

The possibility of different kinds of friendships existed. As our

grand piano sat tipsily on the rotten floor of our Shack, we extended our corollary from, "If you're so poor, how come you're smart?" to "If you've got it, flaunt it." We told curious kids the story of our former life, even though the more we told, the more it sounded false. They were bowled over. Our past started becoming unreal to us even as it made us acceptable to our friends.

Greenwood was just getting started. Most of the highfalutin still lived in Westwood, including three families with three beautiful daughters, the Holmeses with Mollie, the Adamses with Alice, who grew up to be the novelist, and the Sanderses with Harriet. All three had connections with the Episcopal church.

Harriet's farm-plain drawl was anathema, for she had cool, elegant looks. One day she showed me that her house was only a stone's throw from ours. All you had to do was to cut back of Tintop, the black ghetto behind the power plant, and you'd come to a waterfall on Indian Ridge, which was the halfway point in the woods between our houses. We called it Indian Ridge, even if Indians hadn't really walked on it. Such proximity was a revelation. We used to meet there in the afternoon and discuss life. How nobody could know another person. How being poor or rich didn't count, the Chapel Hill ethic.

A few weeks after I had tried out for the radio play, I overheard Mrs. Holmes on the high school porch steps telling our theater-crazy social-science teacher, Mr. Conrad, who directed the senior plays, that William Meade and Lillian Prince were planning to adopt a child. Mrs. Holmes said that it was not a baby, but a grown high school girl who came from Gloucester, Massachusetts.

The odds against her being Gertrude Parsons were nine hundred thousand to one. My sister and I sat in the dark that night not speaking. It was like learning you had cancer and waiting for it to appear. The idea that coincidence could be destiny was irrational.

"But we don't actually know for sure!" my sister whispered.

We were paralyzed for a week, and then we knew we must find out. But to get info, you have to put it out. How much could we tell? Should

we confess that Gertrude Parsons was 1) illegitimate, 2) dumb, 3) a pariah? We told all of that and more, describing her so vividly that Mollie and Harriet were horrified. We told them to keep their mouths shut and their ears open, and then we turned to our mother and egged her to pump their mothers.

"But how am I going to find out a thing like that?" she scoffed. At once we saw the tables of family life had turned, that our parents were now diminishing into the background of a life in which we had become principals.

We felt disgrace. A dud Orphan Annie, illegitimate, dumb, and peculiar, floating up a river in papyrus weeds to be brought up by royalty! When my sister and I thought of knowing the innermost secret of the Princes' lives, which they didn't even suspect themselves, we cackled with the same vicious ardor we had pointed our fingers at the millionaires' estates! We fantasized going to the Queen's garden in Greenwood and issuing Mrs. Prince a warning.

It wasn't that simple. It went beyond a joke. It targeted our ethic of worthiness. What illegitimate justice had designed Gertrude Parsons's fate? Could she be Cinderella and we the stepsisters? Did we want to be adopted by the Princes? Each day we walked to school along Cameron Avenue and McCauley Street, looking to the right and left to see if she was there. She was the shadow of our past psyche, our Smerdyakov. We dreaded the day we would find her on the school grounds. What would we say to her? Would we speak? Would she?

At last, through the Episcopal grapevine we learned that the inevitable had happened. She was in Chapel Hill. Nobody had actually seen her. Nobody knew details. And could they pinpoint her from our description? Wouldn't we have to see her ourselves to know for sure? This was the last thing we wanted to do. We felt as if we were at the bottom of a mountain where, if we moved or even breathed the name, Gertrude Parsons might dislodge from Dogtown and start rolling, burying us in her avalanche.

Two days later fate applied the *coup de grâce*. Her name was not Gertrude Parsons any more. She had been renamed Caroline Prince!

Weeks passed. She did not appear at school. Mollie Holmes found out she was being sent to a private school in Virginia.

That year Gertrude Parsons lingered at the edges of our skulls, just beyond identification, a ghost threatening. In a psoriasis of curiosity, I wondered concrete things: Did she have her own room? What color was her bedspread? How did she address Mrs. Prince? As "Mother"? Did she sit on William Meade Prince's lap? I imagined Fatty Wonson asking: "Where does Gertrude Parsons live, Caroline Prince?" And Gertrude Parsons in the Virginia boarding school answering: "George Washington is a liar!" I tried to forget her as I had done at Plum Street Grammar School, but it was impossible.

A year passed. She never showed. In the spring of our graduating year, we learned from the Episcopal grapevine that Caroline Prince had not worked out. She was going to be un-adopted. She was going back to her original home to be Gertrude Parsons again.

"Well, Lillian Prince never did seem like the motherly type anyway," said our mother.

It's one thing for a place to be worthy of you, another for you to be worthy of it. Ever since Job, people have fit their ethics to their circumstances. If they're rich, they deserve to be. If they're poor, likewise. The Chapel Hill we had invested in, and our friends and their mothers and the grownups who surrounded us and lived out such different ethics from what we had known before, had some significance. But what was it? We did not know.

In 1943 Harper and Brothers published *A Tree Grows in Brooklyn* and Betty Smith became famous. In 1950, Rinehart & Company published *The Southern Part of Heaven*. William Meade Prince dedicated it to Lillian, never suspecting that his title would become a bumper sticker and replace "Athens of the South" as the media bait for retirees and hi-tech execs of thirty years hence. The title originates from the anecdote in the book, which took on a life of its own and began to be quoted by townspeople ad nauseam. The story is about a Chapel Hill minister who, on his deathbed, asks, "What do you think Heaven is like?" "Heaven," goes the answer, "must be a lot like Chapel Hill in the spring."

The headlines of the Forties make up a poem of the Princes of Chapel Hill:

From Brush Comes Life
Chapel Hillian in *Dark of the Moon*
Famous Illustrator's First Art Editor Was Frank Graham
Lillian Prince Is Birdie in Playmakers' *Little Foxes*
Artist at Work
She Was His Model
An Illustration Is Born

Shortly after the success of his memoirs William Meade Prince joined the cast of *The Lost Colony* in a small part. One day he caught two suspicious characters loitering near the outdoor stage in Manteo. He held them at bay with a fake pistol, a stage property, until the highway patrol got there to take them into custody and discovered they were ex-convicts.

"Prince a Detective," wrote the *Chapel Hill Weekly*.

On November 10, 1951, on a Saturday morning at 11 o'clock, William Meade Prince committed suicide. He called Dr. Fred Patterson and told him: "Come right away. There's an emergency."

"Hastening to the house," reported the *Chapel Hill Weekly*, "the doctor found two notes at the front door." One said: "I've shot myself in the studio. There's nothing else you can do for me. Please see about Lillian." The other said that he had been despondent, and gave a minutely detailed page of instructions on how to dispose of his affairs.

The Durham Herald demurred: "However, close family friends and neighbors in the comfortable east side residential section said he had appeared quite cordial and happy even in the past few days."

In January 1988 Harriet Sanders appeared at the memorial service for our mother who died at age ninety-seven. I recognized her immediately, her beauty still cool, still paradoxical to her down-home voice and the sudden break of her smile, after four grown, married children and a new career in Wilmington, Delaware, in home restoration.

"Do you remember the Princes' adopted daughter?" I asked, getting

her into a corner at my house, drinking tea, still wanting, after all these years, to describe Gertrude Parsons.

"Of course," said Harriet, who was chewing on the cookies she had brought. "I'll never forget her at that Hi-Y meeting in the Episcopal church. Remember, they were held there then? And when we'd taped this white line on the floor, and the game was that you had to walk the white line and not lose your balance or step on the floor. She couldn't do it. And she didn't know anybody. And she kept laughing and laughing, nervous, you know, because she was a new child trying to be accepted. Terrible. And every time she lost her balance and stepped on the floor she would laugh more. And she wouldn't quit trying. Oh, I can never get that terrible laughter out of my mind."

Harriet went on talking about William Meade, whom, I hadn't realized, had been her art teacher at the university. "He was the best teacher I ever had, and I was intimidated. You know, he was so famous. I was afraid. But he'd look at your painting, and instead of taking a brush and messing up your work, he'd say something, some small thing, and suddenly you'd see it in an entirely different way!"

The line between literal truth and projections is a massive gulf. The story of Gertrude Parsons is literal truth. There are depositions on file at the University News Bureau, so I have changed her name in case she is alive. Why William Meade Prince killed himself is a mystery. At the time some people said he must have been ill. Others said no. There were rumors that he couldn't stand Lillian's drinking. But mostly people were unpredictably silent as if to make conjectures would implicate them in an untenable view of Chapel Hill. The irony is implicit.

In 1969 UNC Press republished *The Southern Part of Heaven*. Jonathan Yardley, an influential reviewer, alumnus of Carolina, and Pulitzer Prize winner, reviewed it, lamenting that Chapel Hill was no longer the sleepy little town on the Hill. He called the book "considerably more than an exercise in nostalgia," and Prince "incidentally, an illustrator of first rank."

In 1962 Mrs. Prince died in New York and left $100,000 to the

university for the Paul Green Theatre. The bequest ended up in a lawsuit, Mrs. Prince's heirs claiming that since the university had not used the money to build the theater but as a ploy for the state to throw in funds, it ought not keep the money. The university won.

I cannot claim to have known the Princes, for they were myths to me then. Now when their reality is, I realize, projection based on the coincidence of Gertrude Parsons, it seems even stranger that their legends have multiplied, born partly of gossip, partly of artifacts.

The other day an old friend from high school told me that many years ago her husband used to ride in a carpool with a woman who claimed to be the Princes' daughter.

There once was rumored to be a couple living in the historic district, friends of the Princes, who kept a shrine dedicated to Lillian, upon which they lighted candles.

In the Carolina Inn cafeteria for a time there was a parade of circus animals carved from Prince's notebook sketches by a refugee named Carl Boettcher. He had escaped Germany and went to Wilmington, then left there for Chapel Hill when people called him a Nazi. In Carrboro he was viewed as an elusive figure, and the word Nazi still hovered in whispers about him.

Prince's wooden circus animals were moved from the Monogram Club, the university's distinguished athletic club, to the Carolina Inn dining room, and now hang on the walls of a staircase in the Hill Alumni Center. While they were at the Carolina Inn, visitors who knew nothing about the Princes except the bumper-sticker logo used to insert pennies through a slit in the glass panel, as if it were the Fountain of Trevi, until a great heap had risen under the elephant's feet. Now, you cannot see the passing parade as well, for you have no distance — it's in close-up, and the curve of the staircase separates the animals from each other, so you become part of its march to the banquet rooms below. But if you pay attention, you can still hear the music the monkeys play, like a film score by Italian composer Nino Rota.

Memories have a finite life and become the frontier for new meanings predicated on the relevance of the past to the future. So do the

illegitimate, the refugee, and the wandering minstrel take shape. When I look at the Princes' photograph, his dish-face is reminiscent of James Joyce, and his mild-mannered glance a small-town pharmacist's. Behind her evil ostrich facade — we always thought of her as the murderer of Mary Queen of Scots and the conjurer of Appalachia — lurks a plain Jane with the long, sad jaw of a buffalo. Glamour is more fragile than memory, but both leave a lingering mystery.

Max on the Beach

I FIRST MET Max Steele in Wilson Library. It was 1947 or 1948. I was twenty-three years old, and Max a year or two older. He came up to me and said he'd heard my reading at a Bull's Head Bookshop tea where Betty Smith introduced my first novel, *The Weather of the Heart*, and a woman had come up afterward and warned me not to be like Virginia Woolf and kill myself. I'd told her defensively: "I identify with Carson McCullers, *The Heart Is a Lonely Hunter*," being spooked by the thought that long noses might mean propensity to suicide.

Max was part of the wave of GIs returning from the war, taking classes on the GI Bill, and he was writing one story a week in the Wilson reference room. We joked about the creaking oaken chairs which looked like upside down behinds, protuberances to fit crevices. He'd just sold stories to *Harper's*, *The Atlantic*, and *Collier's*. He said he always knew when I was in the library — he heard me creaking. I invited him to my house. I was sponging off my family in the Shack till I finished my second novel. He was starting a novel, he said.

In our living room a week later he told me about the misprint on page 39 of my book. Where it was supposed to be "She stroked her thin elbows," they had put a *g* after the *thin*. "She stroked her 'thing,'" he quoted with his South Carolina accent, plopping the syllable out of his mouth like a tobacco wad into a can.

I'd never thought of writers as jokers. To me writing meant Truth of Life, but from that moment I knew I was going to introduce him to Lake, a new friend I'd met through Gurney. They'd been classmates at Gulf Park, a fancy private school in Biloxi, Mississippi.

Lake was a *sensitif,* poet and aristocrat, who'd had TB like Keats, Katherine Mansfield, and Thomas Mann's Hans Castorp, and been in a sanitarium and had her dishes scalded. She lived in a cinder-block hut, named Hiroshima, next to a field where the Carrboro Elementary School now stands (opposite the fork in the road where Old 86 goes right to Hillsboro and 54 Bypass heads left to Carrboro Plaza). I knew he'd be fascinated with her, and vice versa.

Lake, Max, and I had already been out in life, Lake in Chicago, Max in Trinidad as an army meteorologist on the Green Project, deploying troops from the European Theater of Operations to the Pacific War Zone, and me in New York typing for OWI.

My return to Chapel Hill had coincided with the GI Bill inundation and rapid increase of population. The town was exciting, bursting with intellectually serious veterans, real men, older than the beer-frat types before the war. The three of us were trying to finish our novels while we waited for one thing: to get to Europe.

Whenever Lake didn't want people to visit, she strung red or yellow yarn across the door like a spider web. It was all clear that day, so we knocked and waited. When she came to the door, my advance hype had so intimidated Max, who was shy really, that he couldn't think of anything to say. We stood there nervously and then went in. He still couldn't think of anything to say.

"Diagram yourself," I told him.

He was shocked. She was too.

"Diagraph," he corrected.

It was the We of Me era. We were into identity. Max said I'd gotten my first novel out of Betty Smith's garbage can, and so much for its being autobiographical. I retorted his name was really Henry Maxwell Steele, which was true. He called himself Max because he hated Henry, but that if it were me, I'd call myself Henry. Lake said the whole unexpurgated name sounded like a big, mixed-up, oversized tie. That clinched their friendship, so Max told how he and his sister, Harriet, had once got so mixed up that she'd gone to a psychiatrist and he'd gone with her and she was so scared that when the psychiatrist

asked her her name, she answered, "I'm Max and I think I'm growing a beard." So, he added, "I'm going to transpose my names around and go by only one name: Steele."

We were impressed by that since *hot rod* was just beginning to replace *Tin Lizzie* for souped-up flivvers.

"Do you think I look like Alfred E. Neuman?" he used to ask. We told him we didn't think so, he didn't have crossed eyes, and his ears weren't all that big. But he identified with *Mad Magazine* all the same and often talked about Alfred E. Neuman.

He pretended to be proud of his wrists. He took to stroking his arms, saying, "Don't I have magnificent forearms?" And, "Don't you hate fat wrists? My wrists are elegant because of these hollows below my wrist bones." They were. He was a weightlifter and swimmer.

During winter 1948 it was so cold that in our badly heated houses our fingers froze on the typewriter keys. We conned offices out of the churches, Max in the Presbyterian, Lake in the Baptist, and me in the Episcopal. But Lake didn't want the Baptist; so she got the basement of the Episcopal, while I was in the choir-robe room on the second floor where I had to ward off presences emanating out of the robes hanging on hooks. Late afternoons we would find each other in town. Lake was the only one with a car, so it was easy to track her down. We smelled each other out. Max said he always knew where Lake and I were because of the smell of kerosene.

One late afternoon at Ptomaine Tommy's, the Greek café to the right of the Varsity Theatre, we huddled over our coffee. "What's the best first line of any novel you've ever read?" Max asked, holding his hands tight around the mug to warm them.

"Last night I dreamed I went to Manderley again," I said.

"It happened that green and crazy summer," said Lake.

These were too easy to guess.

"I remember that my heart finally broke in Naples," Max said, making our future subsume our past in one fervent twitch, the first sentence of *The Gallery*, the best-selling 1947 war novel that came out to sensational press and faded into obscurity, as its author, John Horne

Burns, died at age thirty-six after two later unsuccessful novels. (He has since become an unknown classic you can find out about on the Internet.) But Lake and I knew the answer then, and Europe was a promise that was already sad.

Max said how lonesome writing was. The word *lonesome* echoed through the knives and forks and across the dishes like an echo across the universe. He could make *lonesome* sound awesome and endless, like *Om* in the Malabar Caves in *A Passage to India* by E.M. Forster.

In March 1950 Lake and I decided on impulse to drive to the coast. As we headed out of town, we spotted Max walking on the gravel sidewalk near Betty Smith's house. I opened the window and screamed, "Hey, Max, get in."

"Where are you going?" he said when he'd slammed the door shut.

"To the ocean," said Lake.

It was only when we'd descended Strowd's Hill and passed the drive-in movie in the field where Eastgate is now (there was no Durham Boulevard) that he believed us. "You're kidding." But he said it like the banker, Buddenbrooks. He had a test on Monday and had left his books and notes open on a reading table in Wilson Library.

He was the one who usually got to play the outrageous roles. One hot day in town, he ran into my mother and for some reason told her I'd gone to Washington D.C. in Emmy Lou Davis's airplane. Emmy Lou was a rich sculptor we knew who had a private plane and was a Communist who'd worked helping build the Moscow subway system.

"Washington?" my mother exclaimed. "When is she coming back?"

Max said he didn't know.

The truth was that Emmy Lou Davis had invited me for a ride to see Durham from the sky. When we got up, I noticed a smell of whiskey mixed in with gas fumes. At first I worried. But there was nothing I could do since I didn't know how drunk she really was (and didn't dare ask), so I leaned back to enjoy myself in the follies of fate. It felt like hanging in the sky in a pail.

When we got back to Chapel Hill, we had to make three passes at Horace Williams Airport before Emily Lou could beat the updraft

Daphne Athas and pilot Emmy Lou Davis just after landing at Horace Williams Airport in Chapel Hill. Photograph by Dan MacMillan.

caused by hot air. We laughed, me nervously, at the failure each time, but finally she got the plane safely down on the runway.

My mother, having believed Max's Washington story, ever afterward considered Max an ill-willed liar, not a gloriously inspired fiction writer.

Another time, Fanny Gray Patton, famous for writing *Good Morning, Miss Dove*, was saying from the podium of North Carolina State College how ignorant graduate students were — "Imagine! They've never heard of Eudora Welty?" Max asked, "Who?" from the panel table, and she leaned forward to the audience to explain, catching herself too late. She blushed to the roots of her honey-blonde hair. All in the timing, said Max.

On the outskirts of Durham, he asked, "When did you know you were going to the beach?"

"Only a half hour ago. Before we saw you. It was an inspiration," I stuttered. I was intimidated, halfway apologetic, afraid he'd decide to

be mad. But Lake laughed and aimed him a look from her brown eyes as lethal as a shot from the hip. Under his frog mask there was an itch.

Past Raleigh near Goldsboro he shifted emotional gear without betraying the exact moment. We were halted at a railroad crossing in the heat of the afternoon, waiting for a long, rusty freight train to clack by.

"Someday I'm going to hop a freight," I said, "and eat from a can in a hobo jungle." *On the Road* had not yet been published, but we had the tradition from Steinbeck.

"Let's do it now," said Max. Shouting to Lake, "We'll meet you in Morehead City!" he was out of the car in a flash, me running after him toward the tracks.

"Last one to Atlantic Beach's a dirty rotten egg!" I shouted back to her.

The train was inching and shrieking, cinders flying up, slow as a snail, heat smelling of tar, but I knew I would swing on, so I jumped past Max at the moment he stopped. I grabbed onto the corroded handle and pulled myself on, but he wasn't moving. I was, while he, stock still, retreated into the distance. So I jumped off.

"My God! I thought you two were going through with it and I'd have to drive the rest of the way alone," swore Lake as we hurled ourselves laughing back into the car. I was disappointed, but the point had been made. We had passed into myth-making. We were turning our lives into fiction.

Just before Kinston he told me, "You should have worn your red shoes." Whenever I wore my red shoes, Max and Lake invented me as a trashy waitress who ended up murdered by the roadside. It was the shoes they saw, brighter than innocence or blood, but empty. I actually did have a job as a waitress part-time at the Rendezvous Room, the snack bar in the bottom of Graham Memorial, then the Student Union, which later became the Lab! Theatre and now is used for special honors classrooms. Since we were living on the razor's edge of budgets, we grabbed what jobs we could. My novel was ballooning endlessly. I told everybody I slung hash. A barbershop was down there too, with a thirty-one-year-old barber who loved country music and fell in love with me because I heated up Campbell's Soup in a special

contraption for him. I learned country music songs as compensation for not requiting it.

"We have two toothbrushes," said Max, getting into the spirit. He was no longer worried about his test on Monday.

"No money for hotels either," Lake said.

I sang "When Moses Was in Egypt-Land" and "You Are My Sunshine," wanting them to sing with me, but neither was any good at music. I switched to a theme from Beethoven's Seventh. Max listened rapt, because in the second grade he'd been forbidden to sing. The teacher divided the class into the nightingales and the crows and he was a crow, and ever after he had an obsessive love of music. We stopped by the roadside and with Lake's jackknife, opened two cans of what we pronounced *vye anus sausage.*

"We can sleep in churches," I said.

We worked in churches. We had faith in churches as asylum from *Les Misérables,* and *asylum* was a word not just for the insane, but drifters, outlaws, incognito kings, vagrants, writers, criminals on the lam, unwed mothers, and all glamorous outcasts.

The tobacco and cotton fields, freshly plowed, flattened out and a church stood on the horizon. It had that dark and weathered look of old naked wood. The air smelled like shore and we could sense the salt horizon beyond the pecan groves. We stopped the car, walked past a mangy umbrella tree, and went in. The air was musty, the floor was bare. We lay down on the pews to try them out, but they were hard.

"We need an Episcopal church, they have cushions," I said.

"Look! A cockroach!" Max whispered. It was really a spider, but we saw cockroaches swarming in Protestant churches and decided to try our luck at the next one.

By New Bern dusk merged into darkness and we came to a church whose windows, ablaze with light, replicated Rosie the Riveter's eyes and the shape of her false eyelashes. Its mouth was wide open, and claps and gospel singing exploded out. We went in, and stood behind the black congregation. It was before Civil Rights, and they stomped and sang, pretending not to notice our color and our presence.

There was a black woman preacher down from the North, and when she got to the top of her versicle and response, she came to a dead stop, and said in a thrilling voice to Max, "Are you washed in the blood of the Lamb?" and when he didn't answer, asked, "What's your name, honey? Come on down here and say."

He answered but didn't go down, and instead gave her a grin that slayed her. The audience didn't move.

"I see a light above your head!" she cried.

The hair stood up on my arms because this was the second time somebody had seen a nimbus surrounding Max. A woman who we heard was a Hungarian countess named Baroness Orczy (or something that sounded like that curious romancer of the Pimpernel and hung around Graham Memorial in refined gauze dresses and gold spectacles, knitting at lectures) had seen a light emanating from both Max's and Lake's foreheads. (Later we found out she was the widow of Edward MacDowell, the composer, and she invited us to the famous MacDowell Colony for artists.)

"And where you from, honey?" the woman preacher asked, turning to Lake. Lake said her name and "Chicago, Illinois." And the preacher-woman said, "I see a light above your head, too."

It was my turn, and when I answered my name and Chapel Hill, North Carolina, the preacher-woman said, "We're glad to welcome you all to church tonight."

"Now tell me one thing," she sang. "I see some pillow, wet with tears. Is that your pillow, honey?" she asked Max. He smiled, embarrassed, and shook his head. She asked Lake if it were her pillow. She shook her head. Then the woman turned to me: "Oh honey, is that your pillow, wet with tears?" I said, "No," but she rolled her eyes up and proclaimed to the three of us and the congregation, "Don't you be 'shamed of crying tears into no pillow, for I see that pillow wet with tears, and the Lord sees that pillow with tears, and the Lord knows them tears, and the Lord knows them tears on that pillow tonight. And you don't have to cry no more. No, Lord. You remember that!"

"No, Lord," the congregation said.

At the Inland Waterway there was an empty Coast Guard boat moored to a dock. It was pitch-black. We parked beneath the shoulder of the bridge, and the dogwood blossoms jittered in the cold, black breeze, shaking and jerking incandescent eyes, peculiar, religious eyes the shape of the cross, in the light of the bridge lamps.

We decided to sleep on the boat. We each chose a separate deck, and when we had disappeared from each other's view, our presences grew enormous. Waves lapped the hull bottom, rising when the wind rose to beat out a series of knocks which spoke some message. The vibration was punctuated by bullfrog grunts. Now and then something rustled in the underbrush. The boards were hard, the spring dew clammy. Suddenly a giant stood at the corner of the galley, stroking its arms and shivering, making the sound of suffocated laughter.

"We can't sleep here!" whispered Max. "It's too cold."

On the other side of the galley came Lake's echo, a sharp laugh.

So we drove the rest of the way to Atlantic Beach. Nothing was open and no lights were on. We drove to the edge of sand dunes whose bald heads sprouted silhouettes of grasses, like the last creatures on earth. We waded upward, deep footsteps in freezing velvet sand, to the top where the great blank of the ocean roared beneath in the darkness.

"This is the Atlantic Ocean," I said, testing the words in their ultimate banality. But Lake and Max would not condescend, moved away upon separate paths toward the sound of the horizon. The sand's cold consistency was of Elysium, the land of Shades, and the waves pushed their phosphorescent syllables onto it. So Lake and I took off our shoes and socks, wading in to read the meaning through the soles of our feet. It caused an ache from our ankles to our knees. The shells shone, but our feet were too numb to feel them cutting. Max had stripped to jockey shorts and run into the surf and swum out of sight. When he returned, his shorts were phosphorescent with small sea organisms.

"Your halo has slipped," Lake said.

He looked inside his jockey shorts and was delighted.

Later we found a telephone booth lying on its side without its telephone, rooted, perhaps, out of some defunct casino and discarded into

Max Steele.

the waves to wash up here, a trundle bed for the one most likely to understand the message.

We were euphoric. Which one of us would sleep in it?

Max tried it first. It was uncomfortable, he said. Lake tried it, but said it smelled of seaweed and deceased clams. It was claustrophobic. Was it a farce to mock our endeavor? I tried it too, trying to stay in it longer than the others. It shielded the wind, but was harder than the church pews or the coast guard boat, so I got up and lay against the velvet sand and fell asleep in the cold wind.

The next morning we bought some coffee, lit a fire of grasses and driftwood in a hole in the sand, and fried bacon. The sun warmed us up despite the strong spring wind. Max, crouching next to the fire, told

how he had gone insane in Trinidad. He described the water and how he had looked across it and into the jungle and his brains had leaked out into the jungle and disappeared into bird cries and waves which then came licking back at his feet. "But when I leaned down and tried to get a handful of the water, they sucked away again.

"There, in Trinidad," he said in his quiet, mesmerizing voice, "suddenly terrible memories of the mainland of my life rose up before me, coming in and going out, coming in, going out."

As he remembered, we knew we were no longer real. Max's insanity was musical, and he had masterminded our disappearance into the dark waters, into the jungle, with those same cadences Carson McCullers spoke in her green and crazy summer.

We didn't talk for hours, not even in the car driving back. It was long after we passed Goldsboro, where we did not recognize the train tracks of that other life, the one before we had kidnapped him, when he said, "Let's each one of us write this trip from our own point of view. Then we'll read each one and see what happened."

But we never did. Max finished a novel, *Debby,* and it won the Harper Prize (years afterward a different edition appeared under the title, *The Goblins Must Go Barefoot*), and he was asked to ride with Betty Smith on the Christmas float, throwing candy to fraternity students along Franklin Street.

"You know what's the best thing about winning that award?" he said, blowing steam off his coffee in Ptomaine Tommy's, for other than mocking his success, he didn't change.

"What?" we asked.

"I'll never be lonely again."

We were sitting one warm March day on the wall across from the post office when he made a discovery. "Do you realize that the rose blossoms out of the thorn?" We were amazed at such a paradox, and it took us weeks to perceive the literal truth. But Europe was opening up. In May Max left for France, and soon after, Lake left too.

I Never Dreamed
We Had Gone So Far

Overleaf:
Daphne Athas in New Orleans.
Reprinted by permission from
photographer Arthur Lavine.

Carolina Red

The Perilous Journey of Junius Scales

ON APRIL 30, 1987, a reception was held in Morehead Planetarium for the publication of *Cause at Heart: A Former Communist Remembers*, the memoir by Junius Irving Scales, written with the assistance of his classmate and lifelong friend, Richard Nickson, professor emeritus at William Paterson University in New Jersey.

Guests included gray-headed environmentalists, musicians, media people, and artists, many of them Thirties and Forties graduates of Chapel Hill High School who mingled with contemporary Carolina professors and students. It was a motley crew of people I'd known in different eras of my life who, I hadn't realized, knew each other.

The dining room exuded the solemnity of Saint Peter's Cathedral mixed with the allure of a bugged embassy. The room's acoustics were famous. People were trying to listen to each other in the crowd from positions thirty feet apart. They whispered syllables to see if the sound would bounce off the dome and reach their friend's ear. Yes, you could hear!

A graduate student clutched his PhD dissertation on Scales, trying in vain to get nearer to his subject in real life. Garret Weyr, an undergraduate in creative writing whose college-novel, *Pretty Girls*, was published in 1988 by Crown Publishers, whispered breathlessly: "A real-live Communist from the McCarthy Era! Wow! That's glamour!"

It felt, however, like a high school reunion. People greeted each other excitedly as if they'd never been enemies (or friends) in the

crucial days of the red scare. Among them were two of my lifelong friends: Mary Louise Huse, a high school classmate, and Charlotte Adams, who lived near us during our Patterson Place days.

In 1954, when the Morehead Planetarium was still new, Junius Scales had been arrested in Memphis and brought to Greensboro in handcuffs and leg irons. He was to spend the next six years in court, his case going to the Supreme Court twice as a landmark test of American constitutional principles. He was defended by Telford Taylor, prosecutor at the Nuremberg Trials, and McNeill Smith, a well-known Greensboro attorney. Telford Taylor wrote the foreword to *Cause at Heart*.

The irony was that Scales had become disillusioned and quit the Communist Party. But during his trials, he had refused to name names. He was convicted under the Smith Act on charges of being a member of the Communist Party and was sentenced to six years. Some party leaders prior to Junius's trial also had been indicted and jailed under the Smith Act, but on charges of the "conspiracy to overthrow the U.S. government" clause and "advocacy of violence against the government" clause. They were sentenced to five years. Junius was the only American ever to be incarcerated under the "membership" clause. In 1961 he began serving it in Lewisburg Penitentiary.

A growing public awareness of such inconsistent punishment drew attention to the case. A petition was circulated and signed by such notables as Archibald MacLeish, Mary McCarthy, Martin Buber, Linus Pauling, Eleanor Roosevelt, Erich Fromm, James Baldwin, Alexander Calder, and C. Vann Woodward, and in 1962 at Christmas President Kennedy commuted Scales's sentence. After having served fifteen months, he was released and got a job as a proofreader on the *New York Times*. With his wife and child, he retreated into anonymity.

By the 1960s Vietnam had supplanted the outrages of McCarthyism in the public consciousness. The mechanics of fear about Political Otherness segued into a different vocabulary. In the 1970s Professor Lewis Lipsitz of the University of North Carolina fashioned a drama out of the actual testimony of the second Scales trial. He called it *The*

Junius Scales with his daughter, Barbara. Courtesy of Barbara Scales.

Limits of Dissent, and it was performed in courtrooms throughout North Carolina by the Carolina Readers Theater as an educational program on civil liberties. Each performance involved the choosing of a mock jury of audience members who "decided" once again the guilt or innocence of Junius Scales.

"It was the publicity about those dramatic verdicts staged in court-rooms around North Carolina — so unlike the unanimous findings of the actual ones back in the 1950s — which led to our collaboration," said Richard Nickson.

Nickson was president of the Bernard Shaw Society, editor of *The Independent Shavian,* and author of a book of poetry, *Staves.* He also had collaborated on numerous documentary film scripts and wrote lyrics for music composed by Benjamin Lees and Larry Alan Smith, dean of the N.C. School of the Arts.

As they worked, Nickson said, "Junius' memory (an elephant's) and flair for anecdotes," and his (Richard's) sense of style and structure

became a tremendous boon for the book, and a tremendous experience for both men. It took eight years. Their shared culture and mutual love of opera and jokes, and their passion to tell this story, resulted in a handsome volume with sixteen photographs. *Cause at Heart* is not only a unique American historical document but a work that in some ways evokes more about Chapel Hill than anything yet written.

It was not until the 1980s when the controversy about the Cold War and the McCarthy era retreated enough to allow a more objective assessment that the question of guilt or innocence was revived in public discussion. Freed of a lot of vitriol, the nub of the question became, In what context should that period be seen? The question still occupies the twenty-first century, when many of its moral influences operate in unrecognized, unknown ways.

Chapel Hill has always been super-sensitive about its virtues as the *Athens of the South* and its authentic value as an academy where dialogue and controversy can be trusted an open forum. It is easy to see why *Southern Part of Heaven* won out as a moniker over *Oasis in a Cultural Desert* or *Hotbed of Communism*. The phrase of the Thirties and Forties, *Hotbed of Communism,* developed when danger of violence was fading. It blossomed when the real threat was dead.

The town had always enjoyed scandal. In the Thirties and Forties, the atmosphere was sophisticated and Southern, and without TV to multiply the scare-effects, there was little concern that economic harm might damage the reputation of the university. The wits of the town perfected their gossip and relished their dirty linen. They spun with freewheeling eloquence, but at the same time lived their liberal beliefs with whole hearts. Everything was in the timing.

I met Richard and Junius in 1946 when I got home from working in Boston and New York. I had another novel half finished (*Weather of the Heart*), but no money. So to make ends meet, I lived at home and got a part-time job.

Chapel Hill's population more than doubled between 1940 and 1950, and the new energy was palpable. The atmosphere was heady. Yet our old Forties vocabulary wove itself into the new. A Victory Village for

GIs with families was built out of prefabricated military structures dismantled from Camp Butner; appropriations were passed by the state to replace the university's two-year medical education with a four-year medical school; and new housing developments started at Mount Bolus, Dogwood Acres, and Glen Lennox. As the local economy grew McCarthyism grew faster.

Mary Louise Huse introduced me to Richard. I'd seen her frequently in New York when she was studying at Art Students League and had a job at *Time Magazine*. She lived on MacDougal Street. From time to time she threw paper bags of water out her third floor window to watch them splash.

In high school Mary Louise had been a scapegrace with the comic talents of a Judy Garland, the ability to draw perfect likenesses, and the daring to back truck kids for school office. She'd gotten me into the Hi-Y Club. Although a progressive and a do-gooder, she had been suspended once when the *Daily Tar Heel* reprinted a line from her dirt column ("The Keyhole") in the high school newspaper, *Proconian*: "Edith and Ed did very well last week at Gimghoul. Was his lap soft, Edith?" We all knew who Edith was, and Mary Louise was suspended from school for three days. It took her father, Dr. Huse, the translator of *The Divine Comedy*, to come to school and speak to Mr. Honeycutt, the principal, to get her back in. Dr. Huse, it turned out, was one of Junius Scales's favorite professors.

Back in Chapel Hill in the mid-Forties, Mary Louise had just painted a portrait of Phillips Russell. One day she announced that she was going to get married. She'd just gotten engaged to Richard Nickson. Through them I met his best friend, Junius, who, I discovered, had gone to Chapel Hill High. As with Walter Carroll whom I hadn't known there because he'd been three years behind me, Junius had been three years ahead, in the same class as Ouida, and they were buddies and had graduated the same year! Such was the intertwining nature of different friends, different classes (both social and school), and different eras.

Back from serving in Europe late in the war, he had come to study

*Lia — Mary Louise
Huse Nickson. Courtesy
of the Nickson family.*

comparative literature at the university and continued his Communist organizing work during these studies, needling the powers-that-be on Negroes' rights, attending party functions, and starting study groups.

Richard and Junius called Mary Louise "Lia," the name she signed her paintings with. In 1947 she did my portrait — *The Weather of the Heart* was just published — and one of Phillips Russell's young daughters.

In *Cause at Heart* Junius describes the wedding which took place in August 1947 at Chapel of the Cross:

> I, whose reputation had grown steadily redder, was the best man. At the wedding reception I was in fancy dress and feeling conspicuous and thoroughly useless when Phillips Russell, the university's professor of journalism and my friend for years, shouted across the drawing room, "Hello, Junius, you old Bolshevik! You don't *look* like a Bolshevik!"

Dapper, dry, and distinguished, Phillips Russell had written a steady stream of books: *Benjamin Franklin: The First Civilized American; Emerson: The Wisest American;* and *Jefferson: Champion of the Free Mind.* As a teacher of creative writing, he was a Chapel Hill myth. In the Twenties he had crossed Mexico on a mule and worked for the *London Daily Express.* In his class he told us that there were only three plots: Man against Nature, Man against God, and Man against Himself. He never gave A's. If Shakespeare got an A why would we think we deserved one?

Richard and Mary Louise married and went to Europe, leaving a hole in Junius's life. "Richard had acquired a master's degree as well as a bride . . ." he wrote.

[They] left on their honeymoon and [went] to Europe. . . . The cold war atmosphere was rising inexorably, and the hysteria against domestic Communists kept pace with it. I began to think that it might, in a very small way, help to stem that tide locally if I, a respectable married veteran, a member of a well-known family, and a generally reputable person, came forward as a "Communist sympathizer" to defend Communism and to speak my beliefs more frankly.

Five weeks after the wedding he went public about his party membership. "Most of the state press made much of the story . . . some raised banner headlines. . . . *The Daily Tar Heel* at first acted thunderstruck; then it drizzled along fatuously day after day with columns, stories, and editorials seemingly designed to please the university's trustees and the ever-watchful state legislators."

Yet his new status as an admitted Communist appeared on the personal level to have changed little:

My former high school acquaintances, except for one or two, still greeted me cordially and would stop on the street to chat (though they rarely talked politics); the window men at the post office, although they must have known the FBI was opening my mail, addressed me by my first name as they had when I was a teenager; student acquaintances

were generally cordial, although there was some recognition that I had become a celebrity; a few professors were cool or hostile, but others were friendlier than before. On balance Chapel Hill took its first public Communist in its stride with little noticeable perturbation.

When Henry Wallace, running (unsuccessfully) for president on the Progressive Party ticket, made a speaking tour of the South, Dr. Frank Graham asked Junius to sponsor an unofficial reception that Dr. Graham could attend. Junius sat next to Josephus Daniels, then eighty-five, who reminded him of some comments he had made at the age of four about his false teeth. "Seated nearby," wrote Junius, "was a lovely North Carolinian, the movie star Ava Gardner, who was visiting her sister in Smithfield. . . ." He was blown away. A delegation of some thirty strikers from the Reynolds Tobacco (Camel cigarettes) union in Winston-Salem attended the reception, and when Junius introduced Ava she delighted them in their midst by asking, "Does anyone have a cigarette? Anything but a Camel will do."

By 1949 Junius had gotten his BA in comparative literature, and started a graduate degree in history. I ran into him one afternoon at the Baptist Student Center and he invited me to visit him and his wife in Carrboro.

Brimming with curiosity, I felt the words, "What makes you tick?" come into my ear unbidden, like tinnitus. I couldn't make them stop. They induced the memory of Pi Martin, a girl in Dr. Brooks's sociology class, who became my friend when she asked for a copy of my definition of the word *Religion* from a paper I'd read aloud in class.

Pi lived with her domineering mother in a little house on Kenan Street, and one day I met them at Eubanks Drugstore. The mother, a drama coach at the now-defunct Sullins College, had birthday-cake hair, a pink bow, and a trembling melodramatic voice. She'd taught the movie star Margaret Sullavan. She leaned across the marble table at the soda fountain, fixed me with her ice-blue eyes, and said, "What makes you tick?" I was stunned and then stricken with terror, for I felt obliged to reply with equal intensity but I didn't know the answer.

I accepted Junius's invitation with meretricious alacrity. I was determined to ask him the same question, perhaps with the same disconnect; and when I went into the mill house, it reminded me of Wayne's and Ouida's houses in the old days. Far from personifying the Communist of one's terrors, he could have been anyone's idea of a divinity student. He wore glasses, was soft-spoken, and had genial manners; and if he hadn't had sparkle, the ebullience of a bubbling tea kettle, and a witty style of talking, you might have taken him for a goody-goody.

He reminded me of my Greensboro intellectual friends who talked classical music and girls in a self-deprecating way and were anecdote-tellers with low voices. They trimmed their Southern accents and acted old, like professors, and for all their talk of girls, they always went steady with their girlfriends. Junius had that Greensboro style.

We drank iced tea, sitting on a beige sofa against the tongue-and-groove walls, and he was urbane and mischievous, telling how the FBI kept him under *surveillance*. He used that word. It titillated me.

"You mean they're out there watching every day?" I asked. I searched out the big old window, but only saw the street. "You mean in the bushes? On foot? What?"

"They go by in cars."

It was exciting, like playing a game: Commies and G-Men. But I did not ask what made him tick right then.

A week or so later I met him again, this time at a Baptist church picnic where there were about twenty young people. We walked into the woods of Battle Park and sat down on the leaf-covered ground. Chewing fried chicken, I talked about the incongruity of Christianity, Communism, and picnickery. I was working up to being logical, but a feeling of magic arose and the conversation took a different turn.

Chapel Hill itself was the myth then (and, we thought, always). But that afternoon had the glory of dreams, and the dreams of the young are subversive because they change the world. My dream was to conquer through art, while his was to rectify racial inequality and unjust class systems. Perhaps his vulnerability made me hesitate. I recognized him as one who will feed mangy dogs and who loves birds with

broken wings. I kept stalling. I didn't want to hurt his feelings with Hegelian dialectic.

I knew I was not motivated by the common good. I'd avoided signing petitions in college because I was a purist. How without doing research would you know the Martinsville Nine, the Scottsboro Ten, and the Something or Other Seven were totally right? Sure, black people should be equal, but how could you force people to see them as equal let alone rip the old attitudes out of them? Aesthetically, I liked the sound of *violent overthrow* (Smith Act jargon?) but Communist rhetoric was awful.

My big question was, now that the war was over and America was so prosperous, how could he think there'd be backing for a revolution? It was not Americanese to think in words like *Masses* or *New Masses*. Americans saw themselves as individuals.

Night fell, moonless and dark. We jumped up alarmed. You couldn't see your hand before your face. We bumped into trees trying to find the way. Junius took charge quietly. He told everybody to look for a pocket handkerchief. We collected six. "Now let's rub them in the leftover butter," he said. "Now wrap them around sticks." We lit these torches with matches and formed a hissing procession.

At every footstep I thought, it's the last chance to ask him. The firelight flickered on the leaves miles above our heads, making a ceiling. But our movements felt blind in our tent of light, and the night sounds beyond were so mystical that the world was a darkness beyond imagination. I never got to ask him. By the time we reached Forest Theatre, we felt fooled by time, trivialized even, but valiant.

"I didn't dream we had gone so far," said Junius.

By 1987, I had approached reading *Cause at Heart* as a testament of defenses and reaction, the ins and outs of Thirties and Forties Communism, or an anti-Communist document. But what I found were the places I too knew when growing up in Chapel Hill, the library we studied in, the people we knew then. Scales the man was our parallel life. Scales the legend we gasped at. But Scales the reality, with whom we walked in Battle Park, what did we know of him?

He grew up in a thirty-seven-room mansion on Lake Hamilton near Greensboro with maids and tutors, read *King Arthur,* Mark Twain, Howard Pyle, Abraham Lincoln, the Bible, and *Lorna Doone,* and didn't go to school until he was twelve years old. He was related to Pells and Hendersons, scions of the state from Colonial times. After the 1929 crash, his father had reverses and a nervous breakdown, so the family moved to Fort Lauderdale and then to Chapel Hill.

> I was pleased with the new home. The heavy, seminal scent of mimosas . . . bordering on a vast woods known as Battle Park. . . . The high school had an easygoing atmosphere and by far the highest level of teaching I had encountered. . . . The most interesting spot in town for me was Milton Abernethy's Intimate Bookshop.

He tells anecdotes about Clifford Odets, Henry Wallace, and Paul Robeson:

> At Ab's I met [within two or three years] figures as disparate as Allen Tate, Norman Thomas, Paul Green, Muriel Rukeyser, Clifford Odets, Ralph Bates, and W.H. Auden. When Auden came to town and gave a reading, the students jampacked him in their car to give him the tour. Just as it ended, I felt a tremendous pinch on the behind which could only have come from Auden. After my first amazement, I suddenly realized that [he] was homosexual, and blushed fiery red.

But it was when a district organizer of the Communist Party, Bart Logan, needed to use the mimeograph machine to print leaflets for a High Point textile strike, and Ab Abernethy at the Intimate Bookshop was on vacation, that Junius found his vocation. "It's working people and Negroes that make the Party tick," Bart told him. "They don't join it in a burst of idealism like a lot of students do. They join because they need it." Bart had a careworn face which made Junius think of the Isaiah passage in Handel's *Messiah:* "a man of sorrow, and acquainted with grief."

Junius was nineteen years old when he joined the party. He divided his time between college and the *reality* he had not known. Like

Simone Weil and Lord Buddha who could not eat when they learned the world was not their mansion and other people did not *have*, Scales joined the millworkers and union men, black and white, of the mills of High Point in the work of the hands by the poor of the earth.

His book gives haunting pictures: a child in an outhouse so mal-nourished her intestines had fallen out her rectum; a co-worker, Gro-ver, who taught him to be a bobbin man in the mill, who collapsed with TB. He provides details of the process of knitting and weaving in the textile industry, a description of the Communist Party School in Upstate New York, never before written about, and anecdotes of fac-tional in-fighting. He joined the army the day after Pearl Harbor and was prevented by the FBI from rising in the ranks. But after pushing for overseas duty, he got to Italy when the war was almost over.

A couple of years after our walk in Battle Park, the party ordered him underground. He left Carrboro, and spent three years traveling on Greyhound buses, separated from wife and child, trying to remem-ber what name he was going by in what state.

Richard and Mary Louise had returned from Europe and were in California by then, Richard getting his PhD, Mary Louise working steadily painting. I was in England, having left by boat in 1952 with $300, to become a part of the generation that witnessed the prone Western World, the wounds of bomb craters and rubble, ration-book living and rotten food, from which we escaped to France to eat a de-cent meal, living like kings because of the dollar, believing we would always be the richest country on the earth. I did not get back to Amer-ica for seven years and missed the McCarthy era at home.

The headlines in the Durham and Raleigh papers of 1954 and 1955 chronicle not a political crime, but a sin. "Red Units at Duke, UNC Detailed," wrote the *Durham Sun* on September 21, 1953. "Witnesses Tell Solons About Printing Press. Senate Committee Releases Testi-mony on Communists During '30s. Use of Chapel Hill Bookstore Al-leged." Ab's? Where I had spent hours reading? We had laughed at the myth while living it, but the published face was phantasmagoric.

The Durham Herald of April 15, 1955: "Scales Plotted Destruction

of U.S. From Carrboro Home: Infiltrator Pictures Cottage as A 'Den of Communism.' . . . An FBI undercover agent today pictured a little white cottage in Carrboro as a den of communism where Junius Irving Scales was at work plotting the destruction of the United States. He said Scales's little white frame house at 36 Carr Street in Carrboro was the scene of many discussions dealing with how the Communists expected to overthrow the government."

In his foreword to *Cause at Heart,* Telford Taylor reveals the lingering effect of what he calls his own *sense of failure.* His consideration of the Scales *life* is extremely poignant. "Scales was the only one of my some 25 clients who were criminal defendants that I failed to keep out of jail, and he was more deserving than all but a few of the others."

A reader longs for a howl of pain in the prison sections of the book. Scales went in just when the events of civil rights (described in John Ehle's *The Free Men)* were straining the seams of Chapel Hill. The ironies were palpable. His refusal to name names had so impressed the Mafia at Lewisburg that they became his unspoken protectors from rape or worse, and after graduating from kitchen duty, he started an opera-listening society. Urbane and indomitable, he magnetized the inmates with the recordings and his commentaries of *Bohème* and *The Messiah.* The sessions were packed.

The only sign of despair came in an interlinear, an epigraph to a chapter where he quotes the words of his prison friend, Carlos Pfohl Johnson:

> Aw, June-Bug, don't even try to tell your folks what it's like in the pen. I tried it and it's no use. . . . The ugly stuff is all over us like the fog. You can't pin it down. And even if you could, it would only hurt them. So just tell them about some of the crazy people and some of the funny things we laugh about, or how snafued everything is. After all, laughing about it is how we stay sane.

There were three times when its members deserted the Communist Party, first in 1931 – 32 when Stalin conducted mass killings in the Ukraine; second when the Nazis and the Russians each for their own

Richard Nickson and Junius Scales. Courtesy of the Nickson family.

reason made a pact in 1939 not to attack each other but to share Poland half and half; and third, when the Soviets invaded Hungary in 1956. Junius stuck with the party until that moment.

At the planetarium reception, he said his regrets dealt less with his ordeal in prison than with his disillusionment with the party. He repeated these sentiments on a book tour which brought him back again to Chapel Hill in 1988:

> I was a hundred percent sucker. Coming out of a religious background, I was concerned about the brotherhood of man. . . . The most important thing of all to me was racism. . . . At that time . . . you couldn't live without coming into contact with it. . . . You either had to close your eyes to it, adapt to it, look the other way . . . or you had to face it. I don't regret any of the motivations that brought me to the Party or the ideals that sustained me, but I certainly regret misrepresenting the Soviet Union as a socialist country . . . [I had been] hoping to reorganize the Party into something American and non-doctrinaire. . . .

Asked why he wrote the book, he said that Richard frequently invoked Socrates's injunction that an unexamined life is not worth living. "I felt at age fifty-seven that if the book was to be written at all, it had to be started no later, or writing it would become a race against old age or its alternative!"

Had there been much difficulty in getting it published? He responded:

> We gave it to three commercial publishers and got favorable comments, but they said memoirs by actors and political celebrities were more marketable, especially when a scandal was involved. They suggested we send it to university presses. Naturally we submitted it to the UNC Press first, since we both have academic degrees from this university, but the UNC Press wanted to remove most of the material relating to Chapel Hill and North Carolina and begin the book in the year 1946 with the trials that followed. But we weren't interested in an academic recount of the McCarthy period. Without including background, the reader would never be able to understand how a Tar Heel born and bred felt, what motivated him, and how he got himself into that situation.

In 1974, one of Scales's favorite professors, Phillips Russell, died, his volume of Emerson open on his desk to a page on freedom and soul. Mary Louise's portrait of him hung for awhile in Howell Hall but dropped from public view when the School of Journalism moved to Carroll Hall.

When the Senate Investigating Committee into Communism leveled at Ab Abernethy the accusation, "Did you or did you not advocate the entrance of Negroes to the University of North Carolina?" it set the Communist Party into a context not of *good* or *evil* but of the political continuum of human rights twenty-five years before the Accommodations Act was passed.

"What is the right of free speech? It is the right of controversy." Bernard Shaw's words, used as the epigraph to Junius's chapter on justice, were, we supposed in the Eighties, a guarantor of the university

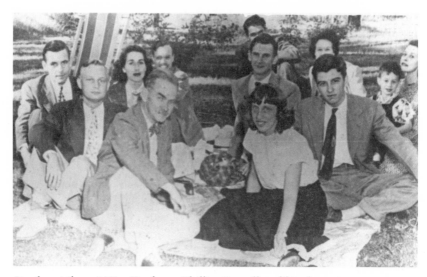

Daphne Athas visiting Professor Phillips Russell and his class, circa 1947.

as academy. *Cause at Heart* can be read as a document of the American left, centered on the region of the South. But for Chapel Hillians it cannot help but be seen as an evocation of its past, rose-colored, shocking, sentimental, and irresistible.

What is the fate that plucks one of us to enact for the rest a social melodrama akin to Candide's? The battle between Man and Nature, or Man and God, or Man and Himself goes on *ad infinitum* in the place and time where we live, but how can it arise in its specifics, evoked so impeccably, and not have been known by us in the twentieth century?

I cannot find that definition of religion I wrote in Dr. Brooks's class. *Re ligare* means *to pick up and bind again,* which reminds me of the sticks and binding them with handkerchiefs to use as torches. No one, though, leads us out of anything other than a particular wilderness. Pi was the same age as Mary Louise and myself, and was falling in love with Dr. Huse at the time Mrs. Martin was asking me what made me tick. Pi and Dr. Huse struggled through a decade or more when he became separated from Mary Louise's mother. At last Pi escaped

her mother, married him, and stayed with him happily for the rest of his life.

"Junius, do you remember that Baptist church picnic in Battle Park?" I asked him at the planetarium, thinking of the words *thick darkness* (not just *darkness*) in the Old Testament which God chose to make a canopy within. His face was blank and then a spark lighted it, and I could see the picture form on his still unlined face.

"I never dreamed we had gone so far," he said, unaware that those were the very same words he'd uttered forty years before.

The conformation of a person remains, it seems, but what makes one tick cannot be answered and is even irrelevant. It is only time that ticks. This is the long view which Proust and Tolstoy explored in their novels, and it's the one I drew from his book.

He Lived to Live

Ab Abernethy and the Intimate

"ASK ANYONE ON the campus where to find a Communist and you will be referred to Abernethy — Ab many call him," reported the Raleigh *News & Observer* in its report on Chapel Hill on May 11, 1940. "Abernethy seems to like it. He has a certain distinction in Chapel Hill Town which gives him unending pleasure. . . . 'I don't know why they call me a Red,' he guffaws, 'the only politics I ever did was with the Young Democrats.'"

I was a high school senior then, and Ab was a fixture at his bookstore, the Intimate, a barnlike wooden building next to the Presbyterian church. He was always tilting back in his chair, reading, his bare feet on the rungs, his black hair receding on his balding dome like Humpty Dumpty. His cheeks were heavy, dented like potatoes, which gave him a perpetual smile. He played the radical to the peanut galleries and gave off a whiff of danger.

The store was the guts of the town's intellectual life. As the proprietor of books in a town of youth, he was the gatekeeper to imagination. The store was Ab, Ab the store. The distinction of his name came from its being the obverse syllable of the word *bad,* with the *b* left out. Like *dog* and *god.* You never remembered his first name, Milton, or that his middle initial stood for Avant. People just called him Ab Abernethy. And the store wasn't called the Intimate either — that sounded dirty — just plain Ab's.

Books had a different meaning then. They were an escape route

for youth — no TV or iPods and few cars. They compensated for the injustice of the world, tore the veil off the forbidden, and carried the psyche beyond sentimentality. They were also a concordance to sex. People looked up *orgasm* and were amazed. Books turned flesh into words and sensations into ideas, and we were besotted, trading them as we traded opinions, kisses, jokes, moods.

I had a conversation in the 1980s on Franklin Street about book-stores. Jim Webb, the retired architect, said in an ellipsis of thought: "Did you ever read any of the *Contempos?*" I hadn't, because Ab had put out that "journal of books and personalities" in 1931, a decade be-fore my time. It was when he'd first started the Intimate in a dilapi-dated structure he bought from Hoot Patterson for $4,000.

In the Fifties the place burned down. Ab was gone by then and Kemp Nye, a crony who used to work for him, ran a record store there. We used to claim Kemp had done it for the insurance, which only goes to show that myths are inherited as well as contagious. In the ashes lay most of the last copies of *Contempo*.

One day in 1941 when Wayne was a freshman in college — I was a sophomore — he left Ab's with his green bookbag slung over one shoulder. He was supposed to meet me at my hideaway in the base-ment of Peabody Hall. Turning on Columbia, he passed houses later torn down to put up the Ackland Art Museum and reached Swine (Swain Hall), the cafeteria, when he heard footsteps behind him.

"Ab told me to come after you," said Kemp Nye. "He saw you take the books." Kemp copied Ab's style. He was in his twenties halfway between Wayne, a freshman of sixteen, and Ab who, we assumed, was forty-five or older. "He's been watching you for two weeks. He said to bring you back 'cause he wants to talk to you."

Wayne couldn't lie with the books right there in his pack, so he followed Kemp back through the campus. From the perspective of Battle-Vance-Pettigrew you could see underneath the Intimate, like looking up a lady's dress, because its four corners were propped up on stone pillars. The roots of the big tree at the door clutched the eroded red gravel.

Ab was on a ladder putting records on a shelf, his bare toes aimed at Wayne's eyes. He turned around sideways asking: "How many do you reckon you've taken in all?"

"Maybe seventy-two about," Wayne brazenly said. It shocked and impressed Ab.

"Well, you know I got to do something about it."

"I'll bring 'em back — " Wayne said, getting scared, blurting he'd meant to all along.

"Then you shoulda done it before your snout got stuck in the trough."

Wayne always blamed me for his amorality because I had Socratically undermined his belief in God in high school.

"There's got to be a penalty. What would you say the penalty should be?" said Ab, while Wayne tried to think up what to say. "You know this place; you borrow anything you like and you pay me when you have the money." He came down from the ladder. "If you bring 'em back, all of 'em, I'll think about what I'm gonna do. I'll give you two weeks."

In the Intimate's heyday everybody either worked for or stole from Ab, and boasted about it. There were only 3,000 undergraduates and one cop, Chief Bates. The only other places for books were the Bull's Head in the bottom of Wilson with genteel teas presided over by Agatha Adams, mother of future novelist Alice, and the library stacks where you sneaked and whispered and which didn't count since it wasn't a bookstore.

We relished Ab looking like a boob. He was a father-figure who puked on authority, mixing the intellectual with the disreputable. Definitive Carolina corn-pone, but authentic. He had a vaguely flirtatious way of turning his head and without looking at you, deriding you and/ or the world. Institutions be damned, playwrights, professors, eccentrics, students, losers, winners, and the famous recognized the crossroads of reality.

Ab knew where every book was. He'd poke through with his finger and pull out the one you asked for. He had all kinds of other stuff he'd

horse-traded — from typewriters to African drums. My friend Lake bargained for a typewriter after the war and got it free on condition she bring three of Maurice Girodias's books (Olympia Press) from Paris. Betty Smith got her typewriter from Ab on credit and paid for it three years later at $2 monthly. Dante authority Dr. Huse came home one day with a hubble-bubble pipe instead of a book, justifying himself by saying Ab could sell you anything.

Behind the laid-back hokery-pokery, Ab was an enigma. The rumor was he let people use the mimeograph machine behind the curtained partition to print up leftish fliers. When people called Chapel Hill a hotbed of communism, we hooted with glee. Were they afraid that have-nots would get their rights? Ideas were free, weren't they? And what should a bookshop be but a place where ideas gasp with life at both ends? Noisily. It proved Southern Slobovia was a place of gutless ignorance, and Ab's existence gave us a sense of our own importance, justifying our subversion.

In 1930 Ab was already famous as a troublemaker. As an editor of the *Technician* at N.C. State University (called in those days State College), he wrote articles muckraking exam-cheating practices. He was kicked out. The *News & Observer* supported the story. He was reinstated. Unrepentant, he took on the ROTC.

The *Chapel Hill Weekly* gives this picture of him:

This boy Abernethy . . . has figured . . . pretty prominently in academic circles . . . the lad about whom many grave alumni of NC State College were disturbed because of his apparently radical leanings. Abernethy toted radical literature around in his pockets. He engineered protests against compulsory military training. He wrote advanced pieces for the papers in fearful English . . . he took a completely mischievous joy in being obnoxious. With it all, he was a frank, likable youth. . . . Abernethy's father, a wholesome, sturdy citizen, came down [from Hickory] to find out what was happening to his boy. It seems he had little sympathy for the boy's half baked ideas, but he was tremendously concerned about his getting justice. It wound up with a modification of

Abernethy's expulsion order. The father agreed to take him out of State College provided he could leave with an honorable discharge and a recommendation for matriculation at the University of North Carolina.

So Ab moved to Chapel Hill and started the Intimate from his dorm or boardinghouse room with books discarded (given?) by Paul Green and Phillips Russell. He was registered as an on-and-off-again junior, and took aesthetics from Green and writing from Russell.

With a crony named Anthony Buttitta he started *Contempo.* In 1931 they advertised the new store in its pages:

> Not many people know of the existence of such an agency as The Intimate Bookshop. [It is] a place where one can read without cost and buy with regular discount any book from *The Death of the Gods* to *Lady Chatterley's Lover,* a place where one goes for a quiet hour or so to browse about books that seem to stick to his imagination, feel the intimate and personal touch of writers that lived to live, literature move before him as a vital and dynamic force rather than a support for the dust of the ages. [*Sic*]

Later the store moved upstairs over the Cavalier Cafeteria, halfway between the post office and the Varsity Movie Theatre. "Any cautious coed may now join the booklovers." Titles alternated exquisitely, *Green Grow the Lilacs* with *Lady Chatterley's Lover, Moby Dick* with *Mickey the Mouse (sic)* by Walt Disney, *Look Homeward, Angel* with *Russian Primer* (survey of Soviet system), and Paul Green's *In Abraham's Bosom* with Pierre Louys's masterpiece *Satyrs and Women.* They advertised "a handsome, inviting couch near the window near two comfortable rockers and a boudoir chair from the lady fair's apartment." They put up heavy green curtains. "An Adam and Eve interpretation," they called it, wallowing in their Garden of Allah mockup.

But a worm ate into Eden. Ab and Buttitta had a feud. Buttitta was apparently more enamored of literature than politics, so he left Ab and started his own Intimate in Durham. He also claimed ownership of *Contempo* and put out a couple of issues. Ab protested that the Durham

Contempo was fake and politely hinted litigation. Buttitta gave up and in a few months moved to Asheville, got in with the Fitzgeralds (Zelda was institutionalized in the sanitarium where she later died in the famous fire), and by our time was a non-person.

Ab published *Contempo* irregularly from 1931 until 1934. One day he was delivering some pages to the Orange Printshop, then located somewhere near Columbia Street. Suddenly he clutched his stomach and rushed to the restroom. A man named Nelson Callahan and some other people heard him groaning through the door: "I'm dying, I'm dying." "I'm sure," Nelson Callahan said, "it was because he didn't have enough to eat." Whether the corollary is apocryphal, it's indisputable that in the early Thirties hunger was possible, jobs were not.

On April 28, 1931, *Contempo* was announced with great fanfare by the *Daily Tar Heel*: "New Literary Organ Appears on Campus." Two days later they panned it: "Obviously with some sort of literary goal in view the embryo publication has apparently launched a crusade to acquaint the student body with the art of fine and sophisticated writing. Articles purporting to have been written especially for the *Contempo* by national figures endeavor to enhance the sheet as a creation for the campus intelligentia [*sic*]." They claimed it had nothing to do with the university because students didn't run it, and finally stopped mentioning it altogether. Out of sight, out of mind.

What was this magazine the *Tar Heel* wanted to forget?

On the first page of the December 1, 1931, issue was the poem by Langston Hughes, *Christ in Alabama*: "Christ is a Nigger/Beaten and black___ / O, bare your back." A state paper, shocked, wrote: "*Contempo* says Christ is a Negro," and termed it a "sorry sheet." *Contempo* informed readers in a column that "Langston Hughes, prominent poet and novelist, is soon to be [a] guest," and gave local literary news: "Phillips Russell, of historical and literary biography fame, recently married Caro Mae Green, sister of Paul Green of *The House of Connelly* ***William Faulkner while guest of *Contempo* was surprised to learn that the University of North Carolina library cannot afford a copy of any of his novels."

William Faulkner and Milton (Ab) Abernethy standing behind the Chapel Hill Post Office, 1931. Courtesy of the North Carolina Collection, University of North Carolina at Chapel Hill.

Boris Pasternak's poem, "We Are Few" appeared July 25, 1932. This was before *Zhivago* made him famous, before his disaffection with communism. The grandly passionate words about revolution being history now have the sadness of a greater truth: "We were people. Now we are epochs."

Faulkner had an issue devoted to him, with two or three poems, one entitled "The Flowers That Died," and a story he hadn't been able to get published, "The Lugger," about bootleg hooch buried on an island in the Mississippi. It was the era just after *Sanctuary* when he was working on *Light in August*, learning how to write short stories to make easier money. He was just then getting famous and publishers were vying to steal him away from Cape & Smith.

James Joyce was featured in an all-Joyce issue in 1934. He didn't know Ab, but his description in the section of *Finnegans Wake* that *Contempo* published as a work-in-progress sounds as if he did. "Yet may we not see still the brontoichthyan form outlined, aslumbered, even in our own nighttime by the sedge of the troutling stream that

Bronto loved and Brunto has a lean on. *Hic cubat edilis. Apud libertinam parvulam.*"

Samuel Beckett wrote a poem, "Home Olga," in that issue too, with the first letters of each line forming an acrostic of Joyce's name. "J might be made sit up for a jade of hope/ (and exile, don't you know)/ And Jesus and Jesuits juggernauted in the heaemorrhoidal isle. . . ."

James T. Farrell had two sections of *Studs Lonigan* in the May 1932 and May 1933 issues. Nathanael West had a section of *Miss Lonelyhearts* in July 1932 and one of his poems appeared in February 1933, with his own commentary on *Lonelyhearts*. Pirandello had a story called "Old Man God" in the July 25, 1932, issue. Erskine Caldwell's story, "Picking Cotton," appeared in the June 25, 1933, issue. Ezra Pound's two essays, "Publishers, Pamphlets and Other Things" and "The Depression Has Not Begun," appeared in 1931 and 1933 respectively.

D.H. Lawrence published a long poem, "The Ship of Death," in the April 5, 1933, edition. It was posthumous; he was three years dead. Sergei Esenin had a poem in the July 25, 1932, issue. Rainer Maria Rilke had three poems in that same issue. Wallace Stevens's poem, "The Woman Who Blamed Life on a Spaniard," appeared in December 5, 1932. Robinson Jeffers had three poems in two different issues in 1932.

Conrad Aiken's poem, "Prelude," appeared in May 25, 1932. Vladimir Mayakovsky appeared in the July 1932 issue with his poem, "Poet out of Surrealism." Theodore Dreiser wrote a column about the Scottsboro case. John Dos Passos also wrote about Scottsboro. Hart Crane was represented by a posthumous letter, "Dear *Contempo*," in the July 5, 1932, issue. George Bernard Shaw wrote a "Dear *Contempo*" letter in the November 21, 1932, issue. He was alive. Leopold Stokowski wrote about "Spirit in Music." And Leon Trotsky, before his assassination, was represented by an article "What Is Historical Objectiveness?" in the June 25, 1933, issue.

The second-rank writers were a hodge-podge of names: Max Eastman, Upton Sinclair, Louis Adamic, Witter Bynner, Barrett Clark, Mordecai Gorelik, John Middleton Murry, Norman Thomas, Mark Van Doren, Malcolm Cowley, Archibald Henderson, John Gassner,

Phillips Russell, Robert McAlmon, Waldo Frank, Kay Boyle, George Antheil, Edward Dahlberg, Louis Aragon, Faith Baldwin, Bennett Cerf, S.J. Perelman, Jules Romains, and Padraic Colum. They wrote reviews or essays on hot topics of the day — Frank Harris's biography of Shaw, censorship as applied to Joyce's, Faulkner's, Nathanael West's work, Scottsboro, and communism.

"Now he's [Ab's] going to Russia," the Chapel Hill paper announced, treating him with a patronizing, if sophisticated, folksiness.

> That's his right. But aside from the satisfaction of a wholesome curiosity about Russia the adventure promises to be unfortunate. There's room aplenty in America to accommodate all the native radicals that may develop. We can use comfortably a few more radicals whose roots are set deeply in native soil . . . in fact there's too great a need to look with complacency upon the alignment of a promising rebel with the purely conventional revolutionists who somehow seem to reason if it isn't Russian, it's wrong.

This obliqueness reflects the troubles of the university with its liberalism. On October 28, 1936, the AP reported:

> University authorities were silent tonight regarding attacks on Dr. E.E. Ericson, of the university English department for being a dinner guest in the hotel suite of James Ford, negro Communist vice presidential candidate, in Durham last Sunday. While declining to be quoted Ericson was represented as feeling he acted within the rights of an individual . . . and that his act had no connection with the university. . . . Dr. Roy W. McKnight of Charlotte . . . declared such an act violated the sensibilities and social traditions of thousands of university alumni and taxpayers, and demanded that the university administration start "a house cleaning."

There is no report of what Ab saw or didn't see in Russia, not even in the master's thesis on *Contempo* written in 1977 by Judith Hay Meader of the University of Louisville. It is unclear whether he ever did go to Russia at all. She tells how in 1931 he announced he was "going to go

and get me a woman." The literary brokers got around in those days, burning the road up and down the East Coast in one another's cars, flaunting their intellectual adventurism. Ab had been introduced to nineteen-year-old Minna Krupskaya of Brooklyn, a radical at Hunter College with a round, beautiful face and brilliant. They got married in spring of 1932.

As late as our day everybody complained that Minna was trying to organize the place. She kept accounts and tried in a nice way to get money from the people who borrowed, took, or stole. Now we added her name to the store, calling it not only *Ab's*, but *Ab and Minna's* or *MinnerandAb's* as if a tongue were wagging inside a bell. She tried to catalog the books. But even bohemian wifehood glues men together. Ab and his cronies maintained their laid-back style by attrition, and not a whit of male integrity was lost. A Yankee-Jew-Emma-Goldman intellectual, a hambone pinko, and a scantily clothed little girl (by this time they had a child) playing around the tree root like some Brooklyn stoop were anathema to Chapel Hill. Many people were delighted suckers for the Left Bank style and exulted. Others kept their pleasure vicarious. Two more decades had to pass before flower children.

The cognoscenti claimed it was Minna who was the Communist, not Ab. I remember Jessie Rehder, friend to both, whispering she was positive Minna was the card-carrier. We used to mulch that over, but in the Forties, "Communist" was too far-fetched to take seriously.

Ab wasn't supposed to be domestic. That their marriage was respectable didn't fit. He should have had a roving eye or done some real lowdown dirt to live up to his reputation, but he disguised any virtue, sitting there paunchily reading.

Newspapers doted on him, figuring the more outrageously they described him, the more outrageously he would perform. "Abernethy is hail-fellow with all," said a 1940 *News & Observer* feature article, describing the store as one long room, with no place in it for back-room conferences, explaining the charge "that he had a back-room to which the Communists repaired for their clandestine meetings."

A copy of *Contempo* was tacked up on the front wall, they said, but

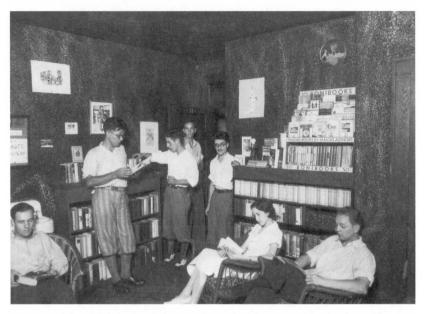

Interior of the Intimate Bookshop in the early Thirties, with Ab Abernethy seated on the left. Courtesy of the North Carolina Collection, University of North Carolina at Chapel Hill.

by then readers didn't know what *Contempo* was. So they had to explain: "A peculiarly sizzling magazine for North Carolina . . . [which] carried with it more sensation than conviction . . . [and at last] blew up. . . . You begin to suspect that Ab, coming from the astute Catawba County Abernethies [*sic*] as he does, has found that it is not bad business to keep the atmosphere of the leftish literati about the place."

In the game of spy and suspect, the real challenge is *what* to suspect. Few smelled out that while he was supposed to be being a Communist, Ab was buying up land. Big acreage. He was running a cosmic game just like with the African drums and hubble-bubble pipes. Doing it by instinct, not design, which is what an entrepreneur does.

When Pearl Harbor was bombed, everything changed. By 1943 we heard that Ab was in the army. "He's too old!" I told Wayne, but he turned out to be only thirty-seven. He enlisted in an officer candidate program and was sent to Kansas in charge of a materiel stockroom!

We had an insane desire to see him in uniform. If a person like Ab could be a GI, then a brontosaurus could live in the Bell Tower!

At the Intimate, Minna took over. She cleaned the place up, organized the books, kept accounts of the people she hired. But she did it in an unobtrusive way, so people didn't exactly notice, and the place felt of Ab so strongly it was as if he'd gone up the street and would be back in a minute.

In 1944 Wayne was in St. Louis in pre-med, I was working in New York, and the world wrested Ab out of our orbit. When I returned to Chapel Hill in 1946 to finish *The Weather of the Heart* I happened to be sitting on the stone wall by Graham Memorial and saw Ab across the street. In uniform! He didn't look younger or thinner like other soldiers, he looked the same but different. Just as sloppy — he'd gotten rid of the black tie and was cocking his head off-handedly celebrating to his friends who were surprised to see him home on leave. But after the last person had walked off, he sat down on the chair, kicked off his standard-issue shoes, and tipped back. It was then with our roles reversed — me wall-sitting trying to crack his enigma with him having no idea I was staring — when I noticed, for his smile became detached, his moon face inscrutable, that his face wasn't lovable at all. It was melancholy. Almost as melancholy as Humpty.

In 1950, probably in preparation for life after disgrace, Ab and Minna sold the Intimate to Paul Smith. Maybe Ab had known the noose was tightening, for he hadn't gotten into the officer candidate program — they didn't promote suspected Communists to officer rank — he'd been discharged from the army only to be drafted three months later into the air force where he served for two and a half years.

In 1953 Ab and Minna were hauled up before a Senate subcommittee investigating "Communist Underground Printing Facilities and Illegal Propaganda." I heard about the scandal in England where I was living at the time. The 1953 North Carolina papers covered it with yellow headlines and thug-like photos of Ab: "Red Propaganda Mill in N.C."

Senator William Jenner was the chairman of the subcommittee that

included Senators Hendrickson, Welker, Eastland, Smith, and Johnston, plus Richard Arens, and a few other staff members. Welker and Eastland were famous red-baiters.

The charge was that Ab and Minna allowed or collaborated with Communists to print subversive literature in the back of the store advocating the overthrow of the American government. The main witness was Paul Crouch of Moravian Falls, North Carolina, a turncoat Communist and paid informant.

I didn't actually know the details until fifteen years later in the mid-Sixties when I read the text in the *Congressional Record* in the Duke library. It was missing (stolen?) from the UNC library. The small print brought youth's ecstatic dreams flooding back, the image of Ab's store in its heyday, Ab sitting there as if time had stopped. "The business there was like our business has always been conducted," he testified, "that is, anybody comes into the store and he wants 1 book or 5 books, and he hasn't got any money, or wants to charge it, he charges it by saying 'I am Thomas Smith.' That is all. No record is made of where he lives, it doesn't matter. If he wants to pay for the stuff later on, he can; if he doesn't it still doesn't matter."

The senators couldn't pin down whether he was having them on or really was the tar-brain he purported to be. The indiscriminate mixture of sublimity and red-clay yawl wasn't a style they were familiar with. Welker asked Crouch if it was fair to assume Minna "was the more dangerous Communist. Is it true that she was sent to Chapel Hill, N.C. to marry Mr. Abernethy, who impressed the chairman of this committee as not being too bright?" "My conclusion is that that is correct," said Crouch.

Ab took the Fifth for everything.

Senator Welker said — the words sound like an accusation: "You have never been a Communist, have you?" Ab answered: "I refuse to answer that question on the grounds that it might tend to incriminate me." "How could it tend to incriminate you when the question was 'You have never been a Communist, have you?' Being a Communist does not mean you committed a crime. Have you understood that?"

Ab blew his bassoon the rhythm of the Fifth to their melodic lead. "Why do you keep playing around with me, Mr. Abernethy?" asked Welker. "I don't mean to be playing," said Ab.

But Minna got them on the word *intimate*. They asked her: "What is your church affiliation?" Mrs. A: "I have no church affiliation." "Are you an atheist?" "No, sir." "Whom do you know on the faculty of the University of North Carolina?" "I know most everybody." "With whom have you been in intimate contact in your extracurricular activities?" "I don't know what you mean by 'intimate' contact."

Richard Arens interrupted: "Did you ever participate in a movement in North Carolina, advocating that the University of North Carolina should accept Negro students?" "What do you mean by movement?" "What have you done in advocating that the University of North Carolina should accept Negro students?" "That is a very general question. I don't understand it." "Have you done anything at any time to advocate the acceptance by the University of North Carolina of Negro students?" "I can't offhand, think what I have done." "As a matter of fact, you have been directed by the Communist Party to do just that in Chapel Hill, N.C., have you not?" "Is that a question?" "Yes, that is the question." "I decline to answer that on the same grounds as previously stated," she said.

The mimeograph wasn't a mimeograph, it turned out, but a beat-up offset press worth less than $500. The process of questioning hit on Ab's connection with the known Communists who'd set foot in Chapel Hill, and on which persons had access to the "back room." Did Ab know "a gentleman by the name of Junius Scales?" Scales, whom everybody knew, publicly declared his Communist Party membership in 1947 as organizer in North and South Carolina.

"Did you know Dr. Ericson?" "I do." "Do you know whether or not he was a Communist?" "I refuse to answer that question on the grounds it might tend to incriminate me."

Could he name any employees? "Yes, sir. Kemp Battle Nye." "Who did you say?" "Mr. Nye." "I mean before that." "His name was Kemp Battle Nye." "N-Y-E?" "Yes." "Where was he from?" "He was from up in a

place in North Carolina called Bradley's Creek." "He was named for the former president of North Carolina, wasn't he?" said Smith bemused.

What was the origin of the bookshop, and who were the cronies who'd started the other Intimates? It turned out that besides the Buttitta's Durham Intimate, there'd been a Greensboro Intimate, started by a Tom O'Flaherty.

"Did you ever know a man by the name of O'Flaherty?" asked Smith. "I did." "How did you come to get acquainted with him?" "He was — " Welker broke in: "What is his first name?" Ab: "Thomas O'Flaherty." "When did you meet him first." "In the middle thirties. I just don't know." "Were you kids together going to school?" "No, sir. He was a boxer there at the university and worked part time for me." "Is he around Chapel Hill yet?" "No, sir." "Do you know where he is?" "He is dead." "He is dead?" "Yes, sir."

And what were the business arrangements with O'Flaherty? "I don't recall the exact setup or anything. Mr. O'Flaherty, as I recall . . . wanted to go into business and I had a lot of books I would like for him to — you know, to help sell in Greensboro." "Communist books?" "I refuse to answer that on the grounds that it might tend to incriminate me."

Did Ab really do business in such an offhanded way or was his vagueness a smokescreen for a communism which he was, under party orders, exporting from Chapel Hill? Ab smiled. Smith: "Do you think that is very funny? I notice you are laughing about that. Do you think it is very clever and funny that you refuse to answer that question?" "I don't recall laughing or — " "Maybe I have taken unfair advantage. I would not do that for anything." "Why — " "You are getting right down to my old home place in Greensboro now where my mother and father and five brothers came from, although I never lived in North Carolina," said Smith, Southernly patriotic, as if Ab by existing were dishonoring his life.

The trail led at last to the partition in the bookstore that was supposed to have blocked off the printing press to do its dirty work. Eight pages of testimony in which Ab explained the building's anatomy.

They even had him draw a diagram. The word *intimate,* mulched in their minds like a pornographic maggot, kept crawling out of their mouths. "When you had this bookshop, Mr. Abernethy," said Arens, "was there a rear compartment to the shop which was not intimately connected from the standpoint of the sale of books with the rest of the shop?" "I don't understand what you mean," said Ab.

Eastland: "I believe you state here that on one side [of the partition] there was an opening that you drew on the diagram — " Ab: "There are openings on both sides." "As I say, on the left side there was an opening 5 feet wide and on the right side an opening 6 feet wide?" Ab: "I meant about 5 or 6 feet wide — they were both about the same." "And then in the center was a partition?" "Yes, sir." "You say you stored stuff back there?" "Yes, sir . . . As I recall the original building, there were two counters starting at the front of the shop on each side of the wall that ran on both sides all the way back." "With the wall?" "With the wall with shelves above the counter. It had been a grocery store."

"At the back, after you opened your bookstore there — " "Yes." "Was there a counter that ran across the store?" "There might have been a table or a counter in front of the solid part of the partition as a display." "That is right." "Yes, sir; there might have been." "Now that counter would bar the public from going behind the partition, would it not?" "No sir. The counter, if there had been a counter or table, would be up against the partition." "Up against the partition?" "Yes, sir." "Did the public have access behind the partition? Did . . . people go back there?" "Well, there was a toilet on the left-hand side and people would go back there."

"What else was back there? . . . Did your employees go back in this back . . . this place behind the partition?" "Certainly." "You state that aside from books that you stored back there, and the stove, there was nothing back there, nothing else back there. Is that your testimony?" "There was a toilet back in the back part." "All right, sir, the toilet. The toilet, the books, and the stove. . . Did the public have access to it?" "Yes sir." "The public used your toilet back there?" "Yes, sir."

"What people went back there? Name some." "I don't recall specifically anybody."

"How long were you in business there?" "Twenty years." "Twenty years. How many years did you have the partition there?" "I don't recall the number of years." "I say, for a number of years it was there, wasn't it?" "Yes, sir." "It was open to the public?" "Yes, sir." "And do you not remember a living human being that walked back there. Is that your testimony?" "I remember walking there." "Who else?" "My wife." "Who else?" "And —" "Dr. Ericson?" "Not that I recall." "What?" "Not that I recall."

"Did O'Flaherty walk back there?" "I guess he did." "You know he did, do you not?" "I have no — I don't recall going back there." "How did he die?" "He was killed." "Where?" "I heard he was killed in Spain." "When?" "During the revolution. He was killed in Spain some time in the thirties."

In the rehash afterward, people said Ab and Minna must be guilty since they took the Fifth all the time. The newspapers answered piously that the Fifth was an American right but they were smug about Ab's comedown.

"We have lived in Chapel Hill for 20 years, all our adult lives, and our opinions and actions during that period are widely known, as we ourselves are, to everybody in our town. . . ." This was part of the text of a joint statement Ab and Minna published when the questioning was over. They denied ever having done "anything disloyal in our lives. . . . We feel that in our own small way we have played a part in resisting the climate of hysteria which the investigating committees are attempting to foster."

The statement was embarrassing rather than reassuring. Besides, nobody wanted to acknowledge heartbreak in their homegrown rapscallion — that touching expression "our town" hit a nerve.

The town liked it better when they discovered what he was up to in New York, where he moved. "There is a stock brokerage firm on Wall Street in New York . . . Morton, Morton and Abernethy," wrote Jake Wade in the *Charlotte Observer*:

Now hold your hats! The young capitalist who is a junior member of the firm is none other than Milton A. Abernethy, alumnus of . . . old friends of Ab here laugh at the irony . . . but they are not especially surprised. . . . They say he's making a lot of filthy lucre, which is a sacrilege to Communists. But he always did that. He's a born money-maker. He's still a big land owner in Chapel Hill, has lots of income-bearing property. He may have been a Communist back in the thirties when young strong-minded men fell so easily to the gimmick in emotionalism and idealism, but his politics or whatever it is never interfered with his own proclivity for raking in the dough. Maybe he was a Communist without a conscience.

The Chapel Hill Weekly bravoed Ab for getting the last laugh, but university dignitaries still tried to distance themselves. *The Durham Herald* reported: "Gordon Gray, president of the university could not be reached for comment. . . . Robert B. House [who had been dean of administration from 1934 to 1945 and was made chancellor when its three branches became consolidated in 1945] said the situation 'had nothing to do with the university.' Then he added curtly, 'I can't help who lives in Chapel Hill.' "

That the investigations occurred fifteen years after the events is an irony on the same order as the conspiracy of silence that has been maintained for the half century-plus since. Once the disgrace had been played out, Ab retreated to the cold place behind his mask which had always been inviolate. But he visited Chapel Hill often, and not incognito. In the Sixties, in a similar spirit to the start of the Intimate, his daughter and former son-in-law founded the Carrboro Art School.

The book of forgetting cannot stop continuity. But at the end he wanted no obituary. "Who wants all that stuff raked up again?" If a talk show host had babbled: "What does Milton A. Abernethy want to be remembered for?" his first reaction would have been: "Who's ever heard of Ab?" But under the circumstances, he would have taken the Fifth.

There used to be a statue of Chancellor House in the undergraduate

library (making him look like a bronze pig). It had a nose shiny from the rubbing students gave it (without a notion of who he was) for luck on exams. After the 2000 millennium, a new pewter-colored bust of Chancellor House appeared with an auspicious, authoritatively dignified face replacing the bronze pig-faced statue. Although a few people in the know have tried to rub the new one's nose, to what effect in the days of grade inflation is unknown.

Although the Intimate went on to be a Kuralt form of gestalt, Ab, censored out of memory, is the great Chapel Hill secret waiting to be discovered.

Contempo is a collector's item. Copies which originally sold for 10 cents are now worth upwards of $150. A spinoff from *transition*, it made international writing a Chapel Hill concern and predicated the importance of writers before they were classics. The publication in its pages of Beckett, Faulkner, and Joyce alone make it a phenomenon.

Since *Contempo* didn't pay authors, how did Ab get the big names? Charm, gall, sharp practice? Jumping for the throwaway stuff writers couldn't place elsewhere or were glad to get published? Letting writers answer bad reviews of their books? Giving them the opportunity to spout forth on controversies? Ab offered a platform and administered proper doses of flattery and insult. He was good at playing with people. He and Buttitta wheedled, finagled, goaded, or browbeat, and they weren't impeccable about copyrights. They oiled what needed oiling.

When Gertrude Stein and Alice B. Toklas visited Chapel Hill in the early Thirties the only place Alice B. Toklas wanted to go was Ab's. She wanted to extract the money he owed for the Gertrude books she'd sent the year before on request.

And when Faulkner was attending the writers' conference organized by Ellen Glasgow in Charlottesville, Ab and Buttitta showed up and drove him to Chapel Hill. Kemp Nye, though only fifteen at the time, was reputedly sent to buy bootleg hooch in Durham to keep the future Nobel winner lubricated during the Chapel Hill part of his famous two-week drunk.

They drove Faulkner to New York in Paul Green's car to attend the performance of *The House of Connelly*. There Faulkner's publishers inveigled Ab and company to keep an eye out and not let other publishers steal him away. After Faulkner sobered up, he swore to his publisher that Ab and Buttitta had kept after him so relentlessly that he finally said yes to everything, and lost a page of *Light in August* in the bargain, left under a bed in some Franklin Street rathole where he'd passed out.

If history is not to succumb to its Kunderan definition as amnesia, then Ab must be recognized as certainly as the fall of the Berlin Wall. Humanism dies when the academy won't risk hemlock. And communism has no monopoly on the book of forgetting. In the famous photograph of post-expungement Dubček (Czech politician and leader 1968 – 69) his shoes remain where his body was edited out, leaving two people with three pairs of shoes.

Wallace Kuralt, brother of Charles, ran the Intimate for more than two decades. In the fickleness of time he became known as its originator, a Renaissance man of books, a symbol of the bookstore. He went bankrupt in the Nineties, leaving the name to roam, a ghost looking for its origin.

If Ab was the gatekeeper to the imagination in Chapel Hill, the word *Intimate* still remains, a talisman of all booklovers' addiction to that kind of truth, a holy and unholy center of a passionate universe that can't be denied.

I Call My People

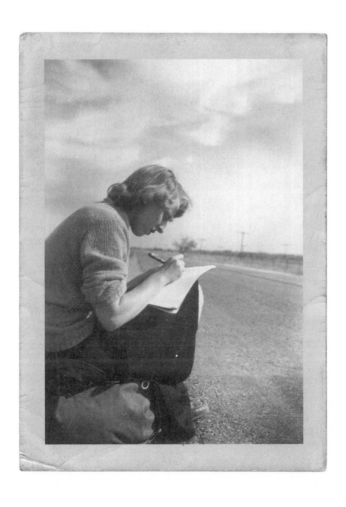

The Spirit of Play

"AFTER ALL EVERY century has to be made by somebody being something and it is difficult to do it again, and anyway when it is done it is done and having been done it does not take any time to begin again," said Gertrude Stein in *The Making of Americans*. She was talking about context, but flouting it with the great American idea, Continuous Present. "In the *Making of Americans* I was making a continuous present, a continuous beginning again and again, the way they do in making automobiles or anything. . . ." she bragged.

Jorge Luis Borges concocted the ultimate joke on the idea of *context* in his boring, fascinating story, "Pierre Menard." A writer by that name has one ambition — to write *Don Quixote* — not a different *Quixote*, which would have been easy, nor a mechanical transcription, nor a copy, but the actual *Quixote* itself. He wasn't interested in situating Christ on a boulevard, Hamlet on La Canebière or Don Quixote on Wall Street. Borges considered such tours de force obvious, parasitic, and plebian pleasures of anachronism. They implied that "all epochs are the same or are different." He has Menard spend years drenching himself in seventeenth-century Spanish and then discusses the fragmentary *Don Quixote* he produced.

"Cervantes' text and Menard's are verbally identical, but the second is almost infinitely richer." (More ambiguous, his detractors will say, but ambiguity is richness.) He then compares a fragment which he prints out twice, as if it were different the second time when Menard writes it from the first time when Cervantes wrote it. ". . . truth, whose

mother is history, rival of time, depository of deeds, witness of the past, exemplar and adviser to the present, and the future's counselor."

He says that when written in the seventeenth century by the "lay genius" Cervantes, the enumeration "is a mere rhetorical praise of history." But as written by Menard the idea of history as the mother of truth is astounding. "Menard, a contemporary of William James, does not define history as an inquiry into reality but as its origin. Historical truth, for him, is not what has happened; it is what we judge to have happened."

Such typical philosophical turnings over and up and down are gamesmanship whose pleasure, nonetheless, demands historical knowledge.

In real life why is Chapel Hill such a singular and literary place? It seems to have always been. But was it? Is it? To figure this one out, historical knowledge is necessary.

In latter days whoever has an axe to grind, whoever wants to sell his brand of vintage Southern, trots out names. What with the rabid development — a black old-timer described it in the following terms: "They took down the whole town and put something else up in its place" — even the people who've lived through many of its eras don't understand it.

In 1940 the town was a most provincial place, with 3,000 students. At the same time it had sophisticated connections with political ties to the New Deal and Franklin Delano Roosevelt, and literary ones to the New York theater. The professors were either revered or reviled, the writers were mostly revered. Everybody was self-conscious and idealistic, passionately so. Frank Porter Graham was president of the university. People saw themselves as individuals, the town was small, the horizon, if you could see it through the trees, large. No Texas developers. No such thing as the Sunbelt or strip malls. You could not broach the subject of *literary* without considering Proff Koch or Ab's bookshop.

In the early Nineties, alias the Era of Money, the Grateful Dead put on a concert in the Dean Dome. It attracted swarms of Sixties tie-dyed clones from all over the nation. Simultaneously, in the basement of

the Carolina Union, a student alternative group was performing original stories written by creative writing students. The place looked like the old Graham Memorial's Fifties Rendezvous Room, painted black walls, a bank of stage lights, and tables with candles.

One of the stories, called *The World We Wanted,* was inspired by Louise Glück's poem, "Gretel in Darkness." A student-actress played a fierce, androgynous Gretel who undertook to save herself and Hansel by becoming Hansel, since he was trapped in the cage. Hansel and Gretel of course didn't trust the parents. That's why Gretel picked up the crumbs. Unlike Thomas Wolfe, they had no desire to go home again.

Gretel not only killed the witch, she dwelt gorily on the details. She reveled in her power, exploded the differences between male and female. "This is the world we wanted / All who would wish us dead are dead," she says, lines from Glück which are used as the story's epigraph.

There was always a dichotomy in Chapel Hill between authentic art and consumer art. A watershed occurred when the Dean Dome was finished and when the Playmakers became an Equity (paid) repertory. The university split off from the town and cynically used its preeminent arts alumni — the Kay Kysers, Charles Kuralts, and Andy Griffiths — as PR.

This dichotomy between low and high art in the town, between the collective and the individual, mirrored and still mirrors the national scene. Ever since America overthrew kings — European kings supported the Mozarts, Shakespeares, Bachs, and Raphaels — American artists have had to haul our European heritage around, to try, without losing authenticity, to integrate it with common-man art. How else to avoid being branded elitist or arty-farty?

The Chapel Hill tradition was always solidly common. *Folk* was flaunted for the first half of the twentieth century so successfully that later generations had no idea it didn't come from over thar yon mountain. It came from the international movement sparked in Eastern Europe. Later generations believed Proff Koch invented *Folk* and put it on the map every Friday night of the summer in the Original Plays series.

Frederick Koch and Paul Green. Courtesy of the North Carolina Collection, University of North Carolina at Chapel Hill.

Yet the folk style sneaked into novels and music to such a degree that contemporary writers and musicians would laugh if they heard it had been an international political movement. They don't acknowledge it, don't think about it, don't know what they come from, and don't care.

Here is where Thomas Wolfe comes in. For he was the legacy Chapel Hill was claiming in 1940. He was newly dead and very famous. He had set out from Asheville, come to Chapel Hill, took classes from Proff, and was determined to be a playwright. He failed at that of course, but the unabashed lyrical extravagance of his language, "A leaf, a stone, an unfound door — O Lost, and by the Wind Grieved, Ghost come back again," formed the melody of the recognizably plebian music of North Carolina.

The folk plays of the late Twenties and Thirties flaunted his combination of mountain illiteracy and lyrical English poetry. Historically, factually they were the same thing, for in the backwater of swamp and

mountain the language of those centuries *kept* and *stayed.* The miracle is that the traces are there still; you find them in the language of John Ehle, Fred Chappell, Lee Smith, and others who come from and write about the Appalachian mountains.

Paul Green was the linchpin of this music. By 1940 he was sitting at the Round Table of North Carolina literature, having triumphed on Broadway, having won the Pulitzer for *In Abraham's Bosom* in the late Twenties. Those plays of the Twenties and Thirties, *The House of Connelly, Hymn to the Rising Sun,* and *Johnny Johnson,* conveyed both the style and content of the period.

In his latter days he allowed himself to be portrayed as the Tolstoy of Chapel Hill, his Yasnaya Polyana being that stretch of land now called Greenwood. But in that era, like Faulkner, he forayed into Hollywood, returning with loot and buying up land in Chapel Hill and in Johnston County. He was in his prime — money, success, and fame — and he was on the eve of leaving what we used to think of as his *serious* writing. He was switching to what he called his *symphonic dramas.*

Now in the twenty-first century he is remembered more for *The Lost Colony* and the Paul Green Theatre than for his plays. Back then it was as if he had used up his personal vision and was left with the rhythm and music alone, applying it to a public, social art — pageant, dialogue, dances, and music dedicated to history.

The question is: Is his history history, or is it myth?

The aesthetic judgment of the younger generation in those days was that the real writer makes a myth of himself and his experience as he is living it. Thomas Wolfe did that. He was prototypical in seeing his own legend while he was writing it. There is a relationship between the individual, perceptive world of a writer who sees his own experience from the inside as well as the outside, and creating a reality which becomes the legend. The world of legend in novels, we thought, was the world of Self-Myth, and therefore was the world of individual truth.

Such thinking is still what drives people to try to write the great American novel. Thomas Wolfe was that kind of writer. Just when he died, Paul Green, sixteen years older, was consolidating what had

always been his social, encompassing Christian vision, inclusive and tolerant of all races, into historical myth.

In the late Thirties when I came to Chapel Hill, Horace Williams, Howard Odum, Proff Koch, the late Thomas Wolfe, and Paul Green were the resident legends. All were Southern except Proff. Our high school generation breathed them in with little idea of what they were about. And since the death of Paul Green, they are fixed harder than ever in the firmament. But like all institutions they remain resistant to time while their meaning escapes us.

Odum intellectualized the common-folk idea in the new field of sociology in the Twenties. Exposed to Freud at Clark University and distrusting Southern social infrastructures, he started the Institute for Research in Social Science to investigate problems of mill villages, tenant farming, and the "Negro field." He ran into the roadblock of fundamentalism and retreated from systematic, scientific sociology, redirecting his passion in later years into writing a half-mystical epic similar to contemporary nonfiction novels. He wrote a trilogy of the real-life adventures of a black road-construction laborer called Left Wing Gordon (he'd lost his right arm), and other characters such as Rainbow Round My Shoulder, Wings on My Feet, and Cold Blue Moon, which nobody now reads.

Odum's colleagues remained meticulously scientific. They described his teaching with admiration and doubt. "We had a course with him when he ... hardly made a single statement," Arthur Raper, one of his well-known researchers, said. "Question, question, question. . . . What kind of wages will the textile industry pay? What will they do with the Negro?"

If this seemed squishy in Odum, it was the foundation of Horace Williams's teaching. Challenge. His life was a reliving of the enlightened humanist period, an attempt to merge narrow Christian ideals with Greek ideas. He studied philosophy and found satisfaction in devoting himself to teaching students the way Socrates did in the agora — by dialogue.

Thomas Wolfe called Horace Williams Vergil Weldon in *Look*

Homeward, Angel, a Hegel in the Cotton Patch, who "specialized in the forced marriage of irreconcilables . . . Socrates begat Plato. Plato begat Plotinus. Plotinus begat St. Augustine . . . Kant begat Hegel. Hegel begat Vergil Weldon . . . Here we pause. There's no more to beget."

But Horace Williams begat Thomas Wolfe. And he also begat Paul Green, who lasted till the Sixties. Green left Buies Creek Academy, which later became Campbell University and where fifty years later novelist Clyde Edgerton was forced from the faculty because the administration didn't like the theological and social implications of his novel, *Raney.*

Paul Green's express purpose in coming to Chapel Hill was to study with Horace Williams. Though his college was interrupted by two years spent in military service in Europe in World War I, he did. He took playwriting with Proff too.

Hard-nosed and practical as he was talented and lyrical, Green got the English and philosophy departments fighting over him when he finished. English offered him $500 to become an instructor. Horace Williams raised the ante to $1,500 and got him for philosophy. Green wrote a thesis on Thomas Hardy, taught aesthetics, wrote plays, went to Broadway and Hollywood, and won the Pulitzer in 1927. Then using Chapel Hill as a base, he joined forces with Proff.

Proff, the non-Southerner, was an enthusiastic parvenu from Dakota who Madison-Avenue-ized the Playmakers to national fame, and who applied the vocabulary of *folk* to Carolina product. In his first class, Dramatic Composition, a practical course in writing plays, there were thirteen students: Thomas Wolfe and twelve girls. "We have a lot of he-men secretly interested in writing here," Wolfe told Proff, "but they are all disguised in uniform." He was too young to go to war.

"Our folk plays are conceived of folk subject matter and legends, superstitions, custom, environmental differences, and vernacular of common people," Proff explained publicly. He got hold of a painted bus and took the Playmakers on tour decades before electric-Kool-Aid-acid tests. Coasting into New York, Washington, and Richmond on the idealistic currents of the age, he let Barrett Clark of Harvard,

Brooks Atkinson of the *New York Times,* Walter Terry of the *New York Herald Tribune,* and the Group Theatre into his Southern secret so that not only did they review the plays, they started coming to Chapel Hill to participate in festivals. Proff played favorites, but touted the whole. Cornelia Spencer Love, one of his first Playmakers, wrote: "His critical faculties were somewhat in abeyance. All his geese were swans."

Although women's presence in the university was scarce in the Teens, Twenties, and Thirties, they were a major animus at the Playmakers. The first play, *When Witches Ride,* put on in the high school auditorium in 1919, was by Elizabeth Lay who became Paul Green's wife and gave up writing for children and Paul's career. Fanny Gray Patton, who later wrote the bestseller, *Good Morning, Miss Dove,* was the author of *Out of the Past,* one of three plays chosen to premiere at the opening of Playmakers Theatre in 1925. Thomas Wolfe's *The Return of Buck Gavin* filled out the bill which the *Daily Tar Heel* reviewed as "the poor bleeding corpse of Art at Carolina."

Loretto Carroll, in the same class with Wolfe, made more of a splash than he. While still a Winston-Salem high school student, she attracted the attention of J.O. Bailey, her teacher, when she wrote *Strike Song* about the violent Gastonia strike of 1929. The strike resulted in the imprisonment of workers, including three women, and spurred the labor protests of the Thirties throughout America. She married Bailey, and they moved from Winston-Salem to Chapel Hill when he became an instructor in the English department. They joined the literary bohemians.

Loretto Carroll also wrote *Job's Kinfolk,* about three generations of millwomen, which the Playmakers took to New York in 1931. When *Strike Song* was reviewed favorably by New York reviewers, she and a friend walked along Second Avenue pouring on their Southern accents in loud voices and laughing as heads turned. As much as anyone in the Playmakers, she contributed to melding the folk tradition to the lyrical political style of the protest movement. Later in her lifetime when the protest movement waned, her work too faded from public attention.

Between 1925 and 1945, the people who established themselves as

the burgeoning talent of the Playmakers included Kay Kyser, Legette Blythe, Vermont Royster, Don Shoemaker, Charles Edward Eaton, Betty Smith, Lillian Prince, Foster Fitzsimmons, Earl Wynn, Josephine Niggli, Cornelia Love, Shepherd Strudwick, Howard Richardson, Jack Palance, Andy Griffith, Louise Fletcher, Eugenia Rawls, and Fanny Gray Patton. Some of them were students, some faculty, some actors, others writers, and still others both actors and writers and musicians as well. Many went on to recognition on Broadway and in Hollywood.

Bayard Wooten, the photographer, was drawn to Chapel Hill in the Thirties and Forties because her interests coincided with the prevailing social movements. In tandem with her brother she saw an opportunity to make a living for herself and her children through photography. She was midway in her life and had a studio in New York. Unrecognized as a major American artist during her lifetime (1875 – 1959) she is often compared with Doris Ullman and Walker Evans and has been the subject of an exhibition in Wilson Library and a biography, *Light and Air,* by Jerry Cotten.

Wooten was born the scion of an old family in New Bern. After two failed marriages and a five-year stint teaching the deaf in Arkansas, she was given an 8 × 10 contraption of a camera. Talking her way into a contract to photograph National Guard servicemen and Fort Bragg, she became so familiar walking around with a huge camera on her back that they called her "The Sandfiddler." After working in New York, she opened a studio in Chapel Hill, supporting herself and her two children, contracting for the *Yackety Yack,* the university yearbook, and for the Playmakers.

She did photos of flowers and old houses as illustrations for books, going on shoots with horticulturist Bill Hunt. But it was her photographs of the hill shacks, mountain faces, ancient houses, Negro workers, and sweating farmers of the Thirties that inspired public recognition, and led to her posthumous reputation. The state has erected a historical marker at her birthplace.

The North Carolina Symphony too was born in this ferment. Lamar Stringfield, a mountain boy in the 105th Engineers in France, met Paul

Green during World War I. Stringfield was a flautist and composer, and from the days he'd grown up near Asheville he'd brooded on the use of ballads as motifs in symphonic music (like "Going Home" in the Dvorak symphony) and dreamed of a symphony orchestra. In 1928 he won the Pulitzer Prize for an orchestral suite, *From the Southern Mountains*. "He could make a stick sing," said Bill Hunt.

In 1931 Stringfield came to Chapel Hill and created the Institute of Folk Music merging the ground between music and the Playmakers and Odum's social view of America. In 1932 in Frank Graham's office, he initiated an idea of a symphony made up of local, unpaid musicians and funded by government programs. Although the musicians weren't paid, the orchestra by 1935 had played 140 concerts in 50 towns in North Carolina with at least one piece of American music on each program. Despite attracting some funding, the enterprise was bankrupt.

Ben Swalin jumped into the vacuum. Since he had always wanted to conduct, and the music department's focus was on musicology, not performance, he resigned to give his energies to the symphony. If you don't have an orchestra, make your own. With the support of Frank Graham he went on the stump for a self-supporting symphony, his concept being to bring classical music to the boondocks, a kind of reverse notion to Proff's bringing the boondocks to the university.

Swalin's efforts were in the American Chautauqua tradition. His wife became his partner, and the Swalins became passionate pioneers of symphonic music in small-town Carolina. They trained musicians and had them play in school gyms and auditoriums around the state, converting people who had never heard such music nor seen such instruments. They started a children's symphony, called the Little Symphony, in which Chapel Hill children played (my sister, a violinist, among them), honed their talents, and even went on tours to Richmond. They fought off discouragement.

In Winston-Salem an official of corporate backers warned Swalin: "They want hillbilly."

"Do you have a son at Chapel Hill?" Swalin countered. "Do you suggest the university dump courses in mathematics, physics, and philosophy?"

"But that's different," said the man.

"Put a burlesque show on Franklin Street and then offer them only the courses and music they think they want," answered Swalin.

The effect of the Roosevelt programs can scarcely be comprehended. The WPA underwrote Playmaker tours and salaries (Betty Smith and others were on the Federal Theatre Project). But Swalin went the private route, and set up a symphony society with backing from town figures like Paul Green, Hugo Giduz, Johnsie Burnham, Adeline McCall, and Colonel Pratt, and borrowed $200 from the bank. Frank Graham arranged for an office on Columbia Street, and J.O. Bailey took off from the English department to organize. By the 1940s the symphony had received state funding and a firm commitment to its preservation and values.

But in the beginning, in the early Thirties, Bill Hunt, an undergraduate art organizer at the time, told a story about the day Mrs. Frank Porter Graham called to ask Bill to give a party for the Press Box people after a Carolina/State game. Dr. Frank, as they called Frank Graham in those days, was away. "Make it arty!" she said.

Bill belonged to the Episcopal choir and glee club, played hymns in Duke Chapel once a week, majored in botany, and danced eurhythmics along with Foster Fitzsimmons in an avant-garde dance group pioneered by a Monsieur Dalcrose of France. He also had ins to Winston-Salem money.

For the post-game party, Bill got teacups, featured the paintings of a Winston-Salem woman artist, and held the affair in Hill Hall. It was such a success that the next year he helped organize the first Dogwood Festival in the South and every artist from Asheville to Wilmington brought folk art, music, quilts, sculpture, plays, paintings which were housed in campus buildings and filled Franklin Street for two days. "Everything new starts in Chapel Hill," a Georgia woman who wanted to start an Atlanta festival told him.

Person Hall was where painting, life drawing, and art history classes met in the Thirties and Forties. The second oldest building on campus, it was the perfect place, quiet, tree covered, and well lighted, and

Katherine Pendleton Arrington, an art lover with money, had it reno-
vated in 1936. The atmosphere was genteel, quieter than the Playmak-
ers. It was like a secret to go there, take a life drawing class, and talk
about which came first, the outlines or the color, while above the leaves
whispered and the statues hinted of something before America.

When the New Deal pumped federal money in, a dam broke and
the response amazed everyone. It inspired a Friends of Person Hall So-
ciety to pay for exhibits. Students and townspeople flocked to see In-
gres, Moholy-Nagy, and Mondrian. John Alcott, Kenneth Ness, Rus-
sell Smith, and Joseph Sloane came to teach. William Meade Prince
was department head during the war, and the circus drawings he had
done as a child were carved into wood and became a campus artwork.
Symbolic perhaps of the antic, joyous march of education.

The romantic notion of a small town being an Athens of the South
was not so ludicrous in those fervent, earnest days. There was no
20,000-member student body, no medical school, no research centers,
no big federal money. Chapel Hill was a small, natural place in a yeo-
man state stuffed between slaveholding Virginia and South Carolina —
ergo not so far to fall — the warren of progressive ideas pushing the
South into the twentieth century. The proportion of intellectuals was
large, and below the gentility there was a high degree of sophistica-
tion. Families used to go for persimmon pie to Mrs. Klutz's boarding
house on Sunday evenings, joining younger professors and graduate
students who lived there in complex and witty conversations. It was a
utopian kind of place where nobody had much money and the notables
weren't that notable, despite connections to New York or Hollywood,
because they lived just up the street.

By 1940 that folk movement was over the hill. Everybody knew it
when students from New York started writing plays featuring moun-
taineers spitting tobacco under pink gel lights. But the spirit of play
itself had always underlain the town's character, and the university was
all of the town's parts.

When the Playmakers didn't have anybody to play the old Arab

philosopher in Saroyan's *Time of Your Life,* they got my father, because he was a Greek. Urban Tigner Holmes, the comparative literature professor, always played Caliban and the gravedigger in *Hamlet.* Vermont Royster wrote a play about financial types. Betty Smith played a Christian princess.

At one Friday's Original Plays Night, Dr. Helmut Kuhn, the German philosophy professor, reacted to a pimply student's five over-ripe *damns* with an obscene scratching, accompanied by hocking and spitting, finally standing up, proclaiming: "I haff never sat through anything so dizguzting in all my life! Not even in Berlin!" and walked out.

Lillian Prince, the tippling actress-wife of William Meade, played a conjure woman and also Queen Elizabeth in perpetuum. During every performance the audience waited with bated breath for her to fall off the throne.

Proff orated Dickens's *A Christmas Carol* for twenty years in a plum-pudding voice, and when he died, Earl Wynn did it for another twenty. The tradition was carried on to the end of the twentieth century by William McCranor Henderson, the novelist. Since then Dickens's classic has graduated out of Chapel Hill to become a Triangle tradition. In the twenty-first century, it is performed by different Scrooges, including novelists Allan Gurganus and Michael Malone in Hillsborough.

In the time of the Thirties and Forties the style of language, both spoken and written, was redolent of the passionate social tradition risen out of the Depression and communicated in movies, radio, and literary works, a plebian musical rhythm involving repetition of dialogue. It was the style of Chapel Hill. On the national scene the cadences could be heard in the Group Theatre in New York, particularly by Clifford Odets.

Ben Hecht was good at that kind of dialogue too, mixing the proletarian with the fancy. He concocted the phrase "minuet in a wastebasket" in the movie *Spectre of the Rose.* Every word of this plebian rhythm was heavy with metaphor and self-consciousness. The substratum of its meaning was predicated upon the nobility and oppression

of the common man and the black man in the dream and promise of America. Faulkner had written his novels in the patrician strand (mixed with a vernacular Southern writing and idiom), but he was belatedly recognized. Snopes didn't count in the Thomas Wolfe account of Chapel Hill.

In 1943 to dedicate the new Forest Theatre, Proff announced: "The same skies that lighted the stage of Shakespeare, the same stars that looked down on the stately theater of the Greeks and listened to the timeless poetry of Sophocles more than 2,000 years ago, look down on us serenely still in Chapel Hill." Coeds in cheesecloth flitted across the Foster Fitzsimmons's *A Midsummer Night's Dream* set, breathing: "Oh, the mewn shines over Athens tonaght."

From 1930 to the end of the Forties you couldn't talk about literature without including Ab's. The Intimate was focal to the visits of national and international writers, because of its mix of literature and politics. The place was dilapidated, the style good ole boy, the politics Communist and colorful. The tolerant small town mixed shrewd, rube, and high art.

In the early Thirties Cornelia Spencer Love heard that Gertrude Stein and Alice B. Toklas were at Sweetbriar. As head of the local branch of the American Association of University Women, she invited Stein to speak and installed the two women in the Carolina Inn.

Stein's reading in Gerrard Hall was a hit. People were surprised she made sense. Even more transparent, Mary Louise Huse's mother used to say, was Miss Stein's dress which was made of linen with such loose threads that you could see right through it.

Sherwood Anderson came to Chapel Hill too. But he was respectable and didn't create scandal.

Clifford Odets came. Paul Green invited him for a drama festival in 1940 but didn't formally ask him to speak "... probably for the reason that I am a radical," wrote Odets in his autobiography, *The Time Is Ripe*. In the depths of matrimonial woes over his wife, Luise Rainer, he set his sights on Ouida Campbell, Paul Green's secretary, who reminded him of Cleo Singer, the heroine of his play *Rocket to the Moon*.

He went to her "poor house" in Carrboro where, because of his fame, "the mother refused to come in and meet me because her hair wasn't done up right."

He criticized Paul Green: "As usual with Paul, the thesis [of *The Field God*] had not been dramatized and the play was poorly constructed, containing, however, two very powerful scenes. Paul, if it's not too late, ought to work with another expert craftsman of a playwright for several years. After that he could put collaboration behind him and stand on his own feet. . . . Now he is frittering away his time and talent on pageants dealing with historical events in the South." After visiting Chapel Hill, Odets went on to Black Mountain.

Mac Burnett, who rented the outside kitchen at our Shack, told me when I was a university freshman how he had gone to Black Mountain for a weekend, and how all the people were crazy but were doing fascinating things. Black Mountain turned out to have been a unique movement, an experiment in the avant-garde, responsible for some of the most significant art and literature of contemporary America.

Among its students were Charles Olson, Lawrence Ferlinghetti, Allen Ginsberg, Robert Rauschenberg, John Cage, Francine du Plessix Gray, Robert Lowell, Josef Albers, Jack Kerouac, and Merce Cunningham, to name just a few.

But Black Mountain had the aspect of a utopian colony of art, while Chapel Hill was a provincial, but cosmopolitan town with curious spokes and ties to Washington, New York, and Hollywood. Black Mountain was rarified, dominated by artist *émigrés* from Europe. Chapel Hill was dominated by Jeffersonian democracy and a native strand of educational idealism — poor farm boys traveling on mules or walking barefoot from the other end of the state to get enlightenment.

With a foot in both camps — the respectable status quo and the avant-political — Paul Green by 1940 had become, two decades before the nondiscrimination acts, an amazingly successful advocate for blacks.

In 1939 Zora Neale Hurston (*Their Eyes Were Watching God*), the flamboyant, black Barnard graduate, folklorist, oral historian, and

member of what Langston Hughes ironically called the "black literati of the Harlem Renaissance" — which Zora, even more ironically, to prick his balloon, called plain *niggerati* — was at North Carolina College for Negroes (now North Carolina Central University). She was supposed to be developing a drama department there. But she was really spending a lot of time with Green and his writers' group. She planned to collaborate with him on a play — *High John de Conquer.*

"You do not need to concern yourself with the situation here at the school," she wrote Green from Durham. "I won't care what happens here or if nothing happens here so long as I can do the bigger thing with you. I see no reason why the firm of Green and Hurston should not take charge of the Negro playwrighting [*sic*] business in America."

She presented herself as a single woman, but unknown to anyone was married to a Florida man fifteen years younger, and in February 1940 quarreled with him. In a suit and countersuit for divorce, he testified he was "put in fear of his life due to the professed practice on the part of the Plaintiff in what is termed as 'Black Magic' or 'Voodooism,' claimed by the Plaintiff to have been acquired by her while living in Haiti and that she had the power both in spirits and in the uses of certain preparations to place individuals under certain spells and that if the Defendant would not perform her wishes she possessed the power to 'FIX HIM.'"

When she left NCCU, there was no visible drama department, but she had finished a new book, her third novel, *Moses, Man of the Mountain.* She'd also fixed her husband and made up. Perhaps less by cause and effect than historical imperative, fifty years later the territory of African American religio-spirit experience, mined post-Hurston by Alice Walker, Toni Morrison, and others, had new emanation out of Chapel Hill. UNC creative writing alumnus Randall Kenan deals with the territory in *A Visitation of Spirits*, his first book, and *Let the Dead Bury the Dead*, his short stories.

But the 1940 visit of Richard Wright to collaborate with Paul Green on the play version of *Native Son* is known to this day as a mini-scandal. When Carrboro toughs got wind that Ouida, the idealistic secretary,

had invited him to her house for a party to celebrate the finishing of the play, they threatened to "kill that nigger."

Dean House telephoned Green. "Your white secretary entertained this colored writer in her house last night, and a lot of people are up in arms about it," he said.

"Good gracious!" answered Green.

"Paul, you've just played thunder. I want you to get him out of town. When you asked me for office space . . . I knew that students and faculty would see him going and coming out of Bynum Hall and might wonder what was going on, but I trusted you to handle everything and not let anything like this happen."

The party did not come off. Wright left town the next day.

In the Fifties' Communism scandal, after Ab was forced to testify before a Senate committee, he had to leave town, disgraced. While Richard Wright abandoned America for Paris, Ab left Chapel Hill for New York, where he bought a seat on the New York Stock Exchange and made a fortune. It was not until the Sixties that any such raffish mixture of art and politics was to appear again.

In the Fifties the university followed the nationwide trend toward consolidation, buildings, and money. Proff had died, and in 1958 the Playmakers put on a parody in which an actor played the part of Sam Selden (who in real life had worked with Eugene O'Neill in New York before becoming Proff's first lieutenant) and uttered the line: "Eugene, I'm going down to Chapa Heel and do folk drama."

In 1958 a curious fate brought the Ackland Art Museum to Chapel Hill. Litigation had shrouded the bequest of William Hayes Ackland, an art collector descended from one of the social pillars of Tennessee — his mother was a member of the salon scene in Washington, London, and Paris in the days of Rutherford B. Hayes. Ackland offered his collection to Duke, Rollins, and Chapel Hill. Duke had been interested, but rumor was they didn't want non-Dukes interred on their campus. This made it impossible to fulfill the stipulation that Ackland be buried in the museum.

Chapel Hill didn't care. When the museum opened, people flocked

to stare at the prone statue of Mr. Ackland as if it were his body Midas-gilded instead of a sculpture over a corpse. They heaved and twittered at the bad taste, relishing him as a Tar Heel Tutankhamen without the stink. But the campus had an Ivy League tradition for self-deprecation. So the art department concentrated on a first-rate museum, disregarding palaver about its ghoulish secret being kept under wraps.

Phillips Russell had wryly and quietly taught a generation of media giants in his creative writing classes (Roger Mudd, Jim Shoemaker, David Brinkley, Jim Reston, Charles Kuralt, Tom Wicker, etc.), merely by telling them to bring on the bear. His genius was listening.

Wilton Mason, a musical/literary giant who had as a graduate student put on a witty musical hit, *Spring for Sure*, took over the music department when Glen Haydon died. Walter Spearman influenced a new generation of reporters, as well as Gail Godwin, the novelist. He wrote the history of the Playmakers. He also took over the syndicated book-review column, *Literary Lantern*, from Caro Mae Russell, Phillips's ex-wife and Paul Green's sister.

Women had finally been admitted to the university on the same terms as men, and Jessie Rehder came to the English department when Phillips Russell died. With pals Betty Smith, Paul Green, Reynolds Price, William Blackburn of Duke, and Max Steele, she presided over a flowering of new talent. Lawrence Naumoff, Leon Rooke, Doris Betts, Wallace Kaufman, Ralph Dennis, and Mary Mebane took classes or taught them, and wrote their first books.

Mebane, one of the first blacks to get her PhD in the English graduate program, describes Rehder in her second autobiography, *Mary Wayfarer.*

> [She] was a writer and a North Carolinian. She was white. She seemed to be in her mid-fifties and had brown hair, liberally mixed with gray, which she wore in a sort of short pageboy, all around her head. . . . [She] always wore comfortable shoes and carried a briefcase. I was surprised when I was told that she headed the creative writing program at the university, for I had been so conditioned by my experiences at

North Carolina College that I could scarcely picture a "head" dressed that way. At black colleges, women who played a certain role dressed the part. They were black college teachers, and that meant they had to dress up. . . . I gave a start of surprise the first day I heard Jessie "cuss." Something had gone wrong, and she said, "Damn . . ." I didn't swear, for a black woman was immediately classified as low-class if not downright immoral if she used the so-called "cuss words." . . . Secretly I envied Jessie's freedom to say what she wanted to say. . . . She once pointed out to me a man in the department who hadn't spoken to her the first ten years she was at the university. He was a full professor and a published scholar, while she was a writer without a doctorate, and a woman. . . . Although he had recently started to speak to her, Jessie was still mad at him. . . . Jessie talked so straightforwardly with me that gradually I began to open up. . . . One day, somehow, I managed to swear. Though I fully expected everyone to turn and look at me with scorn, no one seemed to notice. . . . I don't know if it was Jessie's influence or not, but it represented a loosening that was part of the zeitgeist of the mid-sixties.

In the early Sixties Jesse Helms had announced on his radio show that coeds' morals were being corrupted by a graduate assistant, Michael Paul, who assigned his English class to paraphrase "To His Coy Mistress" in Sixties vocabulary. *Life Magazine* got wind of it and rushed down, relishing its scoop, and printed a three-page spread telling how the university was the last bastion of Reconstruction backwardness.

Mary Mebane left Chapel Hill and got a job in Orangeburg, South Carolina, just as the civil rights disturbances were exploding. She wrote them in lucid detail and sent them to the *New York Times*. Harrison Salisbury pronounced her a major discovery, and her reputation was established as an authentic Southern black voice.

In Chapel Hill blacks and whites marched to the syncopation of a special chant: "Freedom [*beat beat beat*] in Cha-a-a Pool Heel! [*Repeat*]" which evolved out of the middle-aged-ladies' choir of the black First Baptist Church on the corner of Merritt Mill Road. The town

called a curfew during the week of the demonstrations and the white proprietress of the motel on Pittsboro Road climbed up on her restaurant counter and flagrantly pissed on the heads of demonstrators, accompanying her auto-fountain with ungrammatical oaths.

At the heart of this scene sat Bob Brown, a Korean War veteran and history graduate student. It was like a replay of the Abernethy era on a different planet. He formed a printing company and from its profits, plus money from cronies, financed the literary magazine, *Reflections,* and a weekly newspaper, *The Anvil.* "To my everlasting shame, I rejected stories by Doris Betts and Reynolds Price in the beginning. Can you believe it?" said Brown. "But when I read Leon Rooke's first story [one of Canada's three top novelists at the time], I called him up at 4 AM. Every one of those stories in *Reflections* were O. Henry mentions."

Before it folded in 1964, *Reflections* published Lawrence Ferlinghetti's "1000 Fearful Words for Fidel Castro" and Richard McKenna's article on James Baldwin. The group's *enfant terrible* style shared the same intellectual corn-pone and sense of community that Ab's crowd had years before, and was a festival high for a generation, an idealism for the impossible, a personal watershed. The FBI and SBI followed Brown around in an orgy of harassment and Police Chief William Blake threw him in the local clink so many times they got to be friends.

The Anvil lasted eighteen years. Senator Sam Ervin and Governor Terry Sanford subscribed to six copies an issue to keep up with the nasty things written about them. Kurt Vonnegut, William Styron, and Reynolds Price furnished articles, and Jerry Mills, Wallace Kaufman, Ralph Dennis, and Wayne King were regulars.

In the university, Max Steele took over the directorship of creative writing in 1967 when Jessie Rehder died. He said, yes, you could teach creative writing but now it was different from before when people read; now people took creative writing and learned to read.

Two undergraduates from the North, Russell Banks and William Matthews, both of whom became national literary figures, started the magazine, *Lillabulero,* on campus, and the *Carolina Quarterly* was gaining a national reputation. John Ehle, teaching in the media

Max Steele and Daphne Athas. Courtesy of the Carolina Alumni Review.

department and working in Terry Sanford's office, wrote *The Free Men,* a book describing the civil rights scene in Chapel Hill. Jonathan Yardley, *Washington Post* critic and Pulitzer Prize winner, Laurence Naumoff, Whitby Prize novelist (*Taller Women*), and John Russell, a Winston-Salem lawyer and writer, studied writing with Doris Betts and Max Steele.

Doris Betts and I had joined the staff in the late Sixties. In the Seventies and Eighties there were so many students there weren't enough seminar rooms. Visiting writers included Marianne Gingher, Jessie Schell, John Knowles, Lee Smith, Carolyn Kizer, Elizabeth Spencer, Anthony Burgess, David Guy, Bland Simpson, Allan Gurganus, James Seay, Jill McCorkle. Countless others taught there in the Nineties and the first decade of the twenty-first century. The department has evolved an undergraduate program in which a series of prerequisite

courses correlate reading with writing to teach craft. "You can teach technique," said Max. "You can't teach talent."

Both N.C. State and UNC Greensboro offer MFAs in creative writing. But Chapel Hill stuck with undergraduates. "They're at that age when they haven't become sophisticated," said Doris Betts. "Undergraduates are still untrammeled. They don't know what's bad or good. That's often an advantage."

"They're just more juicy," said Max Steele.

Jonathan Yardley, John Russell, Laurence Naumoff, Clyde Edgerton, Candace Flynt, Michael Parker, Tim McLaurin, Jill McCorkle, David Payne, Randall Kenan, Sharlene Baker, Garrett Wyer — Walker Percy and Kaye Gibbons were the exceptions, they didn't take creative writing as undergraduates — mark an unusual phenomenon. Most didn't go to graduate programs but got jobs and worked on novels they had written first drafts of in their 99 Honors class. The record of their novels is simply so large that *Esquire* cited the university as one of the main places in the country where budding writers come from, and the *Boston Globe* began its review of Michael Parker's *Hello Down There* by saying, "From North Carolina has come, once again . . ." and summing up, "Indeed the Tar Heel State can fairly lay claim to a quite impressive list of writers."

There is no let-up in visions of the arts, but they have increased exponentially. It's hard to see them for the forests of the corporate. And no single Chapel Hill exists any longer despite the use of its name as hype. The university was compelled to edge toward the corporate and raise much private money in addition to state funds for education, most of which goes to the sciences. Despite that, the arts, and particularly the creative writing program, have garnered a glitzy share.

Louis Rubin, who taught Honors creative writing with Max Steele for most of his thirty teaching years, contributed to the single vision by starting Algonquin Books with Shannon Ravenel. His vision was as consciously Southern as Proff's was consciously folk. It is as if the canny egalitarianism, red-clay dialect, and sad ballads of that movement had metamorphosed into the voice-based novels of Clyde Edger-

ton, Leon Rooke, and Jill McCorkle, their syllables turned ribald, tough, and sometimes self-parodying, the characters roaming the new chain-store South. The North has loved Bubba-type novels as much as they loved the way Loretto Carroll sounded laughing her way up Second Avenue, although both are subject to changing fashions.

Tempting as it is to claim a cause/effect begetting, the fact is that the source is what is shared. The source is a dying reality. As authentic old mountaineers and rural people have disappeared, their great-grandsons and great-granddaughters are more assiduous than ever about recording them. Lee Smith's *Oral History* addressed itself specifically to the problem, showing a girl transcribing the old voices, who only barely comes to understand their reality. The trap is quaintness. Smith does not fall into it, but many Southern writers do.

Other metamorphoses of the North Carolina-common were in the musical field. *Diamond Studs, Pump Boys and Dinettes, King Mackerel and the Blues Are Running,* and *Kudzu,* works by Bland Simpson, Jim Wann, and Doug Marlette, charmed Broadway with the bluegrass-type folk musical tradition. The Red Clay Ramblers who scored those shows have forged an entirely original American musical destiny of their own, doing the background music for Sam Shepard plays and touring under State Department auspices to such unlikely places as Turkey and Tunisia. New groups make Chapel Hill one of the contemporary musical in-places in America.

Andy Griffith's hoedown *Mayberry* and *Matlock* continue for the nostalgic hominy circuit, unashamedly consumer-driven. There are the symphonic dramas Paul Green promoted, *The Lost Colony, Unto These Hills,* and the other corny but worthwhile *son et lumières* of America operating.

Jonathan Yardley leveled an attack on university writing programs in the Eighties: "The emergence of the writing program has been the most destructive development in literary fiction in the past 25 years." It was an observation relevant twenty years ago but perhaps useless now. He was right of course, but it's like getting rid of the rock in the backyard. It's there.

The spirit of play underlay the high jinks of the old, even rotten eras when people knew how to gossip and self-legendize. Puritanism reared its head. An errant *pee-see-ery* forbids open flaunting of our and others' foibles. But crumbs are always under the leaves, even if the birds and the Gretels think they've picked up every one. There's always the one more undiscovered crumb which, if you find, you can follow back to Proff or forward to who knows what flying creature? Crumbs are proof of imagination.

Mary Mebane wrote:

> When I first opened my eyes to the world, on June 26, 1933, in the Wild-wood community in Durham County, North Carolina, the world was a green Eden — and it was magic. My favorite place in the whole world was a big rock in the backyard that looked like the back of a buried elephant. I spent a lot of time squatting on that rock. I realize now that I probably selected it because it was in the center of our yard, and from it, by shifting ever so slightly this way and that, I could see everything. I liked to look. Mama must have told me several thousand times that I was going to die with my eyes open, looking.

"They told me that North Carolina was not like Virginia and South Carolina and it was not," Gertrude Stein wrote in *Everybody's Autobiography*, choosing not to explain why, and her description of Chapel Hill remains among her writings, like the afterglow of the see-through dress, but grown large beyond imagination:

> There we first saw cotton growing that is to say we saw the stalks where it had grown the summer before, it was the first farming we had seen since we had been in the South, the fields were small and the country was simple and pleasant and then we came to Chapel Hill. I had never heard of Chapel Hill but it is important, lots of places that the name was not known not to me were and here they had the best collection of Spanish books anywhere in the world and lots of students from every-where in the world and a nice town and a pleasant spring. It was spring then. Of course I often have not heard of it even if it is well known but

there are lots of places in America that have enormous collections of something very often the best anywhere and they are not well known at least well yes not well known, and besides Chapel Hill was the first state university in America and I had never heard of it and did not know that it was so of North Carolina. However there it was and we liked it. Duke's College was near too and that was made by tobacco. Lucky Strikes and Camels, the better cigarette that we had met when the doughboys first came over and they had made the Duke fortune and they built this university and now there was the depression and they did not have very much money and so Chapel Hill was the better. So they said and we believed them.

We liked Chapel Hill we liked the hotel, you ate well, we liked the professors and the men and women and I liked walking and then there was a place a sort of tower and it had newly planted box hedges around it and it looked like a water tower but is not a water tower and when I went inside to read what was cut into it, it said that it was erected by a family the name was given and that was all that there was to it. No war no peace no anything, there was a family and it had a name there was a tower and there were lots of box hedges around it and they were small now but some time they would be larger. That was at Chapel Hill.

Why There Are No Southern Writers

TO ENTER THE South at the end of the Thirties from New England was to experience that dead air space between the legend of the Fall from Glory and the New Era about to begin. The South I saw was the raw, ignoble South of small-patch farms and spinning mills. North Carolina rivers were brown or muddy red. The famous Gastonia strike at Loray Mills in 1929, which led the wave of walk-outs and spread violence through the Carolinas, had happened the decade before. There was no trace of Tara or magnolias either.

To come from the outside was to notice, but such was the degree of my unfamiliarity that it was, in fact, to define. The only given was the name: *The South.*

The first thing I heard was the music. The civics teacher said: "Turn to page one hundred and fifty-fo'." There was a blond boy from Alabama named Richard Lewis, the oldest son of Playmaker Kate Porter Lewis. When he opened his mouth in school I could see his lips move and hear a voice, but I could not understand a word he said.

After I got used to it, I realized that Southern speech was not only a matter of pronunciation, it was a matter of repetition. Paul Green captured this:

> "Maybe he's gone on up there and entered college."
> "Maybe he has. Education."
> "Yeh, education . . ."
> "Where is the great I Am, the Almighty God? Listen now while us gi'
> you the call. Eigh, Lord come with the 'sponse — "

I call my people — hanh,
I said my people — hanh
I mean my people — hanh
Eigh, Lord!

"That's right. Sing him out'n the bushes," said the first guard.
"Sing him back from college," said the second.
"Sing."

I call my friends — hanh,
I said my friends hanh,
I mean my friends hanh,
Eigh, Lord!

These lines come from the story, "I Call My Jesus," by Paul Green.
Here is the first sentence:

In the bright glare of a fierce August day six striped convicts were dig-
ging on a blazing road, swinging their picks aloft and bringing them
down.

Compare this to the last section of Carson McCullers's *The Ballad
of the Sad Café*:

The Forks Falls highway is three miles from the town, and it is here
the chain gang has been working. . . . The gang is made up of twelve
men, all wearing black and white striped prison suits, and chained
at the ankles. There is a guard, with a gun, his eyes drawn to red slits
by the glare. The gang works all day long, arriving huddled in the
prison cart soon after daybreak, and being driven off again in the
gray August twilight. All day there is the sound of the picks strik-
ing into the clay earth, hard sunlight, the smell of sweat. And every
day there is music. One dark voice will start a phrase, half sung, and
like a question. And after a moment another voice will join in, soon
the whole gang will be singing . . . The music will swell until at last
it seems that the sound does not come from the twelve men on the
gang, but from the earth itself, or the wide sky.

And what kind of gang is this that can make such music? Just twelve mortal men, seven of them black and five of them white boys from this county. Just twelve mortal men who are together.

Robert A. Lively said that stories of northern life are focused on the abilities and characters of single heroes or heroines, and individuals whose society is the hostile setting for their lonely struggles and ambitions, while Southern stories operate on a social rather than personal scene, with families and communities in a time and geography heavy with past and future. If true, this particular South was the socially conscious, New Deal, WPA, TVA-dominated, post-Depression, pre–World War II, Rooseveltian wave of the future.

The place was Chapel Hill, seat of the University of North Carolina, a school of 3,000 students in a piedmont area where rednecks left farms to become lintheads in mills, where the blending of liberal academia, cosmopolitanism, historical tradition — the university charter and buildings dated back to the late 1700s, with legends of Yankees and horses — combined to make a ferment that belonged to the New Deal.

Sociologists made studies of *pellagra*. Playwrights specialized in words like *mule, mountain,* and *Moon Pie*. People drank RC Cola in response to tattered signs on tobacco barns. No one used the word *prison*. They said "penitentiary," leaving out the first *i* as if they were raising a *tent* on top of a *pen*, so that the word climbed up in a long, increasingly lonely scale, with *ary* trailing away like smoke upon the universe. "O Lost, and by the Wind Grieved, Ghost come back again." Snopes was not yet in the vocabulary. Thomas Wolfe was.

Sociologists and playwrights were in the ascendancy. Howard Odum translated the sociology of the South to Washington D.C., which did something about it, and abolished pellagra; and Frederick Koch inspired down-at-the-heel mountain students to repeat the music of *what they knew*. This South in Chapel Hill was self-conscious.

My goal, as I saw it in high school, was to fit the music with what I saw. I was a proud stranger. As with all strangers I was welcomed

politely and delightfully by cultured Southerners who, without malice or recognition, wore the barrier of *us* and *them* unconsciously in the corset of their skin. Since I had known I would be a writer from age seven, I was amazed to find myself in a place where there were writers who wrote, a place that made no separation between music and event, or music and being. The act and the expression of the act took on reality then as part of the same thing.

But it is also important to recognize that this was the Southern version of a national movement. I paid no attention to this distinction when I first arrived. Morris Dickstein points out in *Dancing in the Dark*, his 2009 cultural history of the Great Depression, that writers who wrote about those times were not poverty-ridden people who "lived" them themselves. It was only after the Depression-era programs which hired photographers, painters, and writers to give artistic expression to these conditions that brought them to the nation's attention. Their work reflected what was prized in that decade and often dismissed as second rate in the following decades.

The artists themselves, though they may not have had much money, were not the "workers, farmers and teachers" they painted in post offices or wrote about in plays like those of Betty Smith or in books like James Agee's and Walker Evans's *Let Us Now Praise Famous Men*. Although most of them were Southerners, many were not — John Steinbeck and Nathanael West to mention two. "The protest writers look[ed] back to Zola and Dreiser on one level, Upton Sinclair and Jack London on another," Dickstein writes.

In Chapel Hill Betty Smith made a careful study of Thomas Wolfe underlining his books in pencil to understand how she could consciously learn and trace his route in writing as he had consciously tried to trace, learn, and transmit New York rhythms in New York when he lived there. The cadences of Richard Wright and Paul Green came together in the play adaptation of *Native Son*, both writers Southern but of different races and thematic penchants, and both under the influence of the often Jewish, self-conscious, proletarian-speak rhythms of

writers and directors like Clifford Odets and Harold Clurman of the Group Theatre. Heavy metaphor. A plebian rhythm.

In Southern writing such ramifications extended beyond the South to include the general protest style of the times. The substratum of that kind of prose predicated the hardship, nobility, and oppression of the Common Man and the black man as he dreamed the promise of America and suffered. Other younger Southern scions of the decade, Richard Wright, Tennessee Williams, and Carson McCullers who lived at one time and another at February House, a famous artists' residence in Brooklyn, forged a new social South.

Faulkner occupied an unrecognized position in the burgeoning *Southern writing* phenomenon. Future generations of critics would discover, probably wrongly, to have accorded him responsibility as a dominating influence on all the younger Southern writers. Of the half generation even younger, Truman Capote, Calder Willingham, Speed Lamkin, and the half generation beyond, William Styron and Gore Vidal, some drop away as names, and most fade into the national landscape of writers, as Southern particularities faded and writing became issue- rather than region-oriented.

This Forties generation of Southern writers, born of the Depression, one might say, inspirited the beginning of recognized black writing, although, inasmuch as such generalities are false, this too is false. It did not, however, inspirit the idea of women as writers.

I had brought to Chapel Hill a firm tradition of woman as writer, stemming from the Brontës and George Eliot in England, and Louisa May Alcott, Margaret Fuller, and that first Southern woman writer, Harriet Beecher Stowe, from New England. I had no notion of Southern women writers per se at the time, nor did I care.

It took twenty-five years, until the Sixties, for me to hear the claim that Ellen Glasgow and Eudora Welty, Southern writers, were without peer the serious American women writers. It took an even longer time, as it did with Gertrude Stein, for me to read and appreciate them.

But it was easy in Chapel Hill in the Forties when *Native Son*, a fait accompli, was being translated into a play, when *The Glass Menagerie*

was so classic it seemed cliché, and *Streetcar* was starting out the Southern-Jewish competition with *Death of a Salesman,* and when *The Member of the Wedding* was seen to be a partial and popularized re-play of the more complete and multidimensional *The Heart Is a Lonely Hunter* — it was easy to know that the boundaries of race and sex had been broken down and that we were in a changed age.

Among artists, boundaries are always open, and so analysis of what history does to literature or literature does to history is ambiguous. The forces which made Faulkner are presumed to have made Tennessee Williams, Carson McCullers, Eudora Welty, and Reynolds Price. And didn't Richard Wright spawn his assassin, James Baldwin, who in turn spawned his own, as the written vision of injustices turned to civil rights and then to civil laws? America has always been a country that has written down what it ought to be and then tried to be it. And that includes TV commercials as well as the Constitution and Bill of Rights as is apparent in the blasphemous similarity between the two.

By the Fifties, however, of the two directions in Southern writing, social-consciousness and gothic vision, social-consciousness dominated the writing coming out of Chapel Hill. The gothic was linked with the aristocratic part of the South and also with the feminine, probably because of its inception in *Jane Eyre* with the governess, the madwoman in the attic, and the female writer. Both strands existed in Faulkner and McCullers. One thinks of Tennessee Williams as gothic but the two viewpoints are submerged in the moral framework, the lost-magic-gone-decadent always at battle with the amoral, brutal plebian force. In these writers, and consummated in their last, sterile offspring, *To Kill a Mockingbird,* the ideals are held by the aristocratic mind, and the plebeians are the renegades, except for dignified Negroes.

It was Truman Capote in the Forties who finished off the seriousness of the gothic and left the field free for women writers with new heroines and for the absurdists of junk. He turned those environmental talismans which younger writers in small towns grew up with into creepy if not amoral humor. The embroidered, the painful, and the lunatic, the

decrepit and scary house of spinsters and transvestites he made accept-
able by crossing the border and having gone over, stopped.

In the decade of the Fifties land-poor families literally abandoned
those houses for trailers, and with that move the gothic was literarily
swallowed up in juxtaposition and absurdity. The new junk landscape
was left to be explored by Southern men and women alike: Harry
Crews, James Dickey, Doris Betts, and Fred Chappell among many.

The idea of beauty was a historical antecedent of Southern gothic,
the beauty, the *Southern belle,* the victim of the sheltered life. She was
basic to the work of Ellen Glasgow; Willa Cather also wrote of her.
She was a tenet and symbol of the set, genteel society until World War
I. By World War II the conception was passé, and by the Sixties the
word *beauty* had been flattened out to banality by Kurt Vonnegut and
overuse, its adjectival qualities rendered cliché in such expressions as
beautiful experience and *beautiful human being.*

It is interesting to notice that in the Forties women writers did not
deal with the Beauty. It was left to the men writers and in a point in
time as far from Eva Birdsong as Miss Havisham. Decayed, brittle,
caricatured, pathetic rather than tragic, neurasthenic, irritating, the
historical nuisance with echoes of nostalgia, the Beauty became the
bailiwick of Tennessee Williams. She was aging if not old, and neu-
tered but sexually active, endowed with furies and male force, a vision
of incipient camp.

Women writers even then had gone on to something different. One
might paradoxically look at *Gone With the Wind,* that historical ro-
mance of the heyday of the *belle,* to find the modern prototype. Scar-
lett, the Beauty, was irresistible because of her ability to eat radishes
and hire convict labor. The only reason people can go on wallowing in
nostalgia is that there is an indomitable if uncertain present. There has
never been enough serious attention given to the ethics of Scarlett's
undervaluing her own penchant for action or, better still, survival.

Scarlett is so unaware that after the whole book goes by and Mela-
nie has just died, she tells Ashley of her lifelong love for him, and then
says, "Suddenly it doesn't matter any more," dumping him out like a

baby with the bathwater — more like a rubber duck. The moment is not to be believed. Why hasn't someone pointed out how unintentionally funny it is?

Well, Scarlett may be disappointed with herself, but the contemporary Southern woman writer isn't. The point is that the Beauty lives, but her vitality is in the scrapping, spunk, schemes, determination, marrying, working, and even in the slapping of other women who fail to have her guts. Certainly a plebian model. One that forms the basis of the contemporary characters of Sylvia Wilkinson, Doris Betts, Lisa Alther, Rita Mae Brown, Bertha Harris, Shirley Ann Grau, Lee Smith, and Gail Godwin. No boasting of aristocratic heritage. Many are strictly from the farm, the mill, the new city, some from the university. Their names are as often Vicki or Elizabeth as Ora Mae or Norma Rae. The character is sexy rather than a beauty, gets on with the job, sees through things but also sees things through.

There is another corollary to this. If it is the backside of the Southern Lady, it may also be a transformation or development from that sensitive girl-adolescent of winsome pain, part perhaps of a backlash against McCullers. This Southern young woman character often has an involuted, magpie brilliance, cousin to Jenny the crookback doll maker of Dickens or to McCullers's Miss Amelia, but the defect is now banished.

By some transmutation of the ethical system, the magpie brilliance has plus value. Innate courage is given the freedom of ambition. The character may be divorced thrice, a librarian, a lesbian, a movie star, an adventuress, an investigative reporter, an executive, or an eyewitness, but she is not a lost child nor is she a lost low-class Southern waitress. That particular pain syndrome played itself out with William Inge and is now a revival classic in movies, played by the real-life, ever-living suicide, Marilyn Monroe.

Self-conscious pain has moved its center from adolescence to characters aged about thirty. It has been part of the Southern contribution to women's writing by writers like Gail Godwin, Kate Millett, and Alice Adams. The brilliance analyzes the pain, and the characters do

not have physical defects and do not consider themselves ugly, deformed, or crazy. In line with the national movement, they see those defects as having been put upon them by men.

I use these prototypes because it seems easier to talk about Southern women characters than Southern women writers. But perhaps it's an off-the-top-of-the-head clue to what may be the human precondition for the modern Southern woman writer. In high school when I heard the music, I was casting around for what it fit *for me*. I was all different from it, yet it was my environment from that time on. It made me aware first of the English language, and then of the Bible which had not been a vivid feature of my high-minded bringing up, and then of every writer I had ever loved or was to love in the future.

I at once cataloged everything that struck me as Southern, the paraphernalia of the environment unfamiliar to me. I have those lists now, and I used them in my novel *Entering Ephesus.* Broom-grass. Tin roofs. Railroad tracks. Red dirt. Sweeping dirt yards with brooms. Lumber mills and sawdust piles. "Thank you, you must wear it sometime." Plug tobacco. My daddy. Your daddy. Snuff. *Ah thank* for I think. Railroad ties. White fountains versus colored fountains. Chinaberry trees. Co-Cola leaving out the *ca*. This list is not very profound, but it is what *was*. Objects. Artifacts. Strangely enough, it is probably not as passé as it sounds, but literarily it is historical. And setting it down makes it a matter of style.

When I was in high school the second thing I brought down from the North, after my notion of women writers, was undisguised or frank ambition. People wrote in my high school annual: "She has ambition." Although I prided myself on it, it was one of the attitudes that prevented me from being allowed to be a Southerner. Not the ambition, merely the undisguised nature of it. Yet it is the quality of ambition connected with the actuality of freedom that made the Forties the turning point for women and, I suppose, created this new female character from *Becky Sharp,* way before the women's movement.

Even now, in a disguise less from literal convention than from an old habit to do with the South rather than with sex — the Southern belle

and the Southern gentlemen both had it — it is good form to speak of ambition at most in a subordinate clause, preferably in a phrase. It is that quality that caused Northern liberals watching Sam Ervin on the Watergate Committee to discover, "He's not dumb, he's shrewd."

My ambition was not to write things as they are, but to write them as I saw them and, if I noticed, to define my terms. It was by the music that I learned. But the music expressed the difference. Little did I suspect, and little did the possessors in elementary and high schools all over the South suspect, that this same ambition was imbedded in them too, these girls who would later be the Southern women writers. It occurs to me now that the music of the important in subordinate clauses is the music of the aristocrat with an overweening sense of noblesse oblige. At the same time it is the music of the underling who has to hide the real thing.

Where did the Southern accent come from? I used to let that question squirrel around in my brain and always arrived at the cliché that it was from African rhythms taught by the broken-Englished Negro nannies.

Be that as it may, it feels to me now as if that subtle way of talking and writing expresses more truth than straight-telling. Straight-telling is a vision of one in an omniscient voice and as such, from the Southern point of view, arrogant. So, after the fact, if the ambition, which spawned the heroines created by Southern women writers rather than lady writers, was there all along, it is a joke that time has played, to mix up our notion of the aristocrat and the plebian as well as of men and women.

The reason I am stressing style is that it is the one constant from which to mine new interpretation. If Southern literature still exists as something distinguishable in contemporary writing, it is in the implications of the prose rather than the content. It is *under* the prose though, rather than *in* it, because the corporate, the standard, and the Internet have changed the environment and language is following.

The days of the Forties, with their repetitions, were the hot style, and if at such a distance the work seems quaint, mannered, or romantic,

people usually blame the content. Yet it's the same content that engendered the Beats of the Fifties and balladeers of the Sixties, Bob Dylan and James Taylor being sons of Josh White and Woody Guthrie, and the code words as yet unassimilated of the cyber age. That content is more valid — for you still have your class systems, haves, and have-nots — than the content of the gothic, born of the eccentricities caused by stricter social forms that have disappeared in the fluid *anything can be anything.*

The extravagance of junk is more difficult to see since one lives in its environment. It demands the cool, underdone style, like talking on an intercom in the thick of battle, that scene in *Apocalypse Now,* which is the key to understanding cool. And cool is so cool in the twenty-first century that it has turned into code.

Eudora Welty may be the extreme feminine counterpart to William Faulkner of the older generation, stylistically as demanding, mixing the colloquial with the complex, and underwriting in long sentences. The two share a maximum secret Southernness which, for the uninitiated, amounts to attitudes behind the prose, foreign attitudes, signs, allusions.

In fact Welty is more incomprehensible and irritating to the non-Southern reader than Faulkner. The only solution is to read her aloud. And to read her aloud more than once. For she socks into her phrases and clauses the essence of Southern genteel music with the most steel-like clench of mind, so that at its most hilarious, the prose doesn't crack a smile. One blind to the South can miss everything. She is the Southern mask that freezes the black and straight plebian into the cadences of mock aristocrat, the mock being what is aristocratic.

The reason I call her a feminine writer is that her continuing success in this renders her triumphant in the minimal. She goes far with what she does not say, and this smacks of disguise at the height of its greatness. To talk of the cool or the hot with either Faulkner or Welty is disconcerting because they are both, and it is the cool, the taking away in subordinate clauses what is given in the thrust of the main

one, that floats the meaning in a new dimension, where the hot, the evocations, or repetitions, can be gotten away with.

Predictably, it is a woman, Flannery O'Connor, who has mothered what seems to me to be the newest direction in Southern writing. It too is part of a national preoccupation with religion, but Southern writers, particularly small-town ones with Bible-reading in their background, are unusually well equipped to deal with it.

This Southern manifestation is Christian on every count, and the writers who have done it are both men and women, among them Doris Betts, Reynolds Price, and Walker Percy. Many of them were and are doing it in perhaps the only way it could be done, affirming by elimination of the negatives. It is as if the twenty-first century's destiny has caught up with Flannery O'Connor's physical imperative that made her say what she had to say with no trucking around, because she had to say it faster. Her intolerance for lip-service and her seriousness about Roman Catholicism had Protestant fervor, and her gothic details were transmuted with rowdy, grotesque humor to serve with frightening economy the harsh, religious view.

Reynolds Price had been edging in this direction with essays and translations of the New Testament, as if stepping into a New World demands a change of form. In *The Surface of Earth*, he presented a picture of Southern women that I have seen nowhere else, an essentially humorless one that is historical, of women in nightgowns who spend a lot of time in bed, analyzing husbands and sons with ferocious neutrality while demanding, if not obeisance, homage to their woman's pain, namely the horror of childbirth.

As unpopular as it was with the women's movement, it ought to be heeded, for it had something universal to say about the psychological imperatives of the later religious direction. The words *earn* and *pay* travel through *The Surface of Earth,* and so do the words *peace* and *kindness,* gestures to the difference between the Old and New Testaments. But I see them as naked emblems underlying this whole direction.

They are understood and named in Doris Betts's later work too,

where Old Testament fatality merges with stoic, logical rationalism in an uncompromising indictment of the easy gratification of the fat and the mindless who both cause and suffer the seemingly coincidental violence of contemporary life.

So far these two streams of thought seem to hint at the only source of rebirth, but they are at odds in a netherworld which the rational world refuses to let be born. In *Lancelot,* Walker Percy cleverly demolished the garbage veneer of the present day with intellectual rather than Biblical prose. It was a dialogue in monologue form. The addressee was the unbelieving, priest-like liberal, personifying the questions whose answers and attitudes the reader provided quite easily.

The speaker was the sane man who had violated what amounts to the insane world. The unspeakable crime was tolerance for the dead emblems of modern insanity, and there is no panacea in the former generation's forms of nobility, which now look like sheer romance. Such is the cleverness of the form of the novel that it leads to a Yea-saying answer without speaking either of God or the Protestant ideas of paying or earning.

None of this amounts to a movement. It is the work of a scattering of Southern writers who find themselves up front in responding to a nationwide automatism and standardization that seem more flagrant in the South because landscape, which had rotted since Reconstruction, became radicalized in the Fifties.

I find myself wondering about the plebian and aristocratic strands in these writers. I find moral compulsion plebian. Despite the Catholicism of two of them, only Walker Percy had the feel of the aristocrat. He dared to hate out loud. But he so thoroughly rejected any hope that the enlightened aristocratic generation of rational judges and lawyers in the Faulknerian canon who prevailed through dignity could do anything against the triumphant, tamed evil wrought by the un-demoned post-Snopeses — so rejected even that pattern of social structure, except as Hollywoodized — that the effect was of an entirely new game.

Throughout *Lancelot* he had segments of self-conscious Southern

dialogue, mock-music as if even Southernism is dead while the forms remain and are spoken without knowing.

Flannery O'Connor is too demonic to be anything ultimately but plebian, despite her unerring sense of every social attitude. Reynolds Price seems to me plebian in attitude, while his prose gives off an aristocratic stance, and Doris Betts, through all her work, from the acclaimed short story, "The Ugliest Pilgrim," through the novels, *Heading West* or *Souls Raised from the Dead,* seems to me to be unreservedly plebian despite the complexities of her subordinate clauses.

Ultimately it strikes me that the women writers of Southern origin or experience were responding to plebian urges. One cannot be a woman writer without being part of, or in some way acknowledging or responding to, what happened since the Sixties to the consciousness of women. Gail Godwin, Alice Adams, Kate Millett, and Anne Tyler have dealt with it directly.

Interesting to note, though, the peculiarly aristocratic impulse in the prose of Alice Adams, who used the South as a gone-by state of being, became overlaid by cosmopolitanism. She used her style of omission and of taking away from the main clause by the subordinate to separate the aristocrats of *taste* from the dogs of vulgarity. There is nothing more elite, lethal, sophisticated, and Southern.

A far cry from that hot, social singsong of the people, prayer and response, that I first noted in Chapel Hill in high school. No white man is writing of the penitentiary, and if he does, it is called *prison* and is a metaphor. Women are analytical now and in content devoid of disguise. If you are to find the South in them, you must look for it in style. It is there. It is simply the reverse of what I heard in Chapel Hill as Southern music. Now it is style gone subtly aristocratic to serve the defiantly plebian.

It makes sense, this paradox, in the case of women writers since it is the natural course to take. But all serious writing has a self-consciousness that it didn't use to have. If Southernness was once an obvious characteristic of writers, it is now mere evidence, detectable in style, waiting perhaps to be recognized.

The Secret in the Forgotten

Chapel Hill Murders

GIMGHOUL CASTLE, ONE of Chapel Hill's landmarks, has its origin in a murder said to have occurred in 1831. An account of this crime appears in the 1912 history of the university written by Kemp Plummer Battle (1831–1919), president of the university from 1876 to 1891. The story revolves around the disappearance in 1831 of a student named Peter Dromgoole. He was from a prominent Virginia family. He wasn't a registered degree candidate and had a reputation for card-playing and wild company.

When he disappeared, there was a rumor he didn't get along with one of his professors and had left town. Another rumor started that he'd quarreled with his best friend over a girl named Fanny and was killed in a duel (an illegal activity at the time), his body hidden carefully in a grave under a rock on the hill where Gimghoul Castle stands today.

After he went missing, his uncle, the Honorable George C. Dromgoole, a University of North Carolina alumnus and lawyer, rushed from Virginia to investigate. Young Dromgoole's roommate from Warren County, John Buxton Williams, reputed to be a reliable person, wrote to the newspaper saying Peter had not gotten into any quarrel, that he'd left Chapel Hill on a public stagecoach. Two or three weeks later the uncle decided the girlfriend story was unfounded, so he went back to Virginia.

"I conclude," wrote Kemp Plummer Battle, "that he [Peter Dromgoole] was ashamed to go home, journeyed to what was then the turbulent Southwest, and was killed in a brawl or assassinated."

Battle goes on to say:

> A modern tradition originating within my knowledge places the scene
> of his fatal duel on Piney Prospect, and asserts that he was buried un-
> der a rounded rock on its summit. Certain stains of iron in the rock
> are pointed out as drops of his blood, and a still later story is that his
> sweetheart, Miss Fanny, hurried to stop the combat, arrived too late,
> went into rapid loss of reason and health, and was buried by his side.
> The spring at the base of the hill, where the lovers are said to have sat
> and cooed, bears the name of Miss Fanny's Spring. . . . The persistency
> of belief in student circles in the Dromgoole legend and its accretions
> throws light on the growth of similar legends elsewhere and in the
> times of old. . . . Some credulous young people unblushingly avow their
> belief that the rains and snows of three-quarters of a century have not
> washed out Dromgoole's blood spots on a rounded granite rock.

Such is the paucity of affirmed fact and the discrepancy of so many
theories that it is no wonder Dromgoole's disappearance created a field
day for dreamers of the nineteenth century.

In 1889 (fifty-eight years after Dromgoole disappeared), an intro-
verted, imaginative law student named Wray Martin became obsessed
by the mystery. Whatever the facts, which by this time had mutated
into a loose assemblage of detail, Martin mixed them into his fantasies
of medieval chivalry, and invented a culture, a secret society called the
Order of the Gimghoul. He wrote in his journal about an imaginary
castle called *Hippol Castle, a fortress for twelve island cities.* In Martin's
vision the Dromgoole quarrel translated to a duel, Peter turned into
a knight, the name *Dromgoole* morphed into *Gimghoul,* and the girl-
friend to a fair maiden who got to the duel scene too late, went berserk
("into a rapid loss of reason and health"), died, and was buried by her
beloved's side.

Martin seduced his friends into this world and they spun off on
each other's fantasies. Among the friends were William Davis, R.W.
Bingham, Shepherd Bryan, and Andrew Patterson. They founded the
Order of the Gimghoul to which only those male students or faculty

who were invited could belong. Parts of records, correspondence, minutes, and membership lists are on file in the university library system, although some of the records are listed as restricted. The society was typical of many such organizations proliferating in colleges throughout America in the twentieth century which were declared social rather than ideological or clandestine societies.

Kemp Plummer Battle recounts that while Wray Martin was a student, Battle, along with professors and townspeople, as well as students, used to go for walks along the high place, the Fall Line overlooking the Triassic Basin which includes Battle Park and a view almost to Durham. On these walks people would pick up stones and place them in a pile. Gradually the pile grew high. Although undetermined as to purpose, this ritual felt significant, like a sort of symbolic ceremony. A kind of remembrance stone.

Wray Martin died fairly young. Battle does not say how, when, or why. Sometime between 1924 and 1926 Martin's friends initiated the actual building of the castle as a putative monument perhaps to Martin as well as to the legend of Peter Dromgoole. The friends had the castle built by Waldensian Italian stonemasons, who were part of a migration from Italy to western North Carolina. A short time later, the seat overlooking the Triassic Sea was built using the stones from Kemp Plummer Battle's pile. The actualizing process is mind-boggling, for it creates Martin's latter-day vision into a stone and cement reality on two-plus acres that some accounts claim cost $50,000 at the time.

The legend is in the tradition of the Brontës' *Angria Chronicles*, C.S. Lewis's *Narnia* books, Tolkien's *Lord of the Rings*, and Rowling's *Harry Potter* cycle, but the psychological obsession contains elements of nostalgia for dead idols like James Dean, John Lennon, Elvis Presley, as well as the creep-me-out horror mystery element of the Dungeons and Dragons game and later the Columbine reality.

Adults are usually nostalgic for or shocked by their own youthful crazes. Yet deeds, edifices, cities, and empires arise from just such projections; the Salem witch trials, the Third Reich, San Simeon, Hiroshima, and Nagasaki.

Gimghoul Castle may be less forbidding than weird, and mangy rather than creepy, for stray beer cans often cheapen its frisson, but that doesn't belie its magnetism. Every high school generation has targeted it for exploration to frighten itself. Students sneak inside when the university is out of session. A high school girl in the Eighties once confided to friends that she'd found a secret panel behind the fireplace that led to a hidden room. *The Daily Tar Heel* on April Fool's Day 1987 described a Round Table hanging in the Great Hall that contained the oath of King Arthur inscribed around its edge, and a suit of armor with crossed swords.

Since the only members were male, the names of the illuminati over the years who were members are male: J.C.B. Ehringhaus, J.L. Morehead, Frank Porter Graham, William Rand Kenan, and William Friday among them. Michael Wilson, director of the Hartford Stage Theater in Connecticut and a Morehead scholar in the late Eighties, produced and directed *Shadows of Dromgoole,* a movie spoof of the murder, luring major figures of the drama and journalism departments of that time, including Pat Barnett and Walter Spearman, to play major roles. The movie was a perennial on WUNC-TV on past Halloweens.

Since the cyber age, a variety of websites use the Gimghoul mystique as advertisement for travel companies, rental agents, and cologne manufacturers. "Get Laid in 30 days," one of them promises, "or Your Money Back." These websites have attracted personal exhibition blogs. One of the recent bloggers complained: "All I hear is blah-blah-blah — I hate when people tell me they know something I don't know but they can't tell me, whose responses range from 'Ooooh! Intriguing!' to 'I'm with you.' I can't stand thinking some know something they won't tell me."

ANY UNIVERSITY CATALYZES the highest and lowest of human desires. Murders, like responsibilities, originate in dreams. The student population is perennially at the age of dreaming. In 1950 a murder was committed by a young man who'd been around town for ten years. Wayne and I, both in our mid-twenties, were back in town after having

been away for a few years. Wayne was in his first year of med school on the GI Bill and I was back at home in the Shack with my family, finishing a novel.

Wayne brought me the news on a beautiful April morning: "Guess what! Leon Smithey killed somebody they say was his roommate in a boarding house in town and then ran down to the Forest Theatre and shot himself! Two hours ago. In some boarding house in town. With a shotgun."

Years before in high school, we'd been accustomed to seeing Leon Smithey walk by the Chi Psi house on the way to visit Billy Pullen, the boy next door to us on Patterson Place (before we had moved to the Shack). He was a burly, barrel-chested tough guy with glasses, the Ernest Borgnine type. Older than regular student age, he was, even then, a Chapel Hill hanger-on, always slightly surly.

We didn't know which boarding house, but the police were rumored to be there still. There was a homosexual tinge to the murder also, with speculation that he was jealous of his roommate. Supposedly the cops had removed Leon Smithey's body from the Forest Theatre.

We hadn't thought of Leon Smithey for almost ten years, yet two hours ago he'd been alive, and now he was dead. He'd crept out of the woodwork and tipped over our universe, revealing the maggots in our (?) his (?) psyche.

There is a game, "Which are you, the victim or the murderer?" according to which you know the answer of your life. We regressed back to our sixteen-year-old selves. If we had been the murderer, would we have killed ourselves from guilt and loss?

We ran through campus — "Just think! Leon Smithey killed himself!" — archeologists of violence entitled — no, obligated — to examine the scene of the suicide. We didn't know the murder victim, but the bloody figure of a tormented Caliban running through the early April campus, possibly on the very route of our footsteps, came as a terrible hallucination in the cool morning, cool with the buds of leaves barely out, cool with the yellowish green lace of the spring woods.

"Did he do it on the stage?" I asked.

"I don't know."

"Do you think he wanted God to see?"

"Does God see it better on the stage than in other places?"

"Sure, if it doesn't have a roof!"

Wayne appreciated my cleverness, but to mitigate ghoulishness, I added: "I don't care. I can't believe it. Leon Smithey killing himself."

When we got to the theater we looked everywhere, especially on the stage. We found no trace.

"Maybe they said *near*, not *in* the theater," Wayne said.

We fanned out and he found it. "Here is some blood and brains," he called out from a rise past the stage, an undistinguished spot at the base of a hickory tree. Wayne had already dissected medical school cadavers. Once he had taken me into the formaldehyde-smelling, tiled basement to look at twenty on assorted tables.

He assumed a cold scientific authority as we explored. But I was scared. It was so quiet, the birds twittering — so early; not past eleven in the lyrical morning — we'd expected other curiosity-seekers — so quiet that the mockingbird pouring forth from the top of that hickory sang a message from Keats.

I looked at the specks Wayne pointed out, dark red, almost black, liquid coating the leaves, and a few strings of red worms, the brains.

"Do you dare poke it?" I asked.

Wayne rejected fishing for suicide. So I found a long, curved stick, the length of a fishing pole, long enough to keep my hand far away from the point and performed the ritual myself. I lifted the dark red worm and raised it into the air for him to acknowledge. The brain bit dangled.

Afterward, shivering, I felt triumphant for conquering fear, and we walked solemnly back through the woods toward the Forest Theatre.

"Do you think he did it standing up or sitting down?" I asked.

"I don't know."

"I hope he did it sitting down." Wayne didn't ask why. I went on: "Do you think it's important whether it was standing up or sitting down?

I do." But he waited for me to say the words: "If he was standing up, it means he was overwhelmed by loneliness and anguish. For killing his best friend. Agony, like Oedipus. But if he was sitting down, he would have been more resigned."

Dylan Thomas's thoughts about his father were bad advice — to rage into death. We should all go gentle. But great deeds and murder are done in loneliness, and in this case the earth could no longer afford this unlikely candidate for murderer, a man who had walked the streets of Chapel Hill for ten years, his most secret passions unacknowledged, a pariah.

The newspapers said it was a preventable murder, that he was "suffering from such a mental illness as made him potentially the killer that he became"; they reported that a professor was supposed to have assumed responsibility for him, and blamed it on the ease of having guns. "The South has a reputation for belligerency of which it has always been proud. . . . A war lies in our immediate past in which thousands of young men handled guns and became more or less accustomed to taking violent action." The social view seemed irrelevant to me.

ONLY ONE YEAR later, though, Chapel Hill's collective psyche was forced into identifying with the victim. Perhaps it was because the murder was unsolved or was so brutal, so unexplained. Everyone knew Miss Rachel Crook personally, a seventy-two-year-old woman who had lived in Chapel Hill since the early Thirties, a town character. The newspapers identified her as an "Elderly Former Teacher," an "Eccentric," a "Spinster," and an "Orange Spinster." If it had been Green County, would she have been a "Green Spinster"? The *Winston-Salem Journal* called her a "72-Year-Old Coed."

Miss Crook used to sit on stone walls to rest from walking, one of those perennial college town regulars with pronounced opinions and perpetual presence. An independent plain Jane with iron-gray hair and glasses, she wore summer dresses and a sweater in the winter, and

resisted stockings, so you were riveted to her varicose veins, except on the coldest days when her dark woolen stockings hung down in wrinkled loops imitating varicose veins.

The facts were that Miss Crook disappeared from her fish-and-nuts store on the corner of Merritt Mill Road and Franklin Street at half past seven on the evening of August 29 and was found raped and murdered on a dirt road near New Hope Chapel at ten o'clock the next morning, her dress around her head and her face so battered it took a long time to identify her.

The police had to piece together information. According to witnesses she'd been abducted in a green pickup truck and carried screaming all the way through town and out Airport Road. Two children frog-gigging in a nearby creek said they'd heard screams from a parked automobile.

Everybody knew Miss Crook was from Alabama, that she owned an 800-acre pecan farm there, that her father had been a Confederate brigadier-general, and that she was always taking courses in economics, art, or philosophy. She'd tried her hand at various jobs to pay her rent and tuition, writing feature stories for state papers, babysitting, and teaching. She'd written a story called, "I Live in a Doll's House," which was published in a 1941 issue of *Carolina Magazine*. It described her life in a made-over chicken coop (above a garage), which still perches over Ransom Street on the corner of Patterson Place.

My family knew her. When I was in high school, my father invited her to our Shack to supper one night, and the two of them listened to radio commentator H.V. Kaltenborn reporting about the bombing of London. Miss Crook kept her mouth wide open as she listened; and when my mother made an innocent remark about there being a draft, my sister laughed so loudly she was sent to her room for rudeness. I wrote about the incident in *Entering Ephesus*.

The first person suspected of Miss Crook's murder was J.B. Goldston, whom the papers described as "a prominent Carrboro lumber merchant." People noticed scratches on his face and somebody discovered a broken string of pearls in his garbage pail. He swore his

innocence and even took out an ad offering $500 reward for "information leading to the rumormonger. The malicious, false rumor, which was started by someone against me in connection with the murder of Miss Rachel Crook, must be stopped."

Three years later another man, whom the newspaper described as a "husky Burlington bulldozer operator" named Hobart Lee, was arrested and admitted he had been so stinking drunk that night after visiting a Durham "sporting house" that he couldn't remember whether he'd murdered Miss Crook or not. They let him go. Not enough evidence.

After so much rumor, police ineptitude, and sensational newspaper coverage, the *Chapel Hill Weekly* protested: "It irks us greatly to have [Miss Crook] referred to as an eccentric former schoolteacher when... the most unusual thing about her was her determination to pay her own way."

Like some of the blue-blooded ladies of New England, Miss Crook sought knowledge. A student at University of Alabama, she moved to Chapel Hill after hearing an economics lecture by a UNC professor E.C. Branson. She was socially conscious, an intellectual do-gooder, but she believed Negroes were inferior. So it was an irony when she bought an abandoned gas station in the heart of the black section, opened up a store selling fish and pecan nuts from her plantation, and spent most of her time with them as both clientele and employees. She also operated there the first helpie-selfie laundry in Chapel Hill.

Miss Crook's store is now the site of the famous restaurant, Crook's Corner, and sports a pink plastic pig and wooden driftwood animals on its roof. Separated forever from the source of its name, it is a kind of circus shrine with a national reputation for good food, where the idea of barbecue and murder bothers nobody because in the cyber age they don't know about it.

SEPARATION OF EVENT from place-name is merely reversal in a town that covers its tracks as successfully as the police with their own footprints covered Miss Crook's murderer's tire tracks. Chapel Hill in its good taste is tirelessly philistine. For instance, Eastwood Lake used

to be the place where high school kids went swimming. It was out in the country between pastures.

Not long after Miss Crook's killing, there was a murder committed by a chemistry graduate student at Duke. While on vacation in Mississippi he killed his grandmother — for the money, people said — stuffed her in his automobile trunk and drove back to North Carolina. Before going to his Duke lodgings, he dumped her in Eastwood Lake.

Not only did every person who'd ever roasted oysters, drunk beer, or skinny-dipped in the lake recoil at the idea of the dead granny, but the story got out that the police had found the murderer by following a trail of maggots all the way from Mississippi. For the next ten years, Eastwood was called Granny's Lake.

Despite their glee that Duke did it, not Carolina — the chemistry student was pronounced insane and put in Dix Hill (Dorothea Dix Hospital) — no one dared to swim there any more. They simply stood on the banks working themselves into fits of yuck about the maggots. When developers built one of the poshest districts in town there some years later, bamboozling the privileged with the names, North and South Lakeshore, wiseacres laughed up their sleeves.

BUT CHAPEL HILL'S Fifties' murders got overlaid by politics. Its reputation as a hotbed of communism became morally serious in the McCarthy years when professors had to sign the loyalty oath.

In 1963, a book called *Blood on the Old Well* was published. Its author was Sarah Watson Emery, wife of former philosophy professor Dr. Stephen Emery who had initiated our family's relocation to the Southern university town after he met my father in Pigeon Cove and described Chapel Hill as an oasis in an intellectual desert, an "Athens of the South." It sounded like the perfect place to get a college education if you didn't have any money.

Dr. Emery was the friend of Horace Williams, who mentioned him in the letter to his adopted daughter, "I went to tea with him at the Gilberts." A kindly, solemn man, he married Sarah Watson in 1948. I remember her as a squat woman with brown hair, glasses, and minimal

charm. Polite but with no sense of humor. People called her pushy. She was *tetched* on the subject of communism. At first the couple was seen at lectures and university receptions. Then Dr. Emery's brownish hair became washed out, and they vanished from view. It turned out they had moved to Texas.

Sarah Emery's book about Chapel Hill hit the town in a lurid explosion of publicity. Stores that sold it were castigated. Some people were ashamed to read it. Others reveled. Everybody laughed, openly or secretly, even people with manners, unused to such sensationalism. But all were aghast at the message on its dust cover, defaming Chapel Hill: "The forces of moral and spiritual disintegration are glaringly evident...." Mrs. Emery had obviously blurbed it herself: "Blood spills on the Old Well, the *Daily Tar Heel* whoops a hatred of the South, of America, of the middle class, of Christian morality. Only a few of the recent mysterious deaths are discussed here. Nine white males, ages 20–46 died between September 23rd and Christmas day 1961..." etc.

What were those mysterious deaths? Mostly suicides. Some unexplained. But three were people who worked for the Carolina Inn. Ignoring the fact that suicide is contagious, Mrs. Emery attempted to build a case that the deaths were murders palmed off as suicides, and were actually political murders. These people knew something, she hinted, and they were therefore shut up. The implication was that they were murdered by U.S. government infiltrators, among whom were some liberal ex-professors at Carolina. She constellated all the deaths around a murder/suicide that, in its homosexual overtones, resembled the Leon Smithey case.

On a Friday night in October 1961 two students were found dead of cyanide poisoning in their dormitory beds: one a good-looking undergraduate musician and fraternity man, named James Barham; the other a bespectacled graduate student named William Johnson, poor, introverted, a waiter at the Carolina Inn cafeteria.

Sarah Emery's book, an amalgam of speculation, testimony, and newspaper quotation, was quasi-scientific, quasi-journalistic in style and had appendices from A to H. Sample titles: "Doctor Frank's Pink

Record," "The University of North Carolina and the Secret Government of the USA," and "If You Like Genocide, You'll Like Khrushchev Too."

State critics called the book naive. It was discredited, its combination of evidence and rumor considered unconvincing. As the *New York Times* pointed out in the Rushdie case decades later: America has its own method of censorship; we hide things in small print in back pages. In sweeping the book under the rug, Chapel Hill forfeited the glory of one of its most curious follies, and perhaps one of the most redeeming.

THE LITERARY APPROACH to Chapel Hill as a locus for murder took another curious turn later in the Sixties with the publication of a novel written by Jacques Hardre, retired chairman of the romance language department. Called *Sous les Magnolias*, it was written in French! Every year Gloria Van Dam, a well-known French teacher at Chapel Hill High School, gave the book as a prize to her best honor students.

Only one person I know has read it, a sophisticated Greek lady living in Athens whose father was the Greek ambassador to Paris. "Very nice, really. *Poly oraia*! Quite beautiful and amusing," she said. Her opinion has to be trusted. It was never translated into English. (How peculiar to think of Chapel Hill known by foreigners as the place of murder beneath the magnolias! The French, with their proclivity for the South, took it as a ravishing *divertissement*.)

On murder considered as one of the fine arts, Thomas De Quincey says, "People begin to see that something more goes to the composition of a fine murder than two blockheads, to kill and be killed — a knife — a purse — and a dark lane. Everything in this world has two handles, moral and aesthetic."

In the mid-Sixties two murders happened in Chapel Hill, both of which must be considered in terms of taste: the Rinaldi murder and the Suellen Evans case.

Mrs. Rinaldi was murdered on Christmas Eve 1963, and despite the principal suspect being her husband, Frank, an instructor in the UNC

English Department, the case was an exemplar of taste, most of it bad. Its ingredients came from *The Postman Always Rings Twice*: a pregnant wife, a friend, an insurance agent named John Sipp, a $20,000 double-indemnity insurance policy, and signs of a struggle with overturned lamps and the wreckage of a Christmas Eve supper.

Frank Rinaldi was tried for the crime. Most of the English department, unable to conceive of him as a murderer, stood behind him. He was acquitted for lack of evidence. But there was so much pathological detail published in newspapers of the contents of the victim's stomach, so much repetition of the name John Sipp, that the aura of greed and condiment — sip and sup — dominated everything else. It had the scientific dispassion of a film noir. In fact the story was published in *Startling Detective* magazine, January 1965, under the title "North Carolina's Murder of the Pregnant Bride."

The second murder happened during lunch hour on July 30, 1965, on a cloudless hot day when student Suellen Evans was walking through the arboretum on her way back from classes to her dorm. There was a sound of children's laughter from the nearby Episcopal kindergarten. Two nuns passing by heard a scream, and Miss Evans appeared, crying, "He tried to rape me. I think I'm going to faint." She fell dead in a patch of periwinkle. One of the nuns later testified that she saw "a black hand coming out of the bushes."

It was the green and crazy summer my brother Homer was in love with a witty, elegant girl named Celia Brown from Wilmington, and that evening Tony Harvey, a witty, well-known editor (and punster) of UNC Press (who also played a major part in Milos Forman's first American movie, *Taking Off*), and I were supposed to meet Homer and Celia at the Carolina Inn for supper. Homer and I were involved in a family quarrel. We picked up the argument where we'd left off at breakfast. "Oh now," purred Celia in her refined voice, "let's talk about something pleasant — " and we interrupted her with stares of *Who are you to interrupt a family quarrel?* until she added in an inspiration, her eyes glinting, "like the murder." It worked.

It would be easy to postulate that since the ingestion of Chapel Hill

into the larger Triangle, its murders have become depersonalized. People predicted randomity and anonymous crime with the opening of Interstate 40, linking the town to the major highway grid for the first time.

They cited two murders that occurred in the early Eighties. That of an eleven-year-old Vietnamese girl, adopted by an academic couple and just getting acquainted with the U.S., who was raped and hung from a tree near Finley Golf Course by a man with a record of mental illness who'd been loitering around the school children. A cosmic conundrum, to be born, raised, travel half the world to Chapel Hill to litanize urban anonymity!

Then there was the case of the two women students held at knife-point one evening in Morehead Planetarium parking lot as they were getting into their car. They did not put up a fight. They got in. One was put out of the car on Columbia Street. The other was raped, murdered, and found days later in a dumpster in Greensboro.

The town was left with a game rather than a reality, the game women play in their minds: Would you have fought in the parking lot when you still had the chance? Or would you have gotten into the car?

The assumption of anonymity was only one element in Chapel Hill killings at the approach of the millennium. A young owner-entrepreneur of the balloon store called Helium Delights allegedly forced his way into a stranger's house looking for the stairway to heaven. The homeowner got the gun he had on hand and shot the young man dead in an act of ostensible self-protection.

Helium delight is not only dream, but the trap of dream, a contemporary variety, spiced with rumors of drugs. Or at least the aura, as in Led Zeppelin's song: "Your head is humming and it won't go / in case you don't know, / The piper's calling you to join him. . . ." But even in the twenty-first century we should take heed of the Sixties "lady we all know / who shines white light and wants to show / how everything still turns to gold." She was not "climbing the stairway to heaven" then. If you listen carefully, she was "buying" it, a curious twist to the two

paths we "can go by . . . there's still time to change the road you're on." Murder, after all, is not literary but real.

Nineties youth knew that "Our shadows" were "taller than our souls . . ." which, though suited to the suicidealism of university towns, was more perhaps than Wray Martin knew, whose fantasy led to the troubadourial castle.

IN THE TWENTY-FIRST century there is an awareness of the globalization of dreams as well as of jobs and investments. Mohammed Taheri-azar, a graduate student born in Iran, but brought up in Charlotte from the age of two, attempted to kill students at the University of North Carolina at Chapel Hill by driving a rented Jeep Cherokee amok into the Pit outside the student union on March 3, 2006.

The event resurrected mirror images of the ideologically muddled rationalizations of the *Blood-on-the-Old-Well*–days of the Cold War. Disconnected enemies are now seen in the context of East and West religious differences rather than European-state divisions of capitalism vs. communism. Newspapers headlined Taheri-azar as "The Jeep Jihadist." He was brought up speaking English and knew no Farsi, the language of Shiite Iran. In high school in Charlotte he was car-crazy, and between 2001 and 2003 got ticketed four times for unnecessary honking, driving down the middle of two lanes, failure to obey directions, and going 74 in a 45-mile-an-hour zone in Carrboro. He was considered antisocial by his fraternity, Sigma Epsilon, which dropped him, but as a gentle honor student by other classmates. He worked at Best Buy but volunteered in hospitals.

When indicted he sent voluble letters from prison claiming his right by the will of Allah to punish Americans by killing them but changed his pleas during the incarceration. He was removed to a mental hospital, and new nomenclature, and the term *sudden jihad syndrome* has entered the English language for similar cases of ideological terrorism attempted by a lone individual under the influence of an idea rather than an organization, who may or may not be considered mentally

unstable. The Korean murderer at Virginia Tech and the Fort Hood massacre carried out by Major Nidal Malik, an army psychiatrist, are troubling current examples.

EVE CARSON'S MURDER in 2008 poses the painful question of the twenty-first century's increasing disconnect between random violence and dreams. She was a valedictorian from Clarke Central High in Atlanta, a Morehead scholar, a North Carolina Fellow, the UNC student body president, a campus leader beloved by a vast number of the students, and she became an avatar of transformation because of empathetic influence. She embodied the most joyous humanistic view of life that could be imagined by the founders of the university from its beginning.

In her case the dreamer was the victim rather than the perpetrator, yet she made hope live up to the adjective *audacious,* which President Barack Obama has assigned to the word.

Eve Carson was kidnapped, held at bay at an ATM, and shot in the head for money (and perhaps by gang-related challenges of *chicken*) by marginal Durham drop-out youngsters who were caught later. They had been in prison for petty robbery and had been let out early. They had no reality of her life any more perhaps than she, who dreamed empathy as the prevailing human reality, had of theirs.

It is the disconnect between the warp and woof of Individual Place across Planet Earth and Always Time through Present Time that catches our attention. You can see it on the bumper sticker *Think Globally, Act Locally.* But Eve Carson's murder transformed the students, faculty, administration, and population of the Obama era to such an emotional belief in the best of humanity's ideals as to suggest American social and political dreams are realizable.

Nostalgia grows for the old relationship to Place continually annihilated by Time's manifest development and new, bodiless vocabulary. But nostalgia is famously thin-skinned even as dreams persist inside all souls, be they victim or murderer.

Maybe the clue to Place lies as much in its murders as its topography

or benign history. Why else do scores of people search for Sherlock Holmes's lodgings in Baker Street? Why do tourist guides stop the bus on the road to Thebes at the spot where Oedipus killed his father? Why are bus trips organized to go to Elsinore or Babi Yar? Dartmoor, the Orient Express, Miami streets, the Rue Morgue, the sleaze byways of L.A., the campaniles of Anglican churches, and the dank docks of London or Key Largo conjure their loci as essential psyche.

We know because of Dorothy Sayers, Dashiell Hammett, Wilkie Collins, Agatha Christie, Dickens, Raymond Chandler, and Poe. We don't remember the plots; we don't need to. The places are understood, their murders located in them.

The Bicycle Path

WHEN I FIRST heard the Bicycle Path was to be built, I laughed but was excited. When I first rode it, it was like experiencing a steamed clam. First you had to taste it, then to understand it, then to get used to it. Only then could you decide.

The Bicycle Path connects Carrboro with Chapel Hill.

It crosses the railroad tracks in three places, not only an inefficient and dangerous intertwining, but symbolically significant. It loops the loop in three unnecessary curves, augmenting the distance between the two towns. It collects gravel from a stone and cement plant, making it skiddable for bicycle tires, and skirts an area of automotive companies which in the beginning was simply an automobile graveyard. It crosses Brewer Lane on a downswing with a half-pint stop sign that, like all the Bicycle Path's signs, resembles a toy that designers of children's games might have had a great time fantasizing.

But the fact is that it is a success. The reason is that it is not a figment of imagination painted on a motorway. It is a real route, separated from automobile traffic. It is dedicated, like an Indian trail or a silk route, to bicycles and walking only, and it was the area's first path to separate the motorized from the human-powered.

It gave rise to other paths like the Shetley Path in Carrboro and the Bolin Creek Path which extends from Martin Luther King Boulevard (the old Airport Road) to the community center opposite University Mall. Whether for ecological reasons or political self-promotion, it is the first path with a sign saying in white letters on green *Bicycle Route*, the first to go beyond the lip service of committee politics and money

deals. Once you coast through its yellow stakes you are in another country, a region of silence where grinding machine noises abate. You have gone through a gap in time.

A Path is a narrative journey. In a children's book its beginning has large, definite borders. Its middle winds upward growing smaller on the hill, and its end is unknown, a disappearance into the forest where the doorway of the witch's house may await. Proust formed a seven-volume novel around the distinction between *Swann's Way* and the *Guermantes Way,* and his clue was memory.

In an inanity undreamed of by its planners and ungrasped by its users, the Bicycle Path is a link to and repository of Chapel Hill's past. Its authenticity is directly related to the fact that it follows the railroad tracks.

When I lived in the Shack on Merritt Mill Road in 1939 I was only a few hundred yards from these tracks. The implications of a Path based on railroad tracks are larger than one suspects and have nothing to do with nostalgia.

In the Forties the railroad tracks had great suspense. The train, then as now, came only once a week, plowing slowly through the forests from Durham, through Eubanks Station, across the trestle where Estes Extension now is, hooting its lonely warning at crossings, an antediluvian breed like bison, going nose-first. The weekly event in the Eighties was still heralded by flares at Main Street in Carrboro, Merritt Mill Road, and Cameron Avenue. The flares emitted ghastly pink sparks and the smell of danger. Who set them? No one has ever known or seen.

In the Forties we called the Power Plant the Palace of Versailles because fountains of water spurted into the sun from the water purification pools behind the plant, the train having reached its destination, dumped its coal there and turned anticlimactically around.

During those summers the rails cracked like ice and shimmered in the heat. They marked off with geographical precision the class system separating the Chapel Hill *haves* from the Carrboro *have-nots.* Now that Carrboro is the Greenwich Village of Chapel Hill, its property

Daphne Athas. Reprinted by permission from photographer Artie Dixon.

taxes higher than Chapel Hill's, the distinctions are blurred, though the demographics are true in a different way.

Children and blacks in the early days were the only humans who knew the tracks were the shortest distance between the two towns, and they had an uneasy truce and secret ritual. Black women walked carrying laundry on their heads. A black man was found every month dead drunk with one arm slung over the rail inviting amputation, bottle still in hand. The enormity of this inspired awe and games. White children dared each other to step on his upturned palm, counting out the footsteps on either side to a periphery that circumscribed death at the center of life.

Railroad ties are the wrong intervals for walking: too near to take a single step, too far to step two at a time. The solution was to walk a rail in sneakers from Cameron Avenue to the Negro Graveyard (now Old Carrboro Cemetery) without falling off. The graveyard was unkempt, dreaming in long grass and honeysuckle, collecting its own

past back to Reconstruction, next to the empty mill where later the Orange County Health Department was located for awhile. It was the symbolic Underworld to which you walked from Versailles, and the big question was: Which end is the beginning? To me, who lived at the black end of town, it was Chapel Hill.

In the Twenties, barefoot boys had arrived from far counties to walk from the Carrboro train depot to the university campus to begin enlightenment. This felt legendary. In 1921 Dr. Huse, translator of Dante's *The Divine Comedy,* picked up a prefabricated two-story house he'd ordered from Chicago. That mail order house, precursor to mass production and complete with plumbing and steam radiators, was erected on Gimghoul Road (and razed in 2009).

Even up until the Fifties we knew things came from afar into the station. We knew that the *Beginning* could be the Other Way. In 1950 fourteen iron casement windows came COD to the Carrboro depot and my family had to beg and borrow from Peter to pay Paul to get them out of there and to the construction site of our new dream house.

We were into upward mobility, but our center of gravity, our point of view, our beginning had started at Patterson Place, where the original bed for the tracks led the train all the way past the power plant to the campus. Our journey as a family was toward the Lower Depths, the tintop of dispossessed blacks on Merritt Mill Road in Chapel Hill, which looked westward to Carrboro, the world of unemployed mill people spitting snuff into cans, where all the streets were dirt.

In the Fifties the depot became extinct, and in the Sixties it was converted into one failing artsy restaurant after another. People began to be killed at train crossings as population expanded. One of these deaths which took place on a Sunday night was of an Andrews of the Andrews-Riggsbee clan. Auto traffic began colliding with the rhythms of older years. The Andrews and Riggsbee grocery store closed down. But the pink sparks that hissed when the train came by lasted up to the twenty-first century, only then signaling the gap in the vanished topography of dreams in which professors, Carrboroites, townspeople, truck kids, country people, and blacks had invested their identity.

When you have known a Path for five decades your center of gravity and point of view change. In the Eighties and Nineties a cement quarry was gouged out where in the Railroad Track days there had been only a high prospect bathed by gorgeous sunsets. Butler's auto lot also grew up then. And the Bicycle Path fronted derelict autos and backs of stores with dumpsters. As stores and goods proliferated, so too did garbage and the pure stink of ordure and orange peels.

With a higher industrial profile and increased mechanization, the crudity of cement and garbage was cleaned up and the path took on a polished, mechanized appearance. The Bicycle Path, cleared out, its backyards, the backs of stores and gas stations abolished, has been elevated to twenty-first century industrialized anonymity. Processed industrialization is more kempt than the days of first bicycle-dom, when the Path was neglected and messy and forgotten. Corporate neatness has minimized the feeling of secrecy but substituted a temporal disguise.

In the forgotten lies the secret. I have witnessed drivers in 5 o'clock traffic on Merritt Mill Road gazing longingly down the Bicycle Path as an alternate route to Carrboro, and if the yellow posts weren't there, they would have tried to enter. I once saw a Vespa sneak through, the driver huddling up into his helmet guiltily, aware of the outrage he had committed by introducing his motor to the silence.

A bike rider is conscious of thinness, of single file. Only the train itself has a two-footed mentality, and it has its own tracks. The walkers, despite two feet, have single-file mentality too, and their own section marked by a solid yellow line. Walking along they suppress a gloat and often burst out, "Good morning!" desiring to share the secret.

Bicycle riders are subversives, anarchists with sneaky personalities and pugnacity, reveling in their freedom with ecological righteousness. In the Sixties they were snobs with helmets spurning baskets on handlebars and anything under ten speeds, patronizing meat-and-potatoes riders, talking wind shear while balancing book bags. But the years have democratized them, and now there are Hispanics with broken-down red bikes and only one operable gear, oldies with baskets

on their handlebars, blacks with ten-speeds, and trudging students with backpacks.

Some people ride without helmets, but little attention is paid to the differences between classes and races. In such an anonymous climate each rider lives in his own world. Through my historical perspective I marvel: "Look, there's an old Vietnamese who may have been one of the boat people escaping a war undreamed of when the only center of gravity was World War II and who is now riding the Carrboro Bike Path!" And, "Just think! The dew that lies on the railroad tracks is the same dew that lay upon them the year the Americans marched from Kuwait to Baghdad, or sixty years before when the Germans invaded Poland!"

The advantage to bike riders, who are not miniature autoists, is profound. No longer must they ply Atrocity Mile that stretches from Weaver Street to Brewer Lane on their way to campus or choose Graham Street over the traffic and turns of Merritt Mill Road. But when they leave the Bike Path at Cameron Avenue they must again dodge, for cars are parked in the painted bike lane, blocking their downward coast to campus. They must again flaunt their moral force in the mosquito role automobiles force on them, lusting to swat them dead. Stories of bicycle martyrdom are legion.

One cold February day in the Eighties with the wind chill at zero, I waited at an endless red light at Crook's Corner. There was no traffic on either Merritt Mill Road or Brewer Lane. So, I synchronized myself. But getting cold, I jumped the gun and pedaled off seconds before the light turned green, unaware of the obese, white prowl car directly behind me. The siren started. I vibrated to the marrow, looked back, thinking, *Not a bulldozer for an ant!* searched for a culprit. I felt the blue light bearing down on me, burning with flashes, and realized, *It's me,* and scrabbled onto the dirt sidewalk like a plucked chicken.

The siren stopped, but the blue light kept on, and a fat arm protruded out of the window motioning me to the front seat. The policeman demanded my driver's license. I begged and pleaded, but gave it to him. He slapped a $27 citation on me, which, out of a sense of honor,

I refused to pay. I took it to court. It was thrown out, but every year for four years afterward I had to call my insurance agent to reverse the $16 penalty for bad driving that the computer automatically added, unable to distinguish between automobiles and bicycles.

In the same stretch of road one 90-degree day that same year, after sheltering from a sudden rainstorm in the doorway of a furniture store, I continued pedaling toward Carrboro, tailgated by a hot, sweating woman with a shrieking baby in a fat yellow car with dents. I came to a puddle flooding the road and veered. She gunned her motor — she had no muffler — and passing within an inch of me, she was forced to slam on her brakes when the Weaver Street light turned red. I sailed on past, trilling sweetly through her open window: "You're in an awful hurry." "I hate you!" she screamed.

When I recognized that she was transformed into a murderer inside an upholstered weapon, I hightailed it to the sidewalk. She stepped on the gas, exploded her Chrysler into a deathly rampage up Weaver Street and into the maw of Harris Teeter's parking lot where I last viewed her shuddering in clouds of black smoke.

If the secret lies in the fact that the Bicycle Path begins at either end, and that history is eaten and digested through it, there still remains a mystery. I remember after the fact that in the Eighties there was an old, abandoned house sitting next to the path just west of Merritt Mill Road, three hundred yards from the bend in the tracks. It had a *No Trespassing* sign and was ignored by bicyclists, hidden behind the tangle of honeysuckles and morning glories staring out like eyes through the holes of its broken windowpanes and peeling paint. If you slowed down you could see the broken hallways and tipping floors through bushes.

One day I decided to actually look. I parked my bike and pushed my way through the tangle of vines. Sure enough, there was an old sleeping bag showing that some generation of crash-pad bum had lived there for awhile, some late version of ancient beatnik or hippie, an effluvium of a third decade Chapel Hill hanger-on, superimposed upon the extinct family life that had occupied the house before then.

But the stain of lost souls was rinsed out and steamed away. The

place didn't warrant a night's shelter or even a drug deal, I decided. So when I threaded my way out through the overgrown vines and got back on my bike I had the feeling that the house went back beyond any trip to bountiful to exist as a picture in a children's book.

I relished that thought and embellished it. The Witch was watching even as the obvious reality lay in some death of a grandfather or grandmother. It must have been a court case about inheritance that kept the rotting place in limbo. Whatever family routine and dreams had once prevailed, there must have been a lingering battle fought by brothers and sisters or aunt, uncles, and in-laws.

Three years later I noticed the house was gone. That meant the court case must have been decided. The disappearance of the actual homeplace reminded me of Gertrude Stein, for there was no *There* any longer. Even the tangle of vines had been cut away to an empty field.

If the secret of the Bike Path is that it begins at either end and that history has been eaten and digested through it, there still remains something to be explained, for there is a relationship between the rhythm of narrative ideas and speed. Too much motion obscures life and that's why you can't see details from a car. Too little motion, like walking, makes you think nothing changes. Bike riding is the right speed for secrets, but not until I decided to tell this, did I realize it.

Such is the gift of the Bicycle Path in making us aware of the backs of the backyards of Chapel Hill life, that myth is authenticated and truth released, however phantasmagorical. You can feel it sometimes even while driving. But you have to slow down, or even stop. Just stop your car at the light on Merritt Mill Road and Cameron Avenue at night, and look down the Bicycle Path through the yellow poles. You will see it like a symbolic stage set, lit in the greenish glare of successive cement post lamps, a Chirico, a route that beckons and at the same time curls into infinity.

ACKNOWLEDGMENTS

Eno Publishers wishes to thank Randall Kenan for everything he did to make this book happen. A note of appreciation to Adrienne Fox, Speed Hallman, Gita Schonfeld, Spencer Woodman, and Mark Meares for their careful reading.

The photographs included in this collection were searched for, assembled, and made possible by David Brown (*Carolina Alumni Review*), Keith Longiotti and Bob Anthony (North Carolina Collection, Wilson Library, UNC), Greg Nickson, Barbara Scales, Julia MacMillan, Nancy Smith, Barbara Ilie (Southern Historical Collection, Wilson Library, UNC), Valerie Yow, Traci Davenport, and Ernest Dollar. And a special thank you to photographers Artie Lavine, Dan MacMillan, and Dan Sears.

This book was made possible by the generous support of the Mary Duke Biddle Foundation.

ESSAY ORIGINS

Portions or earlier versions of the following essays from *Chapel Hill in Plain Sight* appeared in the following periodicals:

A version of "The Way to Find Hestia" appeared in *Botteghe Oscure*, Rome, Spring 1959, and was reprinted in *Chapel Hill Carousel, an Anthology* (University of North Carolina Press, 1967).

A version of "Carrboro,Carrboro" appeared under the title, "Carrboro, Cradle of Dreams," in the *Spectator*, April 30 – May 6, 1987, and was republished in *Frank, An International Journal of Contemporary Writing & Art*, No. 15, 1996. Paris, France.

Some material in "Daddies and Donkeys" is drawn from a column, "A Twinship of Angst and Books," Daphne Athas wrote in the Raleigh *News & Observer*, July 24, 1994. It was republished as "On Leo Tolstoy's Confessions," in the anthology, *Books of Passage*, edited by David Perkins (Down Home Press, 1997). Portions of the essay were drawn from a column on Horace Williams that appeared in *Chapel Hill News*, Feb. 5, 1995.

"Betty Smith Looks Homeward" is based on an essay originally published in the *Leader*, June 22, 1989, Research Triangle, NC.

An earlier version of "The Princes and the Paupers" was published in the *Spectator*, July 7–20, 1988, Research Triangle, NC.

"Max on the Beach" was a feature in the *Leader*, Aug. 11, 1988, Research Triangle, NC. It was republished as fiction under the title "Hugh" in the anthology, *The Rough Road Home, Stories by North Carolina Writers* (University of North Carolina Press, Nov. 1992).

Portions of "Carolina Red" were originally published as an essay-review in the *Spectator*, July 2–8, 1987, Research Triangle, NC, and in the *Leader*, June 22, 1989, Research Triangle, NC.

"He Lived to Live" is based on "Radical Cheek," published in the *Spectator*, June 13–19, 1991. Research Triangle, NC.

A version of "The Spirit of Play" was published in the bicentennial issue of the *Carolina Alumni Review*, Winter 1993. Chapel Hill, NC.

A version of "Why There Are No Southern Writers" appeared in the *Southern Review*, Vol. XVIII, No.4, Oct. 1982, Louisiana State University, Baton Rouge. It was reprinted in the anthology, *Women Writers of the Contemporary South*, ed. by Peggy Prenshaw (University Press of Mississippi, 1984).

An earlier version of "Chapel Hill Murders" was published in the *Leader*, Nov. 2, 1989. Research Triangle, NC.

A version of "The Bicycle Path" was published in the *Spectator*, Aug. 28, 1986. Research Triangle, NC.

ABOUT THE AUTHOR

Daphne Athas, novelist, was a Lecturer in the Creative Writing Program at the University of North Carolina at Chapel Hill from 1968 until she retired in 2009.

Her novel, *Entering Ephesus*, published in 1971, was included on *Time Magazine's* Ten Best Fiction List in 1971 and was a Cosmopolitan Book-Club selection. Another novel, *Cora*, won the Sir Raleigh Award.

In 2007, Ms. Athas published the maverick grammar text, *Gram-O-Rama: Breaking the Rules*, which addresses the gap between classic grammar and cyber sound-byte-language through hearing, word-play, and performance art.

She has been Fulbright Professor of American Literature at the University of Tehran, has published both fiction and nonfiction including travel, poetry, drama and literary criticism, and received the University's Lifetime Mentor Award in 1982.

Her work has appeared in many journals and periodicals including *South Atlantic Quarterly, Frank, New World Writing, Botteghe Oscure, Shenandoah, American Letters and Commentary, Chicago Tribune Book World, Transatlantic Review, Hudson Review, College English, Philadelphia Inquirer,* and *The World and I.*

She lives in Carrboro, North Carolina.

ALSO BY DAPHNE ATHAS

The Weather of the Heart (1947). Appleton Century, New York

The Fourth World (1956). G.P. Putnam's Sons, New York. Reprint 1957, Pyramid Books, New York

Greece by Prejudice (1963). Travel Memoir. J.B. Lippincott, New York

Entering Ephesus (1971). Viking Press, New York Republished 1991, Permanent Press, Sag Harbor, New York

Cora (1978). Viking Press, New York

Crumbs for the Bogeyman (1991). Poems. St. Andrew's Press, Laurinburg, North Carolina

Gram-O-Rama: Breaking the Rules (2007). iUniverse, New York, Lincoln, and Shanghai